FOR A LOVE OF HIS PEOPLE

August 2014

To my dear mentor
Eddie, with much
admiration & affection,

Bitz

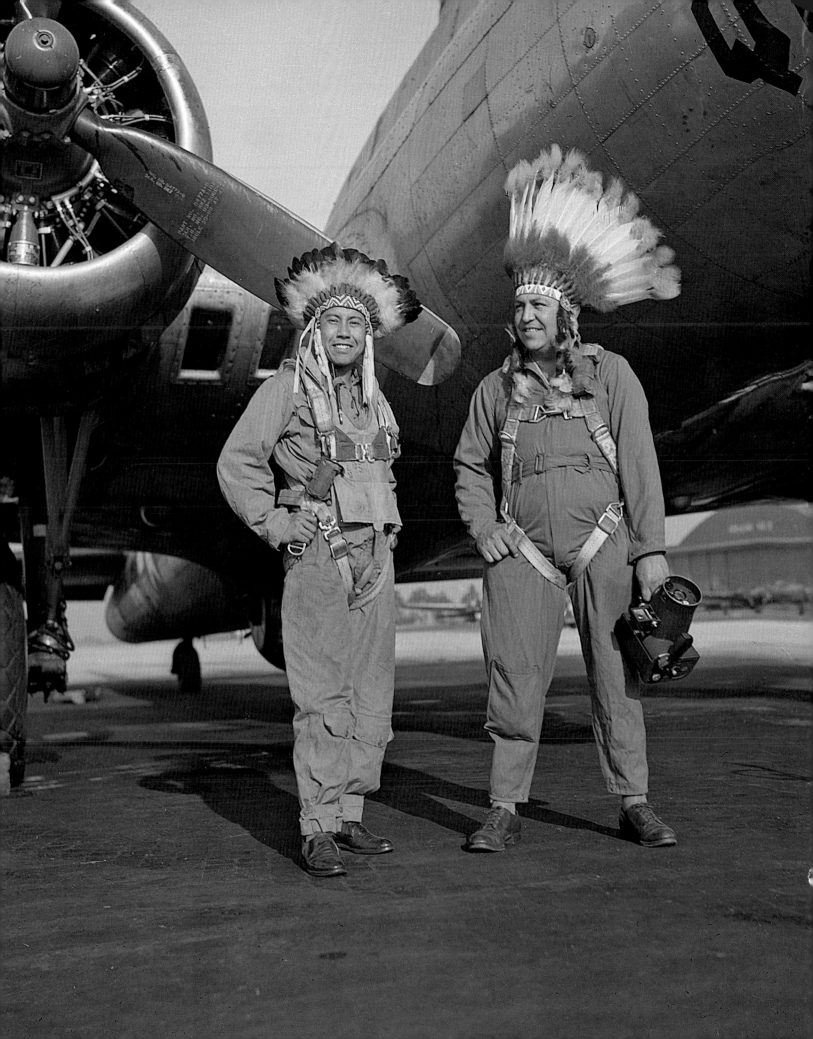

FOR A LOVE OF HIS PEOPLE
THE PHOTOGRAPHY OF HORACE POOLAW

NANCY MARIE MITHLO
General Editor

NATIONAL MUSEUM OF THE AMERICAN INDIAN
Smithsonian Institution

Washington, DC, and New York
in association with

Yale UNIVERSITY PRESS
New Haven and London

The Henry Roe Cloud Series on American Indians and Modernity
Series Editors: Ned Blackhawk, Professor of History and American Studies, Yale University, and Kate W. Shanley, Native American Studies, University of Montana

Series Mission Statement

Named in honor of the pioneering Winnebago educational reformer and first known American Indian graduate of Yale College, Henry Roe Cloud (Class of 1910), this series showcases emergent and leading scholarship in the field of American Indian Studies. The series draws upon multiple disciplinary perspectives and organizes them around the place of Native Americans within the development of American and European modernity, emphasizing the shared, relational ties between indigenous and Euro-American societies. It seeks to broaden current historic, literary, and cultural approaches to American Studies by foregrounding the fraught but generative sites of inquiry provided by the study of indigenous communities.

For a Love of His People
The Photography of Horace Poolaw

Distributed by Yale University Press

Yale University Press books may be purchased in quantity for educational, business, or promotional use. For information, please e-mail sales.press@yale.edu (U.S. office) or sales@yaleup.co.uk (U.K. office).

For more information about the Smithsonian's National Museum of the American Indian, visit the NMAI website at www.American-Indian.si.edu. To support the museum by becoming a member, call 1-800-242-NMAI (6624) or click on "Support" on our website.

Published in conjunction with the exhibition *For a Love of His People: The Photography of Horace Poolaw*, opening at the National Museum of the American Indian, New York, on August 9, 2014.

Associate Director for Museum Programs
Tim Johnson (Mohawk)

Publications Manager
Tanya Thrasher (Cherokee Nation)

Project Editor
Alexandra Harris (Cherokee)

Senior Designer
Steve Bell

Editorial Assistance
Ann Kawasaki
Bethany Montagano

General Editor, Co-Curator
Nancy Marie Mithlo (Chiricahua Apache)

Co-Curator
Tom Jones (Ho-Chunk)

Permissions
Horace Poolaw Photographs © 2014 Estate of Horace Poolaw. Reprinted with permission.

Printed in the United States of America

First Edition

10 9 8 7 6 5 4 3 2 1

Library of Congress Cataloging-in-Publication Data
ISBN-13: 978-0-300-19745-7

For a love of his people : the photography of Horace Poolaw
/ edited by Nancy Marie Mithlo. — First edition.
 pages cm
 ISBN 978-0-300-19745-7 (hardcover : alkaline paper) 1. Indians of North America—Great Plains—History—20th century—Pictorial works--Exhibitions. 2. Kiowa Indians—History—20th century—Pictorial works—Exhibitions. 3. Great Plains—Social life and customs—20th century—Pictorial works—Exhibitions. 4. Documentary photography—United States—Exhibitions. 5. Poolaw, Horace, 1906-1984—Exhibitions. 6. Indian photographers—Biography. 7. Kiowa Indians—Biography. I. Mithlo, Nancy Marie. II. National Museum of the American Indian (U.S.)
 E78.G73F67 2014
 978.004'97—dc23
 2014007060

This paper meets the requirements of ANSI/NISO Z39.48-1992 (Permanence of Paper).

The views and conclusions contained in this publication are those of the authors and should not be interpreted as representing the opinions or policies of the National Museum of the American Indian or the Smithsonian Institution.

Cover: Jerry Poolaw (Kiowa), on leave from duty in the Navy. Anadarko, Oklahoma, ca. 1944. 45HPF173—L.P.

CONTENTS

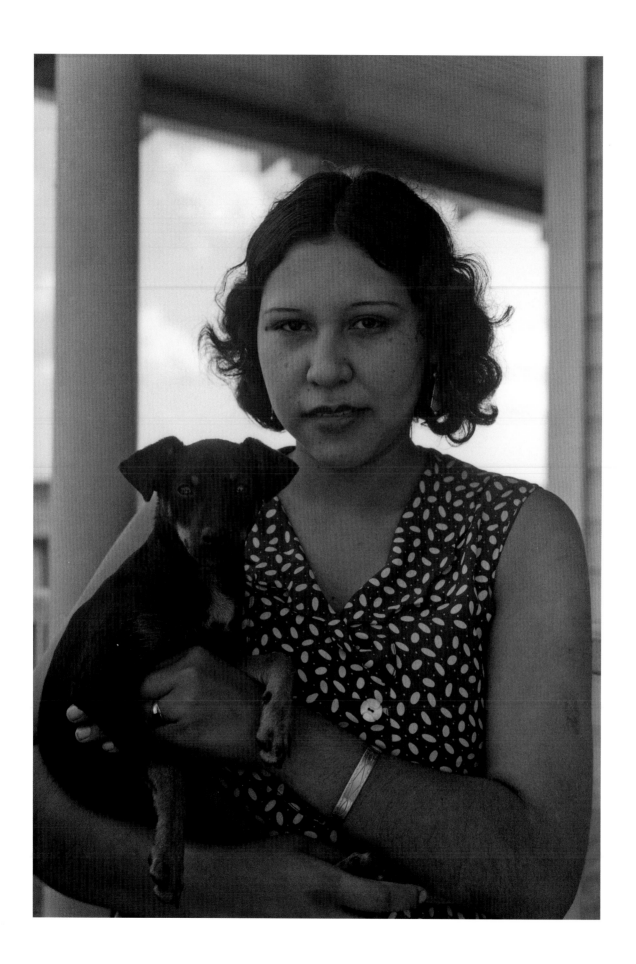

FOREWORD

FEW THINGS IN LIFE ARE TRULY IRREPLACEABLE, save what we infuse with meaning and memory. Since the advent of photography, we have given great value to these small printed evidences of our existence. In these portable replicas, our loved ones may travel great distances with us—off to college, perhaps, or a new job across the country, or even to war on the other side of the world. In our homes we keep the legacy of our families alive through the decades- or even century-old photographs of ancestors we may have never met, hanging on walls, resting between the covers of albums.

This tangible connection with those who came before us aligns directly with indigenous ways of viewing the world. As American Indian communities have imbued their homelands with the histories and spirits of beloved ancestors, so too have they assigned deep meaning to photographs. Rather than fearing the camera and its medium, as popular stereotypes would have us believe, Native people recognized early on the power of photography to capture meaning and memory in the same way stories and art always have. Photography resonates with a Native sensibility.

Nevertheless, in the canon of American Indian artists, photographers have always been a minority. Yet Native people embraced the medium early on, quietly taking images of their own communities, such as turn-of-the-twentieth-century photographers Jennie Ross Cobb (Cherokee, 1882–1958) in Oklahoma and Richard Throssel (Cree, 1882–1933) in his adopted home at Crow Agency, Montana. Of these early generations of little-known Native photographers, Horace Monroe Poolaw (Kiowa, 1906–1984) stands out as one of the even rarer professionals—never able to make a living off his work, yet passionate enough about using his skills to record his community in and around Anadarko, Oklahoma, for more than five decades. As many of the authors in this volume attest, Poolaw evidenced his family and community as they truly lived—as both American and indigenous citizens of the twentieth century. We as viewers empathize with Poolaw's subjects, seeing them as fellow Americans of their place and time. As a "family album," we recognize and identify with these faces because they mirror those in our own priceless albums at home.

At the same time, and for the same reasons, mid-twentieth-century Indians are broadly viewed as an invisible people, located in a zone somewhere between traditional and modern. The authors of this book—scholars, family members, and community members alike—illustrate, along with the photographer's images, the unique space that Native people in Anadarko occupied at this particular time in American history (1920s–1960s). It was indeed a time of change. As exhibition co-curator Tom Jones (Ho-Chunk) adeptly points out, this change is not a unique

1. Trecil Poolaw Unap (Kiowa), Horace's sister, at home with Blackie the dog. Mountain View, Oklahoma, ca. 1928. 57FPN5

occurrence but an ever-present aspect of surviving and, hopefully, thriving as time inevitably marches on. Through Horace Poolaw's images, we now may see his community with all its vibrancy and complexity—a community of multiple tribal cultures and different socioeconomic levels expressing a spectrum of traditional values. Importantly, his work captures an era of transition, otherwise hidden from history, that reveals the many changes and adaptations American Indians were making across the country.

This volume, a companion piece to the National Museum of the American Indian (NMAI) exhibition *For a Love of His People: The Photography of Horace Poolaw*, represents the only major publication of Horace Poolaw's work and celebrates the first retrospective exhibition of his photographs in almost twenty-five years. The momentous effort by the museum is based on the Horace Poolaw Photography Project, the work of two prominent Native scholars, exhibition co-curator and general editor Dr. Nancy Marie Mithlo (Chiricahua Apache) and co-curator Tom Jones. In 2008, Mithlo, Jones, and students from the University of Wisconsin–Madison traveled to the University of Science and Arts of Oklahoma's (USAO) Nash Library, in Chickasha, Oklahoma. While there, they scanned the entire collection of more than 1,400 negatives. Originally, Horace Poolaw's collection included around two thousand negatives; since the photographer's passing in 1984, however, some negatives have been lost and are therefore not included in this project. Those that still exist, though, were scanned at a high resolution and cleaned by Tom Jones and his students for this exhibition and catalogue. Since then, the scanned files have been returned to the Poolaw family for posterity and stored with the prints and negatives at USAO. Although this book features a small portion of the collection, readers may now witness for themselves the breadth of Horace Poolaw's work and the deep connection he had with his community.

As groundbreaking as this venture is, the research on Poolaw's photographs has only just begun. Most significantly, the stories and identities of many in the images are as yet unknown. This project is "living" research; we hope that it inspires scholars and community members to uncover more deeply the life and times of this singular and talented Kiowa photographer.

As with Horace Poolaw's original photographs, the NMAI's major exhibition and publication could not have happened without the support of the Poolaw family and many in the communities of and around Anadarko, Oklahoma. We are indebted to Horace Poolaw's children, Linda Sue, Robert "Corky," and Bryce, along with grandson Tom Poolaw, for their trust, enthusiasm, and deep personal knowledge of their ancestor's work, and to Dane Poolaw for his expertise with the Kiowa language. We offer gratitude to Nancy Marie Mithlo and Tom Jones for reintroducing Horace Poolaw's work to the NMAI and for providing guidance to the team during the multi-year project. For his efforts to produce the exhibition and book image files, we thank Professor Jones for managing the complex process of digitally cleaning the negatives. For their invaluable contributions, we additionally wish to thank Kelly Brown, director of USAO's Nash Library, and Laura Smith, author in this publication and accomplished scholar of Poolaw's work. Furthermore, the family and curators would like to recognize the support and advocacy of Fred Nahwooksy (Comanche, 1955–2009), longtime Poolaw family friend and staff member

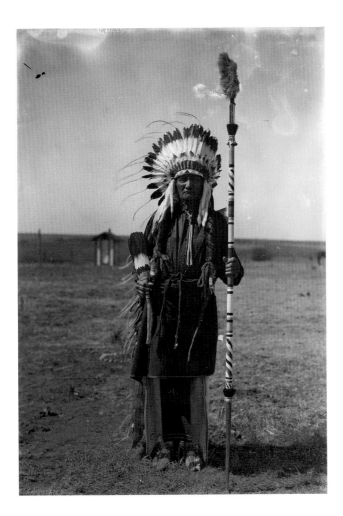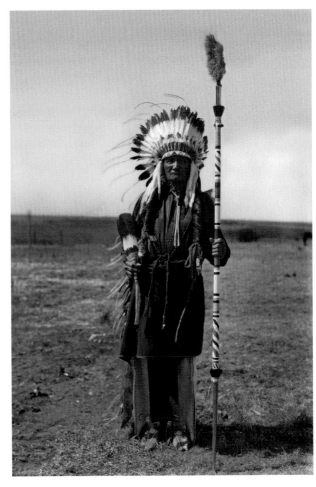

2. Old Man Big Bow (Kiowa). Mountain View, Oklahoma, n.d. 57PC5

As Horace Poolaw's negatives aged, they deteriorated or were damaged. Jones and his assistants were able to digitally clean the scans of the negatives so that they could be restored to their original depth and quality for this exhibition and catalogue.[1]

at the NMAI. Nahwooksy initially championed this project to the museum, and is a much-beloved and greatly missed member of both the Anadarko and NMAI communities.

When Horace Poolaw sold his photos at fairs and community events, he often stamped the reverse with his imprint: "A Poolaw Photo, Pictures by an Indian, Horace M. Poolaw, Anadarko, Okla." Not simply by "an Indian," but a Kiowa man of Anadarko, strongly rooted in his multitribal community. His legacy as a documentarian and artist of his place and time endures.

Kevin Gover (Pawnee)
Tim Johnson (Mohawk)

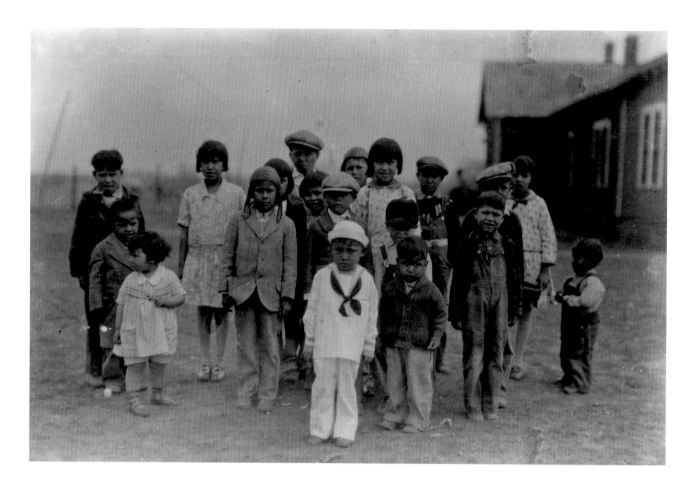

3. Left to right: Edwin Ace Ware, Leo Kyco Ware, Wanda and Thelma Poolaw, Roloh Momaday, Vivian Saunkeah, Newton Poolaw, Eualuh Ware, Billy Tychwy, Jerry, Cleatus, and Rowena Poolaw, unidentified, Elmer "Buddy" Saunkeah, Jack and Donald Poolaw, unidentified, Betty Poolaw, Justin Ware (all Kiowa). Mountain View, Oklahoma, ca. 1928. NMAI P26501

4. Jerry Poolaw (Kiowa), Horace's son. Mountain View, Oklahoma, ca. 1929. 57FK19

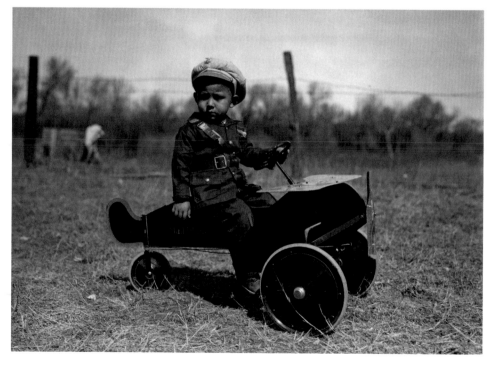

5. The deacons of Rainy
Mountain Baptist Church. Left
to right: Adolphus Goombi
(Kiowa), Lester Momaday (Ki-
owa), Robert Goombi (Kiowa),
Porter Drywater (Cherokee).
Rainy Mountain Church, Moun-
tain View, Oklahoma, ca. 1930.
57PN12

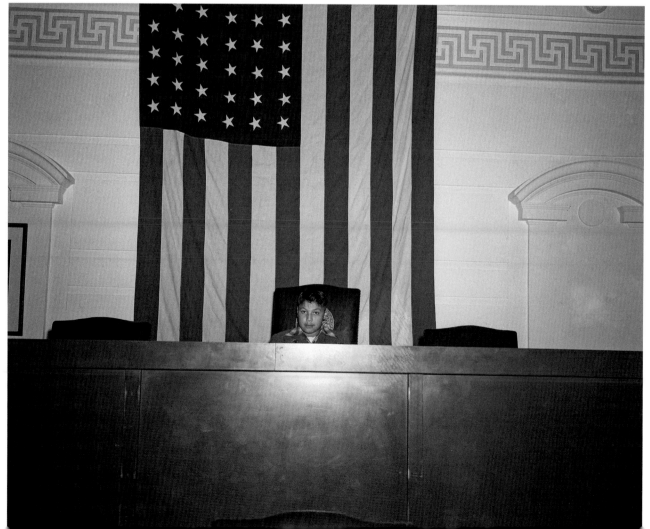

FAMILY PICTURES | FAMILY STORIES

MARTHA A. SANDWEISS

CLOCKWISE, FROM TOP LEFT:

6. Neighbor kids on their way to school. Left to right: Phil Keith Carter (Caddo), Robert "Corky" Poolaw (Kiowa/Delaware), unidentified, Janice (?), Wayne Carter. West of Anadarko, Oklahoma, ca. 1945. 45HPF138

7. Kiowa Tribal Princess Libby Ann Hines Hall, American Indian Exposition parade. Anadarko, Oklahoma, 1948. 45EP120

8. Robert "Corky" Poolaw (Kiowa/Delaware) in the senate chamber. State capitol building, Oklahoma City, Oklahoma, ca. 1951. 45HPF14

PHOTOGRAPHY ARRIVED IN INDIAN TERRITORY with astonishing speed. In the summer of 1842, just three years after the Frenchman Louis-Jacques-Mandé Daguerre announced his marvelous new invention to the world, an Arkansas photographer named C. P. Moore declared that he had taken "a great number of likenesses" at Fort Gibson and around the Cherokee Nation.[1] A year later, in June 1843, artists John Mix Stanley and Caleb Sumner Dickermann set up a daguerreotype camera in Tahlequah, the capital of the Cherokee Nation. They photographed some of the thousands of American Indian delegates attending an intertribal Grand Council, convened by Cherokee Principal Chief John Ross to establish peace among the tribes and to discuss the preservation of their sovereignty. And when the council ended, they accepted an invitation from Ross's brother Lewis to come to his home and make pictures of his family. They made ten portraits; like Moore's, they're now lost.[2] But these earliest photographs of Indian peoples on the southern plains nonetheless offer us an important historical context for Horace Poolaw's work. They remind us that Native communities have long been involved with technology, modernity, and self-governance. They remind us that Native peoples were, from the start, active collaborators in the production of their own images—after all, Lewis Ross *invited* the photographers to his home, and those council delegates probably welcomed a record of their participation in an important political gathering. And finally, they remind us that when pictures get lost or unmoored from their original contexts, important stories get lost, too.

Photographs are paradoxical sorts of historical evidence. They capture a split moment of time, but they speak to changing and fluid situations. For every photograph, we can imagine a before and an after: that moment before the horse races into view, before that boy turns to face us, after that girl rides away in the car. So, they beg us to imagine fuller stories, to fill in what we can't see. But how do we tell those stories?

The physical form of a picture is fixed, but its meaning is not. We can't help but bring what we know to our understanding of a photograph. A portrait that means one thing to the photographer might mean another to the subject, and hold still different meanings for that subject's family. And those meanings might shift entirely when the picture gets cast out into the marketplace, cut free from any ties to a particular person or place. Some of the very earliest photographs of American Indians, like those of the Ross family, were made for the subjects themselves. They were daguerreotypes, singular images on silver-plated copper, made to be treasured

as family keepsakes. But as photographic technology evolved and photographers gained the ability to make a theoretically unlimited number of paper prints from glass—and later film—negatives, most photographers of Indian subjects shifted strategies. Instead of trying to please their sitters, they tried to please their unseen buyers. And so, over the last half of the nineteenth century, photographs of Indians were increasingly swept up in larger narratives about westward expansion and the imagined story of a vanishing race. That's what white audiences wanted. And it's what they got.[3]

The Indian subjects of these photographs, if they got copies of their portraits at all, might still value the pictures as personal keepsakes. But they could not control the stories attached to other copies of the pictures, which circulated in the vast cultural marketplace as pieces of visual evidence about the inevitable decline of Native life. A single photograph could have many meanings, and all too often the subjects' own stories were lost altogether.

Only a handful of Native photographers worked during the nineteenth century. More emerged during the early twentieth century, but few left behind so large an archive as did Horace Poolaw, who remained devoted to his craft for some fifty years.[4] With the exception of some photographic postcards, his pictures—with their careful devotion to family, their meticulous documentation of special events, their openness to the quotidian beauty of everyday life—remained private (fig. 9). He worked to satisfy himself and honor his subjects. His archive gives evidence that photography itself is not an inherently exploitative medium, even if some might use it to exploitative ends.

In recent decades, some Native communities have begun to reassemble the family and tribal pictures scattered about in different archives, reinscribing those photographs with new meanings. Pictures once cast into the world with stories supporting the federal government's suppression of traditional practices are being reclaimed as pictures that speak to a relative's resistance to federal power, or an ancestor's importance as a cultural leader.[5] Such projects underscore both the malleability of photographic meaning and the incredible power of photographs to create and reinforce a community's identity or a family's deep sense of its past.

Poolaw kept his pictures close. They didn't appear in government publications or illustrated magazines or get swept up into stories he couldn't control. So, as we view many of them here for the first time, we encounter them with rich narratives contributed not just by scholars and photographers, but by family members who lovingly preserved their stories along with Poolaw's negatives. The family stories, especially, make vivid these pictures and remind us that they are not simply screens upon which we can project our own desires. Horace Poolaw photographed as an insider; he knew his subjects and understood the many challenges they faced. His photographs are deeply rooted in a particular time and place, in a specific community and family. And even as the pictures illuminate that world for us, they also let us catch a glimpse of Poolaw himself, a remarkable man with a steadfast commitment to capturing a record of Kiowa life in the rapidly changing landscape of twentieth-century America.

9. Family and community members used Horace Poolaw's photographs to share their own stories, inscribing very personal meanings to each image, as in this Christmas greeting from Horace's sister, Anna, and her husband Jasper Saunkeah (Kiowa), ca. late 1920s. 57FGC16—M. S.

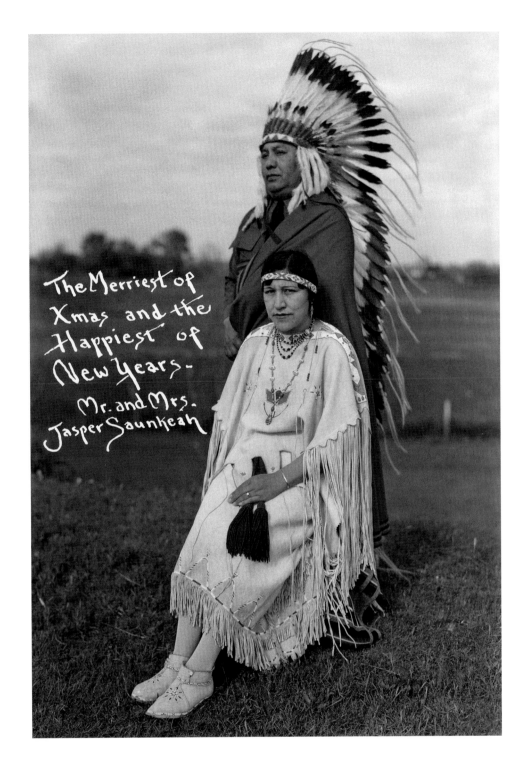

The Merriest of Xmas and the Happiest of New Years—
Mr. and Mrs. Jasper Saunkeah

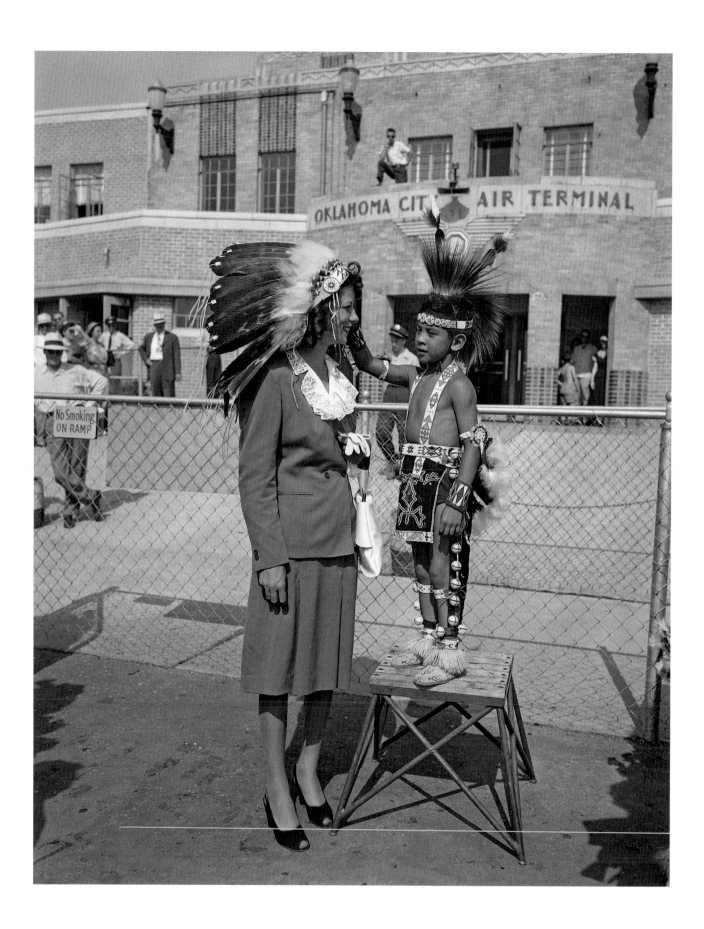

THE TRANSCENDENCE OF THE EVERYDAY

JOHN HAWORTH

WHEN WE LOOK CLOSELY AT A PHOTOGRAPH, we develop a deeper understanding of time, place, and culture. By viewing a lifetime of work such as Horace Poolaw's, we have the opportunity to understand a larger social world, informed both by his background and a visual aesthetic developed over a long career. Horace Poolaw was a prolific photographer, having taken thousands of images between 1920, when he started taking pictures at age fourteen, and 1978 when, with diabetes and failing eyesight, he could no longer work. Through his images we are allowed to view a particular Native American place and time, revealing much about his people, their tribal culture, and southwestern Oklahoma. Poolaw's photography captures both the extraordinary and ordinary in daily Indian lives, while also documenting the rituals that define community and family experience. He reveals the nuanced subtleties of Native social, economic, and political life, especially in terms of how the massive cultural shifts of the twentieth century played out in his homeland. His experience is very much a narrative of his time, an intersection of domestic and community life with the massive technological changes of this period.

In examining Poolaw's work, it is important to first consider the local historical foreground. Tumultuous post–Civil War conflicts deeply affected the Indian Territory tribes, followed in 1887 by the infamous General Allotment Act (or Dawes Act), which divided Indian lands into individualized parcels for the stated purpose of assimilating Native people into the American mainstream. The resulting Oklahoma Land Rush of 1889 then attracted tens of thousands of settlers into the area. In the midst of this upheaval, Horace Poolaw was born, just one year before Oklahoma and Indian Territories would be admitted as the state of Oklahoma. Early social and political factors shaped the kind of place southwestern Oklahoma became during his lifetime, and the way that Poolaw pictured his landscape.

Poolaw came to maturity as a photographer during a time when national events also had great impact on Indians. In the time between World Wars I and II, the United States became a global manufacturing power, which motivated great changes in national Indian policy from an American drive towards urbanity and industrialization. During Poolaw's early life through the 1920s, Indian policies such as the 1924 Citizenship Act encouraged Native Americans to cast off their traditional lives and assimilate into the American mainstream. Native communities throughout the country largely rejected this approach. Rather, Indians advocated for maintaining their own cultures and for sovereignty, with a focus on self-governance and maintenance of their own laws and responsibilities.[1] Poolaw's life runs parallel to this

10. Unidentified woman with four-year-old Woody Warren Weller (Caddo). Oklahoma City airport, Oklahoma, ca. 1945. 45Z14

11. Mrs. Tahbone (Kiowa) demonstrates hide tanning for a US Interior Department's arts and crafts program. Old Town Anadarko, ca. 1941. 45Z20 —L. P.

12. Horace Poolaw (Kiowa), posing for a photo during his work as an arts and crafts supervisor. Old Town Anadarko, Oklahoma, ca. 1940. 45ACOT6 —L. P., A. H., B. M.

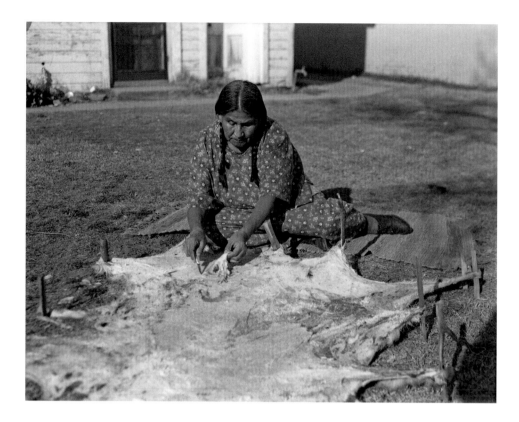

national transition, and his images illustrate the independence with which Native people went about their daily lives.

The structural changes in the US government, especially in the sense of giving Indians greater self-determination, occurred within the context of social upheaval and significant economic and political changes of this period. To deal with the Depression and its impact on the nation, this era witnessed the creation of a multitude of government agencies, such as the Works Progress Administration (WPA), the Civilian Conservation Corps (CCC), and other so-called alphabet agencies under the New Deal. The Indian Reorganization Act (IRA) of 1934 (also called the Indian New Deal) was a particularly significant policy during Franklin Delano Roosevelt's presidency, representing a different direction in the United States' relationship with Indians. During this important era, US policy moved away from former strategies that aimed to undermine and eradicate Native culture and sovereignty. Under FDR, public policy incorporated greater respect for Native culture and recognition for the political power within Native communities.

Many of Horace Poolaw's photographic images exemplify this sea change; in fact, a few may be a direct result of FDR's policies. Poolaw worked for the Civilian Conservation Corps–Indian Division (CCC-ID), established within the US Interior Department by the IRA, or a similar program around 1940, supervising Indian arts and crafts in his community.[2] Through this work, he apparently took some photos for the CCC-ID magazine, *Indians at Work*, which featured American Indian people throughout the country, learning trades, farming, or working on artwork and crafts (fig. 11).[3] One of his few self-portraits comes from this series of images, showing him seated studiously at a desk (fig. 12).[4] This work connected him to other local artists at the time, including the Kiowa Six, some of whom based paintings on a few of

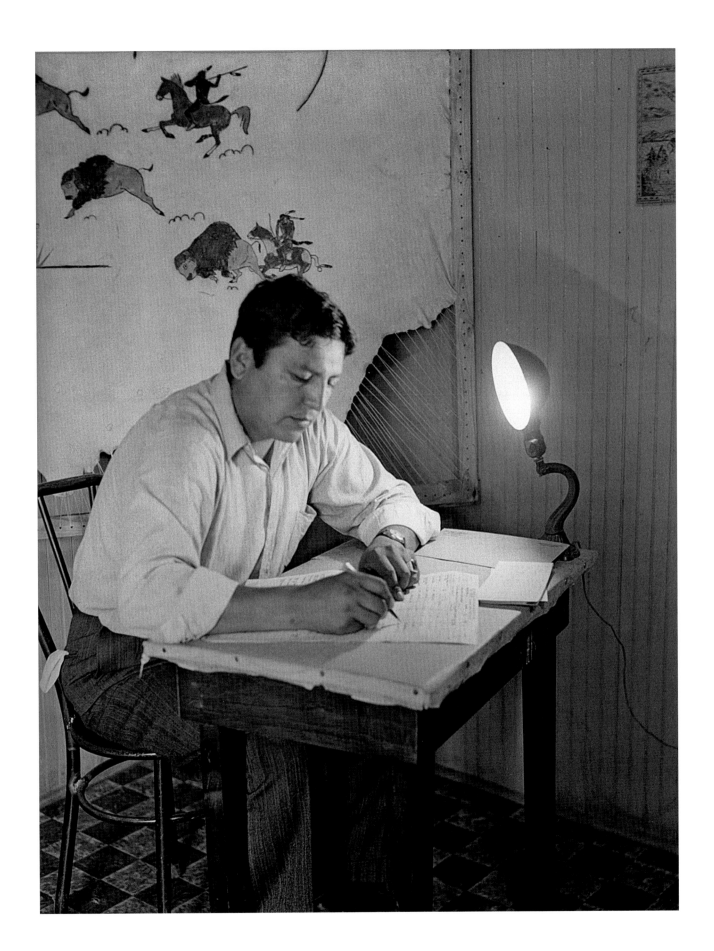

13. Dorothea Lange (1895–1965), *People living in miserable poverty. Elm Grove, Oklahoma County, Oklahoma*, August 1936.

14. Left to right: Newton Poolaw (Kiowa), Jerry Poolaw (Kiowa), Elmer Thomas "Buddy" Saunkeah (Kiowa). Mountain View, Oklahoma, ca. 1928. 57FK1

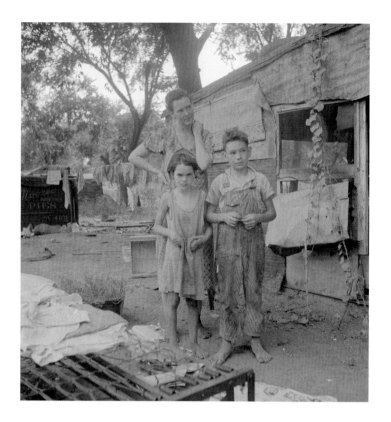

Poolaw's portraits.[5] His creative output was very much in alignment with the larger artistic movements of this era.

From 1936 to 1941, the writer James Agee and Farm Security Administration (FSA) photographer Walker Evans documented the daily lives of sharecroppers in the South, published with much acclaim as *Let Us Now Praise Famous Men* (1941), one of the most significant photographic records of that time and place. During the Depression era, Walker Evans, Dorothea Lange, and other socially engaged photographers went on record with a level of directness and truth about the impoverished conditions of neglected people (fig. 13). In contrast, Poolaw's photographs did not document abject poverty or a social underclass but pictured rural Indians who were comparatively economically secure, socially confident, and proud of their lives and community (fig. 14). His scenes of both daily life and special occasions affirm his respect for Native people (fig. 10). The Poolaw photographs selected for this publication and exhibition are not only evidence of historical shifts but also visual representation of the kinds of lives his subjects led during hard times. Indeed, the six decades of Poolaw's career represent a period of tremendous upheaval, social complexity, and rapid and significant technological advances, with ramifications both locally and nationally. During this time, even photography itself transitioned from being a novelty existing essentially for documentation to a more mature art form.

After World War II, the attitude of federal policy changed once again as the US government enacted legislation to terminate federal protection and support for the tribes, advocating once more for assimilation into the mainstream. Yet Native people remained adamant in asserting their sovereignty, establishing the National Congress of American Indians, an organization grounded in securing and preserving Native rights and preserving Indian cultural values. Poolaw's photography in the period just after the war was especially strong in how it expressed the underlying social currents of these larger national events, but at the community level. His images from the 1940s of Native war veterans and civic life are especially meaningful in terms of this important national conversation that gave greater voice to Native people (fig. 15). In Poolaw's later life, Native American activism increased through the Red Power movement in the 1970s, with highly visible events like the Native American takeover of the Bureau of Indian Affairs in 1972 and the occupation of Wounded Knee, South Dakota, the following year. In hindsight, we see the photographs he made in the 1940s and 1950s as foreground for the significant upheaval in the late 1960s and 1970s. Horace Poolaw's time indeed spanned a history of transitional events for Indian people.

Horace Poolaw's images are a visual textbook about daily life and individual expression. The visual evidence of self-determination, both on the community and individual level, is very much in play, most especially in his photographs of groups of Indians participating in ceremonies and social events. His images focus on the Indian story, yet are certainly connected with the larger twentieth-century American narratives. Though many of Poolaw's images give respect and honor to traditions and ceremonies, others document the broader and complex social changes of major events that forever changed the Indian reality during his lifetime. He was not a writer, but his photographs are nevertheless the text that both documents and illuminates this juxtaposition of assimilation and traditional life within these mid-century historical shifts.

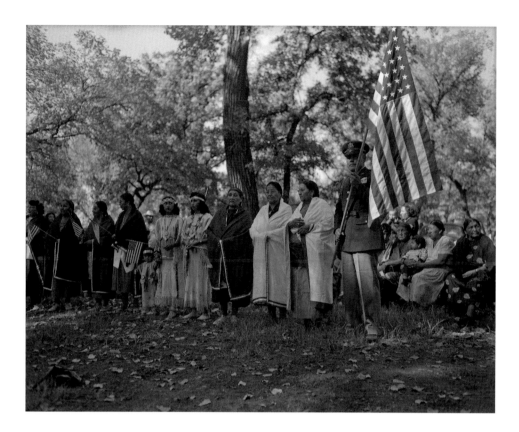

RIGHT:

16. Powwow at Lone Bear's dance ground. Carnegie, Oklahoma, ca. 1945. 45POW55

15. Honor dance at Carnegie Park Dance Ground, welcoming Pascal Cleatus Poolaw, Sr. (Kiowa), home after serving in the Korean War. Poolaw is the most decorated American Indian soldier, earning more than forty-two medals and citations. At his left are members of the Kiowa War Mothers, a tribal extension of the American War Mothers. Pascal Cleatus Poolaw, Sr., holds the American flag, at right. Carnegie, Oklahoma, ca. 1952. 45POW29 —A. H., C. G.

In *Spirit Capture*, the National Museum of the American Indian's photo collection retrospective, editor Tim Johnson (Mohawk) describes the power of photography to document historical and cultural changes:

Virtually every image in the [NMAI's] collection attests to this process of change, for the camera itself was a recorder of differences. . . . The histories, outcomes, and continuing issues of the Indian–European encounter are still being played out and are still very much in debate. These photographs indeed 'capture' the origins of much of the debate, the stark impact of the encounter, and the 'spirit' or will of Indian peoples to continue to be who they are as they adjust to their changing realities.[6]

The methods by which American Indians have been documented in images are convoluted, especially in photography and motion pictures; there most certainly remains, as NMAI Founding Director W. Richard West, Jr., has observed, a "complex relationship between Indians and photography."[7] Poolaw was a witness to this history, not so much as the photojournalist on the front line capturing the explicit, but rather as the quiet observer recording a deep implicit truth. In his extensive body of work, there is a rich and complex portrait of a community.

Although on occasion Poolaw posed the people he photographed, most often he captured his subjects more naturally. Some of his images are glamorous, yet his subjects are not glamorized. Though mindful of visual contrasts of tonality and texture, his compositional strategy was direct, uncomplicated, not painterly, and more about the subject than flashy technical showmanship; there is no pretension. We viewers encounter the natural landscape and have an insider's perspective of this region, as if southwestern Oklahoma itself is the main character of Poolaw's extensive visual

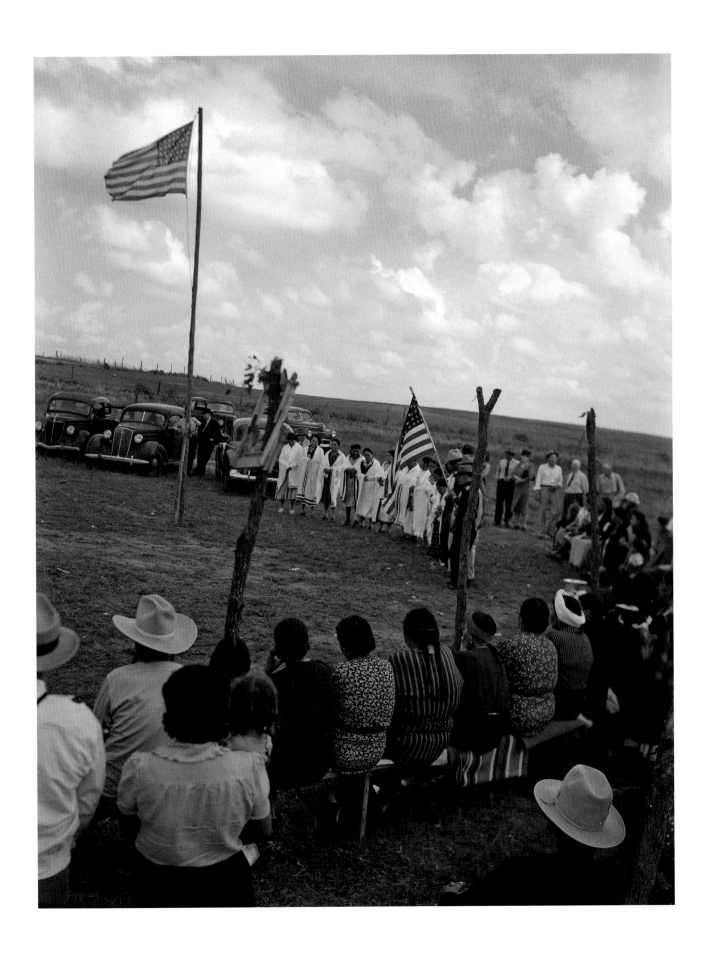

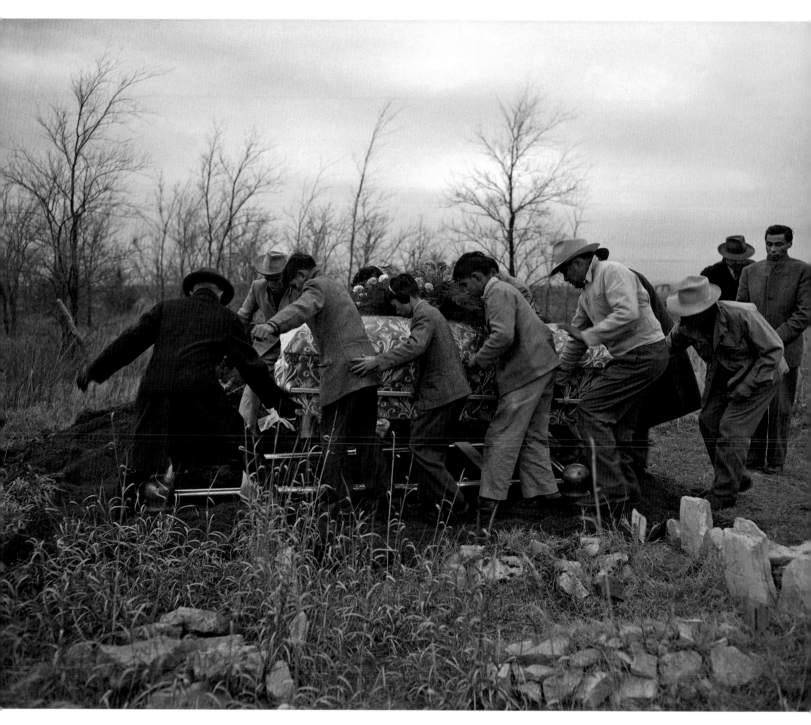

17. Funeral of Agnes (Mrs. Abel)
Big Bow (Kiowa). Hog Creek,
Oklahoma, 1947. 45UFN9

narrative. His documentary legacy was to make the everyday more transcendent, to place his Native community paramount to the interpretation of his particular landscape, and to reveal the centrality of ceremonies and special occasions to the lives of his people. In positioning his community within this special setting, for Poolaw, *they are the landscape*. His viewers encounter the long distance, the flatness, and the particular serenity of the Oklahoma plains. This land is not the iconic geometric geography of the West. Poolaw's landscapes, with their particularly long vistas into the horizon, give us the opportunity to understand the land's serenity and harshness at once, and likewise the hardiness and vitality of the people who live within it. Visually, his body of work reveals the expansive qualities of the lives, ceremonies, and events documented, as well as the limitations of this challenging physical environment (fig. 16).

Much of Poolaw's creative output focused on documentation, certainly in the images taken during the Depression and World War II and those capturing the effects of urban migration in his region. As a photographer from rural Oklahoma, he was not part of a cosmopolitan and urbane universe, though his images are sophisticated. Like other photographers from small towns, he took photos of graduates, beauty queens, and wedding parties. He also documented parades, political functions, community leaders, and honoring events for war veterans. He took pictures of his own family at home during both social and more intimate gatherings, including funerals and birthday parties. Particularly striking is the counterpoint between Poolaw's images of people participating in private ceremonies and those attending larger community functions. This approach contrasts greatly with that of other, primarily non-Indian, photographers who created images of American Indians. Indeed, for more than a century many significant photographers, outsiders to the Native experience, have objectified, stereotyped, romanticized, and glamorized Indians. Yet Poolaw's photographs reveal something different; he was an insider to Native life with a deeply informed perspective. In getting to know Horace Poolaw's work, we also come to know about a Native community, and by its example, gain insight into a "silent" era of American history.

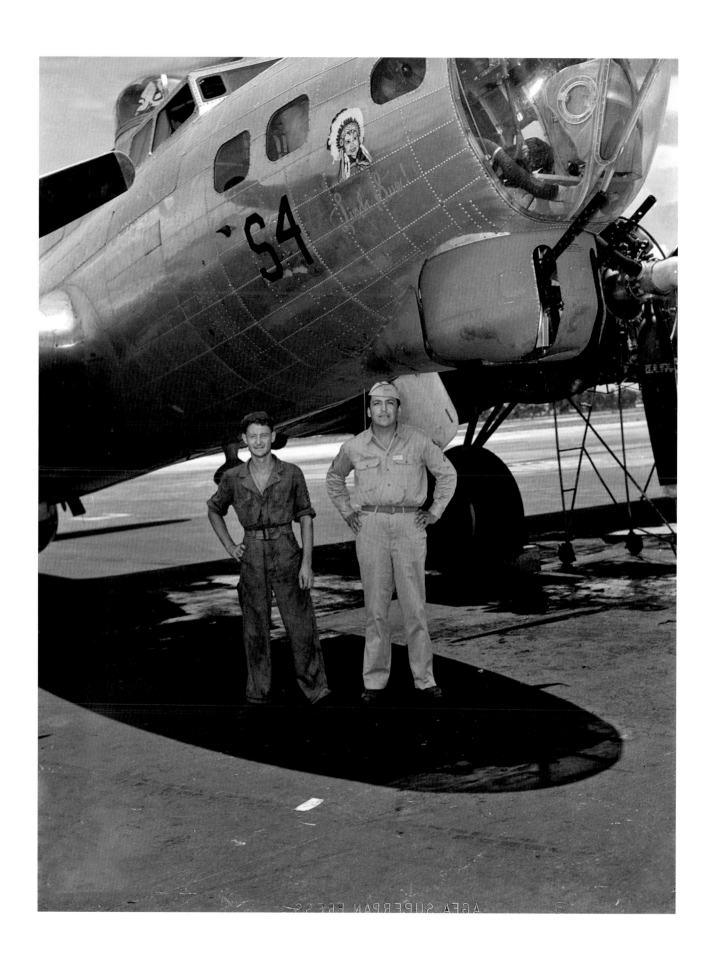

FOR A LOVE OF HIS PEOPLE

LINDA POOLAW

ON JUNE 14, 2009, the University of Science and Arts of Oklahoma (USAO) dedicated a reading room in the Nash Library for displaying my dad's work and named it in his honor. At the opening celebration, I listened to the introductory remarks by the university's president, Dr. John Feaver, and other presentations about my dad, Horace Monroe Poolaw, the American Indian photographer. The university had proposed to manage and house the Horace Poolaw family collection of two thousand negatives and photographs, which included the collection of seventy-two images featured in an exhibition at Stanford University in 1990. The family appreciated the generous offer, and chose Ernest "Iron" Toppah to provide Kiowa tribal music for the occasion. As he began to sing, he turned and motioned for the many visitors to stand. Iron had selected the "Kiowa Chief's Song." My late father had been gone almost thirty years, but I could feel and see him moving quietly in time with the song. In all the years I had been working on my dad's photographs, I had never felt as moved and proud. I looked at my brothers and their families, and wished that Dad could be present, surrounded by Kiowa people and his photos. Horace was not a chief or a tribal leader, but to have that song sung for him was, for me, the ultimate achievement in the Kiowa world. As I listened, I closed my eyes and thought about our father's life.

He was born in 1906 near Mountain View, located in southwestern Oklahoma, north of the west range of the Wichita Mountains. This is Kiowa country and has been since the Kiowa people drifted down from the northern plains to follow the buffalo. By the late 1700s and early 1800s, the Kiowa could be found nestled comfortably in small groups north of the Wichita Mountains. Folk tales, Kiowa legends, and calendar art depict them as being a happy, proud people, rich in traditions and customs. The mountains were abundant with game and fresh water, and offered protection from both the weather and raids from neighboring tribes. The Kiowa would come together in groups along creeks and waterways during the summer for an annual Sun Dance. They shared stories, gossip, and news of the previous year; young people looked for prospective partners; and everyone celebrated, feasted, and enjoyed the fun and games. The different Kiowa societies conducted ceremonies to honor and remember important events. The white man had not yet arrived to change that life forever.

Horace Poolaw, whose first language was Kiowa, was the ninth of eleven children. Their father, Kiowa George Poolaw (1864–1939), was a noted hunter, warrior, and sweathouse doctor. Kiowa George was also a Kiowa calendar keeper, and as a young man was a scout in Troop L of the United States Cavalry at Fort Sill, Oklahoma.

18. Horace Poolaw (Kiowa), on right. Artwork on the plane's fuselage features Horace's daughter, Linda, from one of his photographs. MacDill Field, Tampa, Florida, ca. 1944. 45UFL52

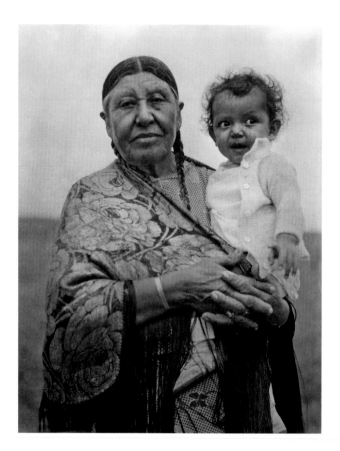

19. Xó:mà, Horace's mother, holding her granddaughter Linda Poolaw (Kiowa/Delaware). Mountain View, Oklahoma, 1942. 45HPF28

Kiowa George had married the two daughters and only children of a Hispanic captive named Cáu:ánàun (Goose That Honks).[1] Even though Horace Poolaw's mother, Xó:mà (Light-Haired or Light-Complected Woman); aunt Cí:dèémqí:gyài (A Person Coming Toward You); and grandmother Cáu:ánàun were of captive descent, they, too, spoke only Kiowa and practiced Kiowa beliefs and traditions. They were Kiowa women.

Horace spent his youth exploring the Washita River near his home, and started public school in Mountain View around 1912. A non-Native classmate of Dad's told me years later that she remembered how, when the bell rang for the end of the school day, the Poolaw boys—Horace and the twins, Bruce and Robert—would be across the school yard, on their horses, and racing home in a cloud of dust before the rest of the children reached the exit doors. She said it was very apparent that the Poolaw brothers did not like school. Our dad left school in the sixth grade. Even though Dad had never been beyond the Mountain View area, he knew he wanted to journey outside its dusty streets; he was never satisfied with being in one place. Yet he did love his town, and included it in many of his pictures. Horace grew up in a household full of children and loving grownups at their home place, less than a mile north of town. His activities blended with the local cowboys, Indians, and shop owners. The town was young, with wooden sidewalks and rutted dirt streets. Over the years, my brothers and I heard many stories of what Mountain View was like around the turn of the twentieth century, its population increasing and growing more socially and economically diverse. The government and religious groups had arrived and were busy introducing modern American culture to the Kiowa people by allotting the land and converting Kiowas to Christianity. It was a time of active change in the community.

Our father shows the adoption of Western culture most clearly in his photos of subjects who posed in both three-piece suits and traditional dress. When I lecture, I state that Dad never began taking photographs with the thought of capturing Kiowas in transition. He just happened to be there with a camera, documenting his community and picturing them as people with pride who dressed and lived as they liked. By the time Dad was born, the Chicago, Rock Island, and Pacific Railroad ran its tracks through Mountain View, coming from Chickasha in the Chickasaw Nation on west to the Kiowa-Comanche-Apache Reservation just south of the Washita River and Dad's home, changing life for most folks. The railroad brought more items for the general store, shipped the livestock bought and sold by ranchers, and made available more varieties of grain and seeds for the farmers. Stories about that time tell of a town that was booming. The railroad also brought folks with their various trades seeking business on a new frontier. Two men in particular got off that train—George Long and John Coyle—one a photographer of portraits, the

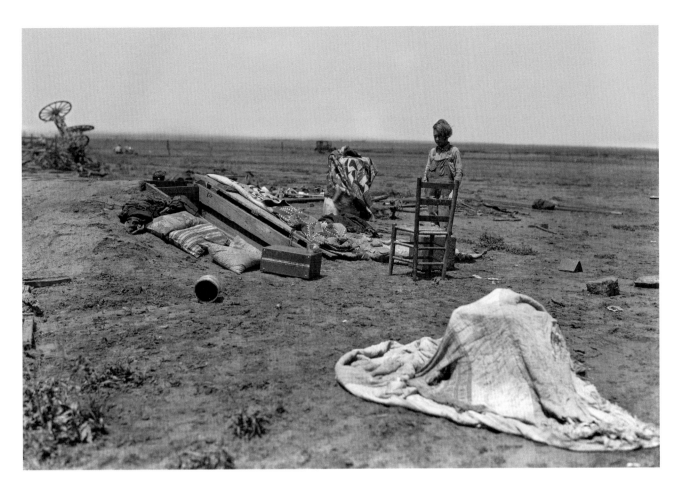

20. Aftermath of the cyclone at Lone Bear's place. Carnegie, Oklahoma, ca. 1928. 57ET4 —S. U., L. P.

other of landscapes. Horace apprenticed himself to both. When each left town, they left cameras with our dad. He was about sixteen years old when he first apprenticed with George Long, and gradually taught himself how to process his film without the luxuries of a darkroom or studio. There was never much money for film, so Dad literally had to make every shot count.

Dad never could make a good living being a photographer. It seemed that folks just weren't interested in an Indian taking their pictures, and neither were they interested in purchasing pictures of Indians. Dad's older sister, Anna Saunkeah, told me that their father, Kiowa George, even set Dad up in the cafe business in Mountain View. In a very short time, he realized that it was equally difficult for an Indian man to stay in the food business. In the meantime Dad continued to take pictures, not as a moneymaker but for a love of his people.

About this time he met and married Rhoda Redhorn, a Kiowa woman from the Fort Cobb area. They soon had a son, Jerry, born in 1926. Jerry was named after Horace's paternal grandfather, a Hispanic captive who had been captured by the Comanches. Even though times were hard and photo work was difficult to come by, Dad did have several opportunities and was hired by townsfolk to take photos of events, funerals, and children. He photographed many environmental disasters, such as floods, tornados, and dust- and snowstorms, as well. The cyclone of 1928 is still talked about today, as it killed a Kiowa woman (fig. 20). He was able to take photographs of the aftermath and devastation. In the collection there are photos of

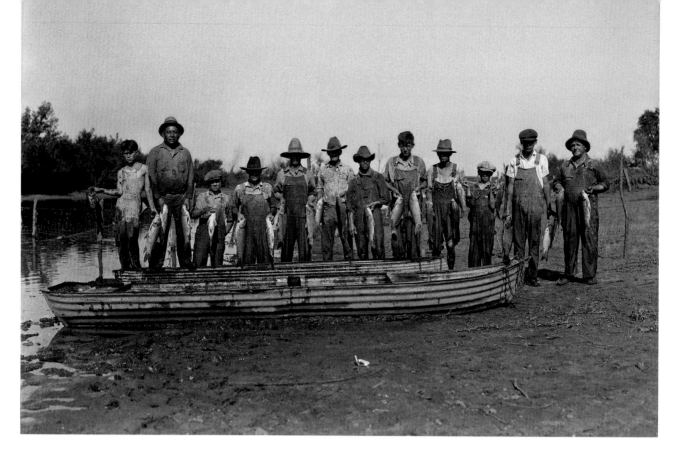

21. Carp and catfish caught after a flood of the Washita River. Second from left: Jasper Saunkeah (Kiowa). Mountain View, Oklahoma, ca. 1930. 57EF3

floods—one in particular that was below his family's house. In the image, a line of young boys hold up strings of many fish—not caught by fishing, but by raking in floating fish that couldn't breathe in muddy water and had come up for air (fig. 21). These events were important to Horace. He loved people and people loved him.

By the late 1920s, Dad was getting more into taking photos. His brother Bruce had gone to New York and married a prominent Penobscot woman, Lucy Nicolar, from Indian Island, Maine, who was in show business on the New York stage and had already achieved fame on the Redpath Chautauqua and other vaudeville circuits, performing as mezzo-soprano "Princess Watahwaso." They traveled up and down the East Coast, performing together. Bruce brought her home to Mountain View, where Horace and every other man, woman, and child was in awe of her (fig. 22). No one in Mountain View ever knew such a woman existed. For one thing, she wore pants and riding boots, and drove a car. The Poolaw women were shocked at first. She was partly raised by a Harvard professor and his wife in Boston who had become her patrons after recognizing her talent. Because of this, she spoke with a heavy, proper Bostonian accent. She was a wise businesswoman who had to win over her new in-laws, which she did very simply. She bought a buffalo and had the Kiowa men ride on horseback and kill the buffalo, old style. For a few days the folks enjoyed fresh buffalo—buffalo the elders hadn't tasted in more than forty years (fig. 23). Needless to say, Princess Watahwaso no longer had to prove herself. And because of her, Horace Poolaw added another dimension to his photography skills: she taught him staging. Up until then, Dad was just doing what he learned as a photographer, taking photos of his community in a straightforward way. When Princess Watahwaso came on the scene, she thought people might be more entertained by his photos if he added to his style by learning to imitate the movies and the vaudeville stage. His photographs of this time reflect her influence.

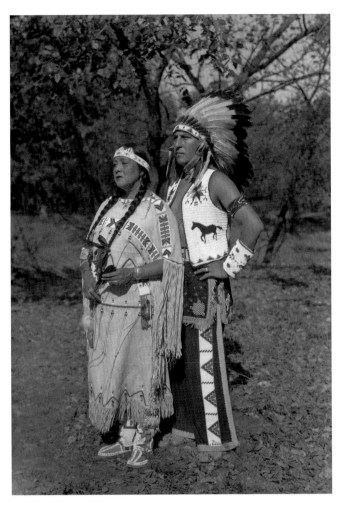

22. Lucy "Princess Watahwaso" Nicolar (Penobscot) and Bruce Poolaw (Kiowa). Mountain View, Oklahoma, ca. 1930. 57FGC10

23. Bruce Poolaw (Kiowa) poses with the head of the buffalo killed during the hunt orchestrated by Lucy "Princess Watahwaso" Nicolar (Penobscot). Craterville, Oklahoma, ca. 1930.2 57FPMC8—L. P.[2]

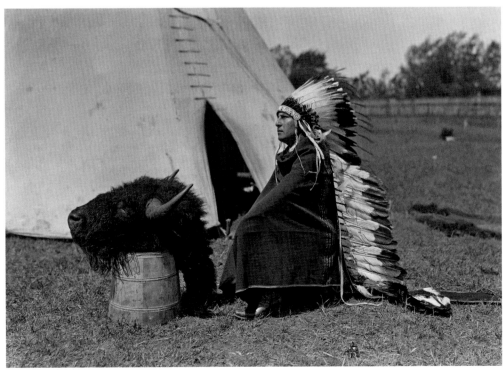

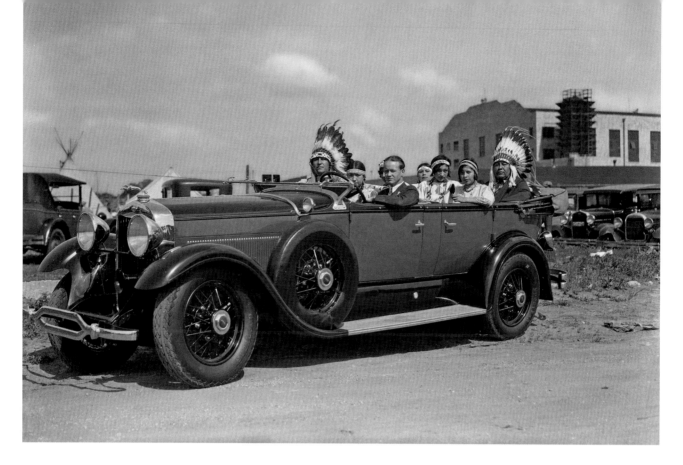

24. Opening of the Farmers
Public Market. Left to right:
Bruce Poolaw (Kiowa), Caro-
line Bosin (Kiowa), Gladys Par-
ton (Kiowa), unidentified man
driving, Mertyl Berry (Kiowa),
Hannah Keahbone (Kiowa),
Barbara Louise Saunkeah (Kio-
wa), Jasper Saunkeah (Kiowa).
Oklahoma City, Oklahoma,
1928. 57LE18

25. Christmastime at Rainy
Mountain Baptist Church. Left
to right: Evelyn Saunkeah (Kio-
wa), Lucy Ahpeatone (Kiowa),
Nell Saunkeah (Kiowa), Vivian
Saunkeah (Kiowa). Mountain
View, Oklahoma, ca. 1930.
57RX3

26. Left to right: Rose Pipestem
(Osage), Winnie Chisholm
Poolaw (Delaware), volunteers
in charge of the home canning
competition at the American
Indian Exposition. Anadarko,
Oklahoma, ca. 1950. 45EXP55A

Watahwaso was admired by the entire Poolaw family—and a big one it was, considering Kiowa George had families with two wives, Xó:mà and Cí:dèémqí:gyài, who were half-sisters. Of Xó:mà's children, Horace's older brother David was quiet and shy, and eventually had three children; his son, Newton, was Xó:mà and Kiowa George's oldest grandchild. Bruce and Robert were the twins, but, sadly, Robert was killed in a car accident when he was quite young. Anna was the oldest full sister and had three children. Dad seems to have taken more pictures of his beloved and beautiful baby sister Trecil than of anyone else. Sadly, she passed on from illness at a young age, leaving her two sons behind. Justin, the youngest of Horace's broth-ers, was the one who lived his life at the home place, raising seven children who today are all successful and good people. On the other side, Xó:mà's older sister Cí:dèémqí:gyài's oldest son, Moses, had three children. Ralph had eight children from two marriages. Dorothy, the oldest child, had six children, and Margaret had one son. As for Horace, by the late 1920s he and Rhoda had more or less gone their separate ways, and their son Jerry was raised by Kiowa George and Xó:mà in Mountain View. Between his siblings, their children, and his own, Dad had an end-less supply of subjects.

Entering the 1930s, the Kiowa world was now fully transitioning toward main-stream American culture. Kiowas attended the Indian schools, soldiered in America's wars, worked in factories and on farms, but also played sports. Indian men took to sports: baseball, boxing, running, and horse racing (fig. 52). The American Indian Exposition, locally known as the Expo or Indian Fair, was a celebration of Indian dances, parades, and competitions that began in the '30s. All tribes were welcome, and they came from all over the region to participate. The Fair was the biggest Indian gathering of its time, earning Anadarko the title of "Indian Capital of the Nation." No other community was pulling that many tribes together. The Fair featured a carnival, ball games, and horse races. The Indians-only competitions included women's home canning, vegetable growing, sewing, and arts and crafts (fig. 26).

Horace took advantage of the opportunity to become the official photographer of the Indian Fair. He was able to capture a tradi-tional culture that was beginning to lose ground but at the same time was evolving into a new stage of ceremonies. This culture is now known popularly as "powwow," but it didn't used to be the spec-tacle it is today. Back when the missionaries came, the regalia and dances were outlawed. A few underground dances were held but the powwows were rare. When Frank Rush brought dancers in for his Craterville Park Fair

27. Postcard of Linda and Bryce Poolaw (Kiowa/Delaware) at the American Indian Exposition. Anadarko, Oklahoma, 1948. 3.56 x 5.13 in.

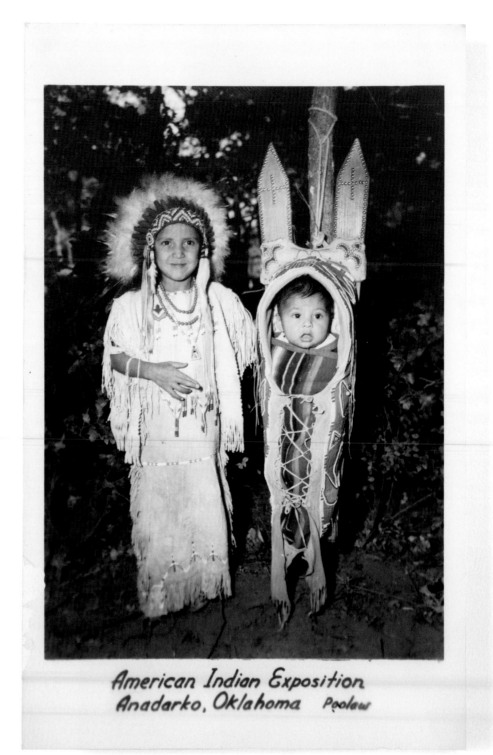

American Indian Exposition
Anadarko, Oklahoma Poolaw

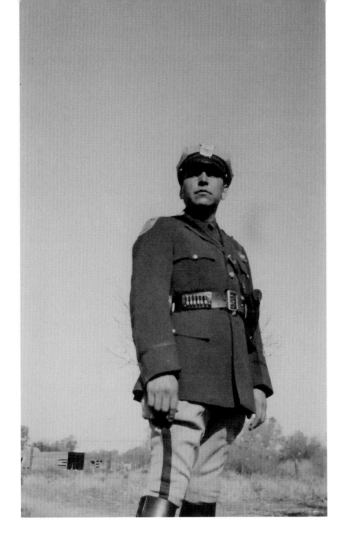

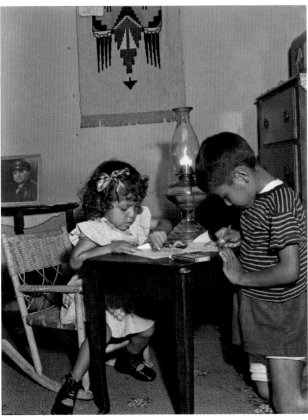

28. Horace Poolaw (Kiowa) in his Oklahoma state trooper uniform. He worked for the Oklahoma Highway Patrol for a year and a half. Mountain View, Oklahoma, 1937–38.
—B. M., L. S.

29. Linda and Robert "Corky" Poolaw (Kiowa/Delaware), coloring with crayons. Anadarko, Oklahoma, ca. 1945. 45HPF53

reenactments in the 1920s, it inspired a comeback. Traditional dancing went through a minor change, going from simple clothing and dances to something bigger. The American Indian Exposition was created as the first Indian-run celebration of its kind, and because of its powwows, contest dancing became popular and Indian people began dancing for themselves again.

Horace's brother-in-law, Jasper Saunkeah (Kiowa), was a friend of the state politicians and used his influence to give our dad opportunities for work. He not only had Dad take pictures of political events, but he helped him get into the University of Oklahoma's first highway patrol school (fig. 28). Our dad looked so handsome in his uniform that he easily impressed our mother. Winnie Chisholm was a very pretty Delaware woman who had attended Indian boarding schools. By now in the late 1930s, she was working on her own at the YWCA in Oklahoma City when she met Horace. They married, and my brother Robert "Corky" was born in 1938. Dad was then contacted by the US Army Air Forces, joined, and trained to teach aerial photography. He ended up at MacDill Field in Florida for the rest of World War II. I was born in 1942, just before Dad went into the war. Bryce was born in 1948 after Dad returned from the service.

Before the war, Dad built us a small cottage on an Indian allotment west of Anadarko. Our mother kept us there, visiting Florida only twice. She was a strong and incredibly resourceful woman and a talented gardener; we were very self-sufficient during the war years. Dad came home after the war to try his hand at farming since we now owned 160 acres. He went to farming and ranching school on a G.I. Bill; my family had never worked so hard in our lives. Dad was good at raising cattle, but we weren't that good at big-time farming. It was not long before Dad gave up on crop farming and just raised a small herd of beef cattle. He enjoyed ranching and continued to raise cattle until his death.

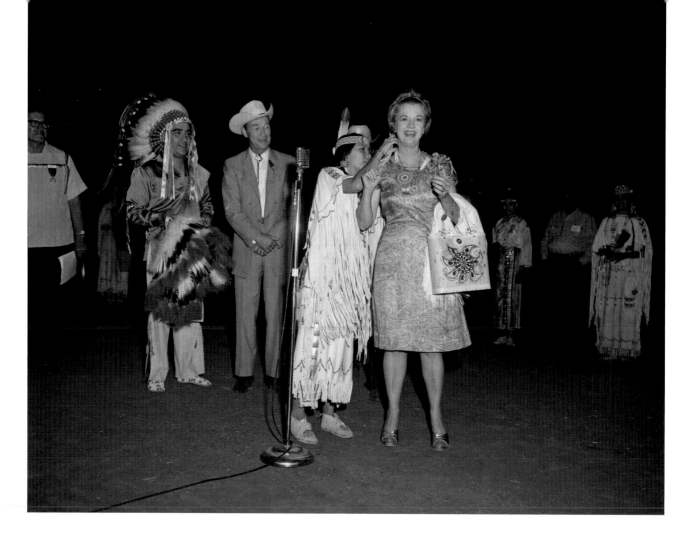

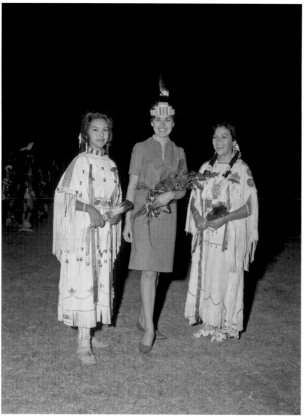

30. Dale Evans is gifted with a necklace at the American Indian Exposition, where her husband, Roy Rogers (Choctaw), received recognition as Outstanding Indian of the Year. Left to right: Robert Goombi, Jr. (Kiowa), Roy Rogers, unidentified woman, Dale Evans. Anadarko, Oklahoma, 1967. —L. P.

31. Left to right: Audrey Palmer (Kiowa), Miss Oklahoma Anita Bryant, and Martha Nell Kauley Poolaw (Kiowa) at the American Indian Exposition. Anadarko, Oklahoma, 1958. 45EXCW29

BOTTOM RIGHT:

34. Family and friends at the Medicine Lodge Peace Treaty Pageant. Left to right, back row: Leo Shay (Penobscot), unidentified, Bruce Poolaw (Kiowa), Lucy "Princess Watahwaso" Nicolar (Penobscot), Florence Nicole Shay (Penobscot), Anna Saunkeah (Kiowa), Jasper Saunkeah (Kiowa), unidentified. Front row: Linda Poolaw (Kiowa/Delaware), Xó:mà (Kiowa). Medicine Lodge, Kansas, 1946–47. 45LE18—L. P.

32. Judith Caddo (Delaware/
Caddo), left, and Patsy Ann
Carter (Caddo/Kiowa) at the
American Indian Exposition.
Anadarko, Oklahoma, 1959.
45EXCW22

33. Trecil Poolaw Unap
(Kiowa), Horace's sister. Moun-
tain View, Oklahoma, ca. 1930.
57FPCW5

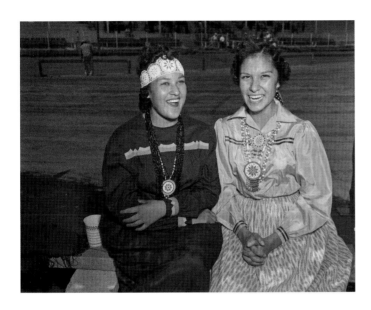

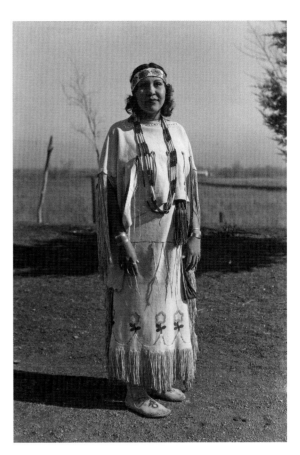

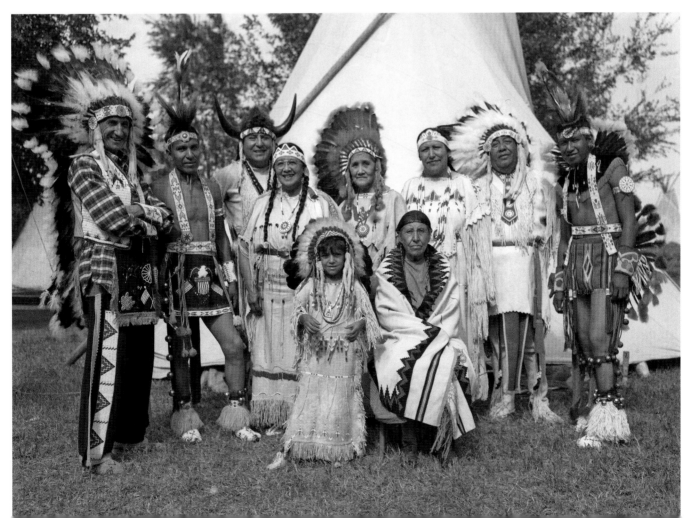

Our dad continued to take pictures through the 1950s and '60s, only slowing down in the '70s when his activities were hampered by diabetes and injuries from a car accident. By that time, his immediate family was grown and developing their own careers, and his grandchildren had begun to arrive. Bryce received his degree from Dartmouth College medical school and became a doctor in the Indian Health Service; he then married Elvina Mithlo and had three children: Audrey, John, and Damon. Corky retired as an officer in the United States Marine Corps after two tours of duty in Vietnam, earning a Purple Heart. Dad seemed content to have all his sons fulfill the Poolaw military or warrior tradition. Corky married Martha Nell Kauley and had three children: Robert, Jr., Thomas, and Tracy. Our older half-brother Jerry had passed on but had two children, Judy and Jerry "Sandy" Poolaw. Our mother had been working at Riverside Indian School and would soon retire. Dad's photographic career had all but ended by 1980, when he was taking only occasional photos of his eight grandchildren. Many years from now our dad may or may not be remembered as a famous Indian photographer. It doesn't really matter, when I think of what Dad was quoted as saying once: "I do not want to be remembered for my pictures, but through my pictures I want my people to remember themselves."

I wasn't deeply interested in my dad's photographs until sometime in the 1990s. At that time, I worked as a tribal liaison for the University of Oklahoma Health Sciences Center on the Strong Heart Study, which examined the risk factors of cardiovascular disease in select American Indian tribes. I received a phone call from Dr. Charles Junkerman of Stanford University, who asked me to come out to the university in California for a year to work, teach, and develop a project on Horace Poolaw's photography. As I thought about this offer, my first reaction was to say no. I was almost fifty and was working toward retirement. I was living comfortably in Anadarko, Oklahoma, in my own house, on the land I grew up on. More importantly, I was living with the people I loved most, Indian people. Besides all that, I didn't even know where Stanford was. But I spoke with my family and we decided that if anything was to be done with Dad's work, I was the one to do it. It was 1989 then, and Dad had passed on five years prior. His photos had been exhibited only once during his life, at the Southern Plains Indian Museum in Anadarko in 1979; the curator, the late Rosemary Ellison, had worked for months to get him to consent to a show. Two thousand negatives still sat in cardboard boxes for years in his home. I prayed for an answer.

On October 2, 1989, I arrived at Stanford University to begin one of the most exciting times of my life. Two weeks later, on October 17, the Loma Prieta earthquake ruined a lot of the campus, including most of the darkrooms. Only one remained, to be shared by the entire campus. It was a challenging time. Thirteen students, a photographer, a designer, and a professor worked on the exhibition, supported by a generous gift from Kodak, among other donors. In 1989, those thirteen Stanford students went to Kiowa country on a research journey for the project. They put two thousand images in front of the Kiowa people, to see and attempt to recall names and places. Students witnessed Kiowa elders weeping as they saw their ancestors for the first time, as some of the photos were more than sixty years old. By the following October, the exhibition, *War Bonnets, Tin Lizzies, and Patent Leather Pumps: Kiowa Culture in Transition, 1925–1955*, opened. No one was more proud than the family of Horace Poolaw.

After twenty more years and now in my seventies, I have gotten to know our dad much better, looking through his eyes, through his lens, at his people. Two thousand pictures have come to life before my eyes, as I see what he saw and what was important to him. As I look at the images hanging in every available space in my house, the pictures themselves have become an extension of my family. Because I know them so well, I can place the subjects in a space and time and not wonder who it was and what they were wearing. I can see the well-groomed men in their dance regalia, the women in their buckskin dresses, the children in their own proudly worn dance clothes. But best of all, I see a happy people, a proud people with many smiles. I see them standing in front of churches, tipis, dance grounds, grandstands, circling the drum and all representing one people, the American Indian.

Our dad gave us the opportunity to see the Indian world through his eyes; he made the past—the transitions and changes—come alive. We can see our ancestors as they really were. This was the work of one man, one man who alone wandered through the mysterious world of white man's photography and recorded his people just like his father, Kiowa George, did years before on a Kiowa calendar. My brothers, Bryce and Robert, and I can be most proud of the gifts our mom and dad gave us: our heritage, our freedom, our discipline, and most of all, our courage. As we look back over our dad's life, we can see the many influences of his picture work. What stands out most is his family. He did not have to go searching for subjects. We were all right there.

As Iron Toppah ended his chief's song, I glanced at the USAO library's new Horace Poolaw Reading Room. I suppose he is a chief—he is certainly an inspiration for his Kiowa people, his grandchildren, great-grandchildren, and Indian people for generations to come. Aho!

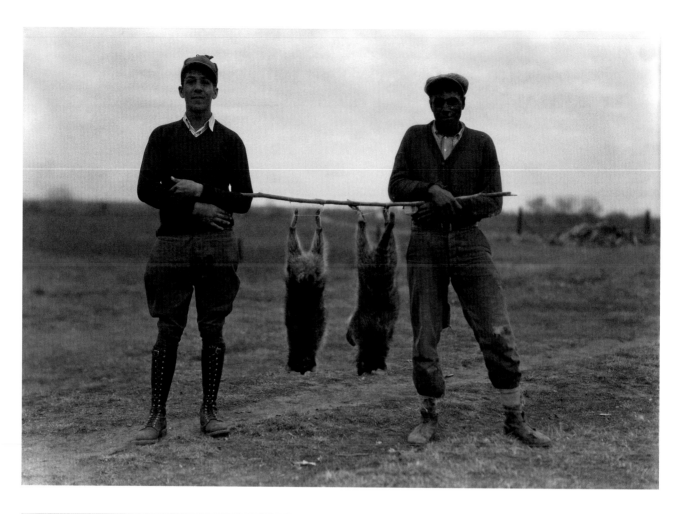

35. Justin Poolaw (Kiowa) and "Big Feet" Dell. Mountain View, Oklahoma, ca. 1929. 57FN5

36. Jerry Poolaw (Kiowa), Horace's son, with his dog, south of the family home. Fort Cobb, Oklahoma, ca. 1940. 45HPF180

37. Jerry Poolaw (Kiowa). Mountain View, Oklahoma, ca. 1929. 57FK2

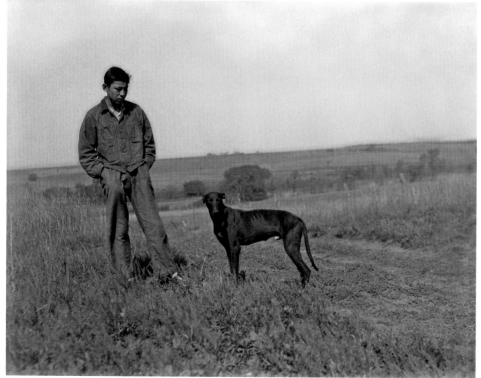

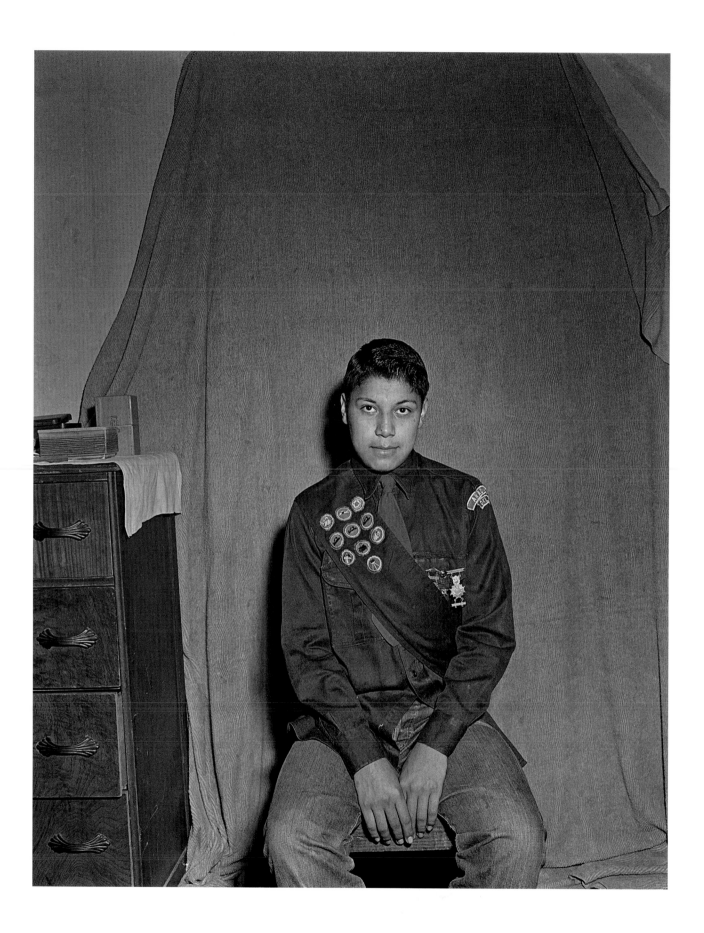

38. Robert "Corky" Poolaw (Kiowa/Delaware), wearing his Boy Scout medals. Anadarko, Oklahoma, ca. 1953. 45HPF17

39. Jasper Saunkeah (Kiowa), n.d. 57FN12

40. Cheyenne, Arapaho, Comanche, and Kiowa Indians on the capitol steps at the inauguration of Governor William Henry Davis "Alfalfa Bill" Murray. Oklahoma City, Oklahoma, 1931. 57IN4

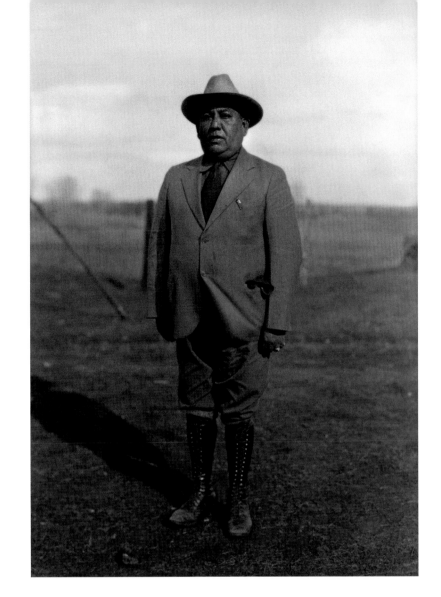

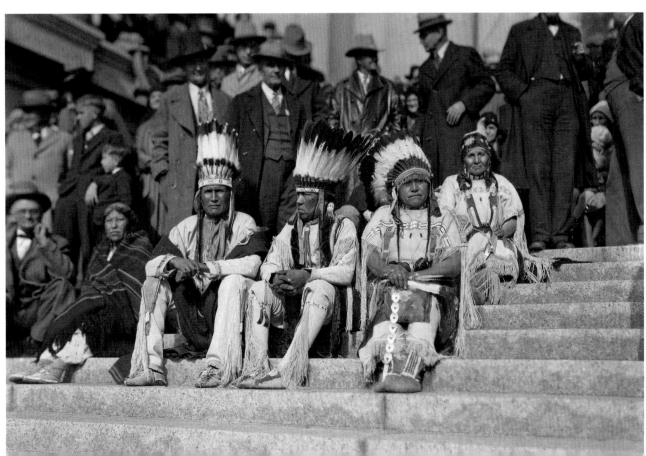

41. Robert "Corky" and Linda
Poolaw (Kiowa/Delaware),
dressed up and posed for the
photo by their father, Horace.
Anadarko, Oklahoma, ca. 1947.
45HPF57—L. P.

42. Robert, Jr.'s birthday party at the Poolaw house. Left to right: Scott Hunsucker, Tom Poolaw (Kiowa/Delaware), Robert Poolaw, Jr. (Kiowa/Delaware), Tracy Poolaw (Kiowa/Delaware), Kevin Roark, Patrick Roark. Anadarko, Oklahoma, 1963. 45HPF105

43. Horace's youngest son, Bryce Poolaw (Kiowa/Delaware), about twelve months old, with his sister's dolls. Anadarko, Oklahoma, ca. 1949. 45HPF67—L. P.

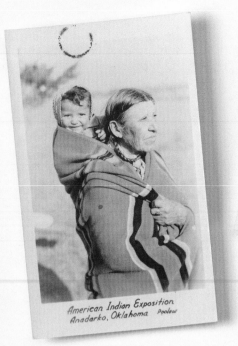

American Indian Exposition
Anadarko, Oklahoma Poolaw

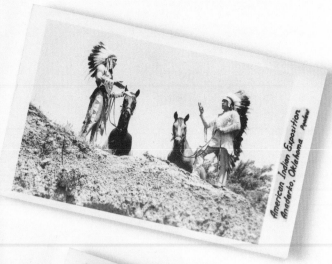

American Indian Exposition
Anadarko, Oklahoma Poolaw

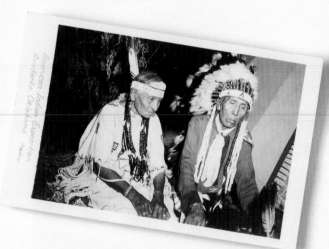

American Indian Exposition
Anadarko, Oklahoma Poolaw

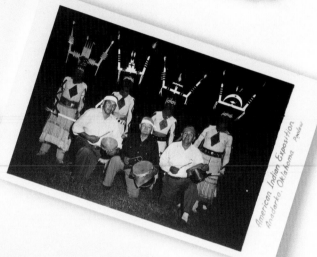

American Indian Exposition
Anadarko, Oklahoma Poolaw

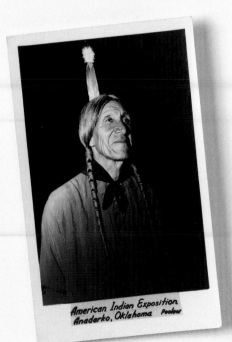

American Indian Exposition
Anadarko, Oklahoma Poolaw

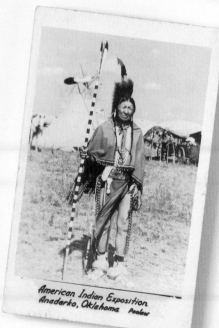

American Indian Exposition
Anadarko, Oklahoma Poolaw

SO THE KIOWA COULD REMEMBER THEMSELVES: *A Biography*

LAURA E. SMITH

HORACE POOLAW, A KIOWA MAN from an esteemed family, was one of the first professional Native American photographers of the twentieth century. Born in Mountain View, Oklahoma, in 1906, he was the fifth child of Cûifò:làu (Old/Mature Wolf, commonly called Kiowa George) and X<u>ó</u>:mà (meaning Light-Haired or Light-Complected). His Kiowa name was Fà:bô, or American Horse. His mother was descended from Mexican captives, and his paternal grandfather was the noted war chief Jánkò:gyà (Black War Bonnet Top).[1] The Poolaw family settled in Mountain View after the government began assigning allotments to the Kiowa in 1900. They eventually moved into a federally funded wooden frame house that still stands on this land, although Horace was born in a tipi.[2]

Horace attended Mountain View public schools and developed an interest in photography as a teenager. He acquired his first camera when he was around fifteen. He learned the mechanics of studio photography from local portrait photographer George Long. By the mid-1920s, he was taking his own photographs, married his first wife, Rhoda Redhorn (Kiowa), and had his first son, Jerry.[3] Most of Poolaw's early images are portraits of family, friends, and noted leaders in the Kiowa community. A few photographic moments outside of the state included a two-week visit to New York City in 1929. He traveled there with his brother, actor and performer Bruce Poolaw (aka Chief Poolaw), and Bruce's then girlfriend, Penobscot mezzo-soprano and vaudeville actress Lucy Nicolar, whose stage name was Princess Watahwaso. For many years, he took pictures both officially and unofficially at the Craterville Indian Fair and the American Indian Exposition in Anadarko, Oklahoma, and the Medicine Lodge Indian Peace Treaty Pageant in Medicine Lodge, Kansas.

Horace pursued photography for fun, for income, and so that the Kiowa people could remember themselves.[4] It is also apparent that he intended to promote himself as a professional photographer, because he stamped the back of his prints with his name and location of his business.[5] Additionally, his cameras were not the mass-market Kodaks but rather the large-format types that accommodated four-by-five- and five-by-seven-inch silver nitrate negatives. The last camera he owned was a four-by-five Speed Graphic by Graflex, the most popular portable professional camera from the 1930s through the 1950s.[6] In the 1920s, Horace Poolaw began to print some of his photographs on postcard stock to sell at local fairs. Indians and non-Indians alike purchased them. His children, who helped him sell the postcards sometime after 1945, remember that their father took up to fifty cards to sell at a time. There are no firm records on the extent of this production.[7] One of the stamps

Poolaw used to sign the images that he sold read, "A Poolaw Photo, Pictures by an Indian," but he didn't use this stamp as commonly as the more modest "Poolaw Photos, Anadarko, Oklahoma."

Besides the postcards, Poolaw also made five-by-seven-inch prints and larger, hand-colored photographic portraits, a few of which do survive. One ten-by-thirteen-inch hand-colored photograph of Comanche Chief Albert Attocknie is in the collections of the Anadarko Heritage Museum in Oklahoma. Poolaw also did copy prints, but probably not very often. There is one five-by-seven copy print of William Soule's nineteenth-century portrait of Geronimo at the Oklahoma Historical Society that has a Poolaw stamp on its back.

He never totally supported himself or his family with his photography. The family isn't sure of the amount of money his work brought in, but it wasn't much. He didn't print from many of his negatives because of the expense. Like many Indians in the late nineteenth and early twentieth century who commodified aspects of their cultures, Poolaw had a great need for income. He farmed and raised cattle, and also had various other jobs.[8] But these pursuits were difficult means for making a living, especially in Oklahoma. In 1943, Poolaw enlisted in the United States Army Air Forces and received training in aerial photography. He then served as an aerial photography instructor at MacDill Field in Tampa, Florida.[9] After being honorably discharged in 1945, he moved to Anadarko with his second wife, Winnie Chisholm (Delaware), and had three more children: Robert, Linda, and Bryce.[10] In 1957, a car accident left Poolaw unable to be employed, but he continued to photograph his family and community until the 1970s, when failing eyesight forced him to retire his camera.

Many people have come to know Poolaw's work as a result of the 1989 conservation and research effort initiated at Stanford University under the direction of his daughter Linda Poolaw and Stanford's then assistant dean of undergraduate studies, Charles Junkerman. This project contributed invaluable documentation on Poolaw's photographs and resulted in a traveling exhibition that commenced in 1991.[11] At the time of the Stanford inaugural exhibition in 1990, there had been just one other public showing of Poolaw's photography; according to Linda Poolaw, her father turned down other opportunities to exhibit his work. He finally consented to a show held in 1979 at the Southern Plains Indian Museum and Crafts Center in Anadarko, Oklahoma.[12] It was the only exhibition to take place during his lifetime. He died five years later.

Horace Poolaw left the world with a legacy of around two thousand pictures that provide testimony to the consistent Native American push to create a meaningful and powerful life in an increasingly industrial and technological world. He photographed floods in the area; Kiowa funerals and weddings; dances; the Indian baseball team; his son Jerry riding in a wheeled toy plane; the first Indian oil well in Caddo County, Oklahoma; and state government events. He created photographs during a time when Native Americans continued to struggle with anti-Indian sentiments and oppressive federal policies. Yet because of his efforts, future indigenous generations as well as students of American Indian culture can observe the vitality of Indian people in the twentieth century.

50. Horace Poolaw's camera, 1940–46. Speed Graphic by Graflex.

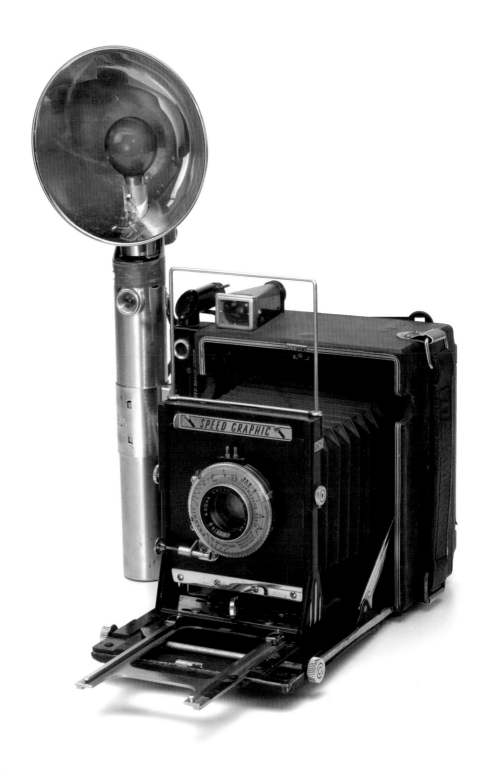

51. Unidentified US Army
Air Forces boxer at MacDill
Field. Tampa, Florida, ca. 1944.
45UFL38

52. Fort Sill Indians football
team at Fort Sill Indian School,
coached by Horace's brother,
Ralph Poolaw (Kiowa), far
left. Lawton, Oklahoma, 1932.
57UT3 —L. P.

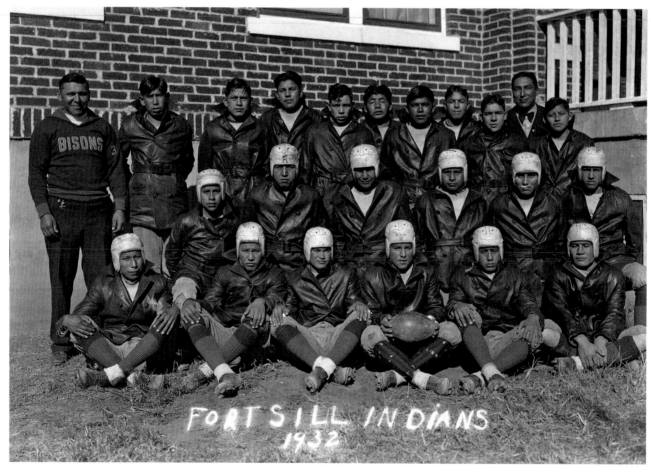

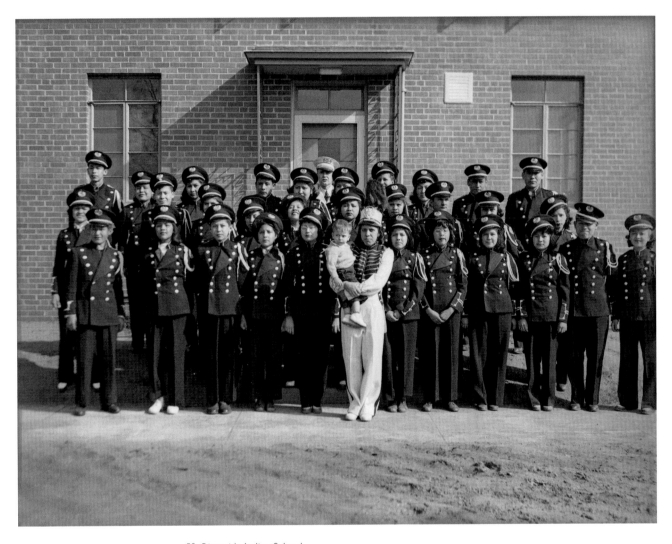

53. Riverside Indian School
band. Jerry Poolaw (Kiowa),
front row, third from left.
Anadarko, Oklahoma, ca. 1938.
45HPF179

54. Caddos and Wichitas play-
ing a hand game at Murrow's
Dance Ground. Binger, Okla-
homa, ca. 1955. 45POW5

55. Black Legging Ceremonies.
Left to right: unidentified, Marilyn Kodaseet Bread (Kiowa).
Anadarko, Oklahoma, 1956–57.
45ICPOW16

56. Frank Given's (Kiowa)
tipi and windbreak, ca. 1930s.
57HP54A

55

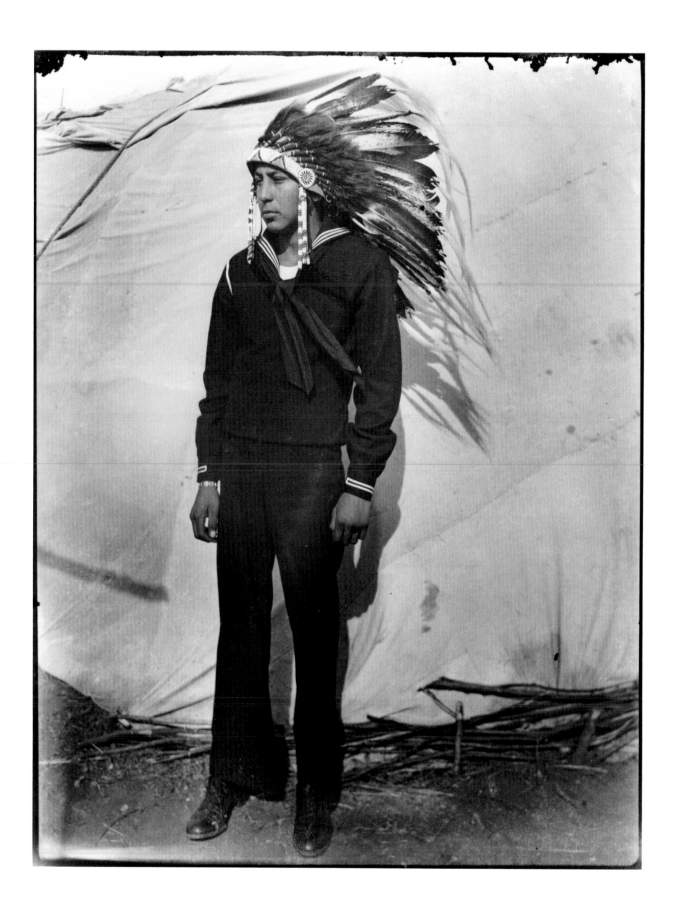

WHY HORACE POOLAW'S
INDIANS WON'T VANISH

DAVID W. PENNEY

IN THE EARLY 1990S I curated a small exhibition of historic photographs of American Indians for the Detroit Institute of Arts.[1] I pursued the task by sorting the images into various visual tropes that, to me, represented frames of reference about what the consumers of such photographs thought about American Indians and the desires such photography intended to fulfill. This experience in no way prepared me, however, for the summer 1995 issue of the photography periodical *Aperture*, a thematic collection of images, critical writing, and poetry titled *Strong Hearts: Native American Visions and Voices*. The editors had invited Native American writers and photographers to "image a world that, until recently, has been pictured largely by white people."[2] A photograph of a Kiowa man wearing a sailor's uniform and a feather headdress stood out to me (fig. 57). Tightly framed, the figure stands evidently against a canvas tipi; this image fit none of the visual tropes that neatly categorized the photographs of my exhibition.

The image had been created by Horace Poolaw. It shows his son Jerry visiting home in Anadarko, Oklahoma, while serving in the US Navy during World War II. This and the six additional Poolaw images were already a half-century old by the time they were published in *Strong Hearts*. Those photographs of the 1930s and 1940s had been created during a period of unprecedented activity and notoriety for Poolaw's Kiowa artist peers—most notably, painters Stephen Mopope, James Auchiah, Monroe Tsatoke, Spencer Asah, Jack Hokeah, and Lois Smoky, known as the "Kiowa Six"—and, more broadly, American Indian painting in Oklahoma.[3] This art history I knew well, but I knew nothing of Poolaw. I won't flatter myself by asserting that no one else did either, but in fact the first general awareness of Poolaw's work stemmed from an exhibition organized by his daughter Linda Poolaw in 1989, five years after his death. Why didn't we know more about Poolaw during his lifetime? Why are we playing catch-up now? And most importantly, what was it about his images, so vivid to us here in the twenty-first century, that could not be seen within the context of American Indian art or imagery of the time?

Even in the 1920s and 1930s when Poolaw began his career, there had been already more than a century's worth of effort to create images of American Indians in photography, prints, and paintings. Arguably, nearly all of these had been intended to capture and preserve images of people and cultures that most thought were destined to disappear. Historian Brian Dippie characterized this deeply ingrained theme of American history as the "vanishing American."[4] The notion was articulated by frontier painter George Catlin in the 1840s when he wrote that he was "lending

57. Jerry Poolaw (Kiowa), on leave from duty in the Navy. Anadarko, Oklahoma, ca. 1944. 45HPF172—L. P.

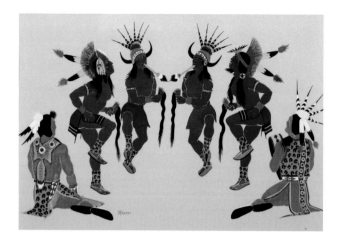

58. Stephen Mopope (Kiowa, 1900–1974), *Kiowa Scalp Dance*, c. 1930. Watercolor on paper. Gift of Clark Field. 1946.45.6

59. Spencer Asah (Lallo/Little Boy) (Kiowa, 1905–1954), *A Dancer*, 1929. Silkscreen on paper, 37.5 x 29 cm. NMAI 25/3911

a hand to a dying nation, who have [*sic*] no historians or biographers of their own."[5] More than seventy years later, Edward Curtis, the well-known photographer of Indians, expressed much the same sentiment when he wrote, "I feel that the life of these children of nature is like the dying day drawing to an end."[6] The images of Indians fixed within the frames of painting and photography by Catlin, Curtis, and many others confirmed their passing into a national memory of the continent's infancy—a timeless, natural era that knew no progress, yearned for from the perspective of urbane civilization in the same way that adults nostalgically recall childhood.[7]

This idea of the "vanishing Indian" originates from a deeper vein of post-Enlightenment thinking that contrasts modernism with what came before, distinguishing the "ancients" of pre-modern Europe or Native American "tradition" from modern American culture. Tradition, in this most severe sense and when contrasted with modernity, is timeless and unchanging.[8] During the early decades of the twentieth century, America seemed to be fulfilling the promise of becoming the world's first fully modern state, its social democracy privileging personal liberty (for some), its progress propelled by scientific positivism. America's break with the past and transition to modernity could be illustrated, narrated, and dramatized by the trope of the vanishing Indian as evidence of the past it left behind and yet celebrated nostalgically as its pre-modern foundation.

Nostalgia can be commodified. Indian pageants, fairs, Wild West shows, Hiawatha plays, and other such events proliferated during the early decades of the twentieth century all across the United States. These were complicated, nuanced transactions: the performer asserting an ongoing presence and vitality, the spectator seeking a nostalgic return to the nation's ancestral past, the vanished Indian resuscitated in performance. In Oklahoma, for the generation of Poolaw and his contemporaries, the Craterville Park Indian Fair (1924–33) was created as one such attraction, followed by the Southwestern Indian Fair, later to become the ongoing American Indian Exposition (also referred to as the Indian Expo, or Indian Fair), which was conceived and organized by Oklahoma Indians. The fairs presented parades, Indian dances, and other kinds of performances and competitions.[9] Poolaw served as a designated photographer to both events.

The Craterville Park Indian Fair and the more enduring Indian Expo can be dimly perceived in the Kiowa Six artists' paintings of dancing, although there is no overt reference to these events. Therein, Indian dancers are painted "flat" against a featureless background, suggesting tradition purified of any references to a particular time and place. Mopope's broadly circulated image of the Kiowa scalp dance,

60. Fancy war dance at the Craterville Park Indian Fair. Chester Lefthand (Cheyenne), center. Cache, Oklahoma, ca. 1928. 57POW11

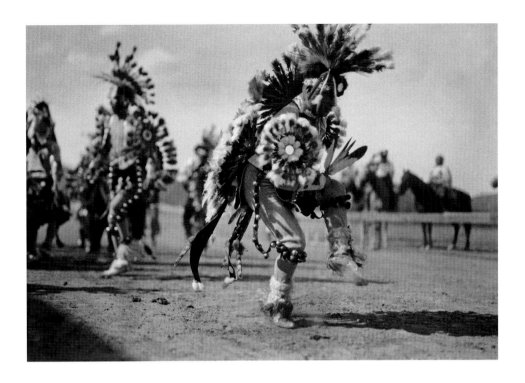

for example, shows four dancers performing the long-standing celebration of successful combat, their enemy's scalps in their hands (fig. 58). But their leopard-print anklets and the vest and dance apron of the two seated men on either side represent the very contemporary fabrics incorporated into dance regalia of the 1920s and 1930s.[10] Some of the Kiowa Six paintings portrayed the then-latest trends in dancing, notably the elaborate regalia of fancy dancers, a style just emerging during the twenties (fig. 59). The energetic footwork and visually innovative regalia emerged from the arena settings and the crowd-pleasing requirements of Wild West show performances to become one of the most popular features of the fairs.[11] The oversized eagle feather head crests and arm bustles very likely would not have been recognized as the newest and most innovative features of the Oklahoma Indian dance scene by most non-Indian spectators at the fairs; few without insider knowledge would have recognized these features in Kiowa Six paintings. For most, performances and images of fancy dancers merged into a broad visual language evoking pre-modern and timeless Indian traditions.

One of Poolaw's photographs of fancy dancers performing at a fair closely approximates the Kiowa Six approach by situating the vantage point low, in and among the dancers, framed tightly to exclude spectators and background (fig. 60). Like the painters, Poolaw emphasizes the geometry of movement in the dancers' frozen posture. More often, however, Poolaw photographed the dancers dressed but removed from performance, standing for the camera "backstage," so to speak—not "in character" but as themselves, looking at us (fig. 81). The background that frames them is grounded as a specific location, but not as a stage or performance space. Poolaw positions us, the viewers of these photographs, as insiders for whom the performance is not an artifice or illusion of timeless tradition, but a topical, participatory event. Poolaw's perspective as participant rather than spectator often contrasts with those of Pierre

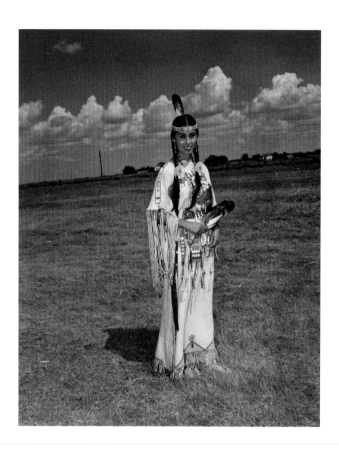

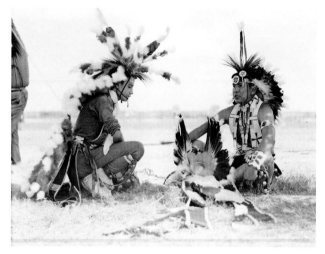

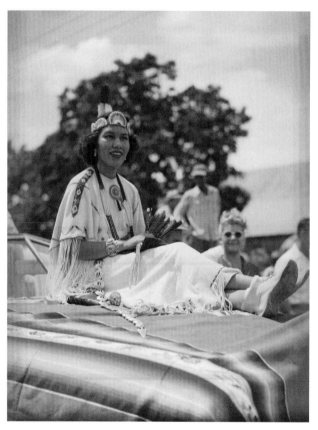

Tartoue, another Oklahoma photographer who worked the American Indian Exposition. Tartoue's image of fancy dancers at rest shows them seated cross-legged on the ground, unmindful of the camera, as if still performing in character as Indians of a pre-modern age (fig. 62).

A parade through Anadarko opened the Indian Expo and featured women dressed in regalia, riding on the hoods of automobiles. Tartoue's photograph of one such woman frames her tightly with only a glimpse of the automobile visible beneath the patterned blanket upon which she sits. Tourist spectators fill the space behind her (fig. 63). The photograph emphasizes the performance and the distance between performer and spectator, for whom the photographer stands as surrogate, in this more promotional approach. Poolaw often included far more contextual detail in his parade photographs. One particularly rich example situates us in the center of the parade, down low among the participants, looking back as a vehicle approaches (fig. 64). A large title sign, "Kiowas," placed upon the hood above the grill of the automobile, locates the center of his composition, with three women arranged around it, one holding a cradle board with a doll inside. On the right we see parade participants on horseback, one wearing a feather headdress. On the left, a man in street clothes with his back to us walks against the flow of the parade, glancing at spectators out of frame to the left, a grain elevator rising in the distance over his right shoulder. The prominent license plate "13-2789/Okla-1941" gives the picture even more specificity—we could look up the registration if we so desired.

LEFT:

61. Claudette Geiogamah (Kiowa) at the Indian Exposition fairgrounds. Anadarko, Oklahoma, ca. 1962. 45EXCW7

62. Pierre Tartoue (1885–1976), *Two fancy dancers "after a powwow dance."* American Indian Exposition. Anadarko, Oklahoma, August 1947.

63. Pierre Tartoue (1885–1976), *Young woman, possibly a princess. American Indian Exposition parade, Anadarko, ca. late 1940s.*

RIGHT:

64. Left to right: Juanita Daugomah Ahtone (Kiowa), Evalou Ware Russell (center), Kiowa Tribal Princess, and Augustine Campbell Barsh (Kiowa) in the American Indian Exposition parade. Anadarko, Oklahoma, 1941. 45EP9—L. P.

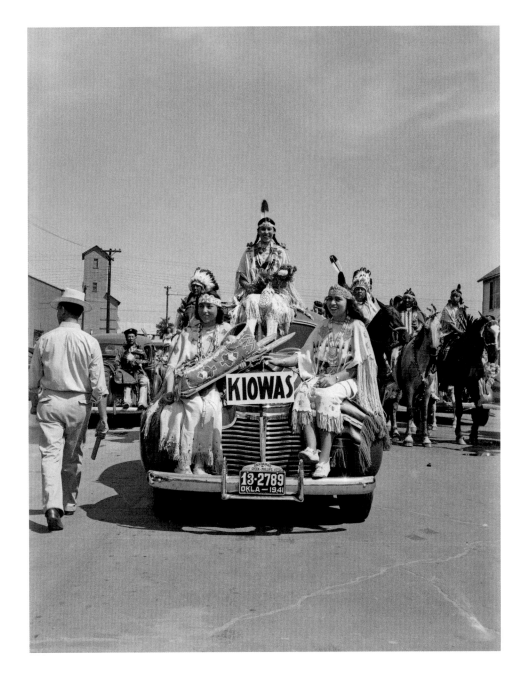

The frame for the plate informs us the car was purchased from the well-known Anadarko automobile dealership Green-Phillips Chevrolet. These visual cues orient us to a particular time and place: the fair, the parade, the town, even who owned the car and where he or she bought it. Poolaw unmasks the performance and reveals it as a topical celebration. He thwarts any attempt to squint our eyes and seek nostalgia for a mythologizing past.

Many of Poolaw's images of Indians at the fairs and elsewhere include similarly abundant evidence of their topicality—automobiles, sailors' uniforms, bobbed hair straight from contemporary fashion magazines, or the camera itself snapping the picture. As such, it has been tempting to interpret Poolaw's pictures as documents

of modernity overwhelming Kiowa tradition, as the title of the 1989 exhibition of Poolaw's photographs suggests: *War Bonnets, Tin Lizzies, and Patent Leather Pumps: Kiowa Culture in* Transition (emphasis mine). Recent scholarship explores the "many modernities" experienced by Indian people of the early twentieth century, the "unexpected places" of modern American Indian life.[12] Such discussions, however, can remain trapped within a modernist construct that contrasts modernity with tradition, where shopworn terms like "assimilation," "acculturation," "syncretism," and, more recently, "hybridity" attempt to describe shades of gray between them: American Indians as hybrid social beings with feet in both or many worlds.[13]

Poolaw's images show us hybrids, but not hybridity in the sense of mixed social identities. Scholar of science studies Bruno Latour rejects any notion of a purely cultural hybridity and invites us instead to think of "hybrids" as human and material admixtures, the human-made things that pave pathways or "networks," connecting human beings to each other and their proliferation during our recent "modern" era.[14] Poolaw's photographs do not show us so much the mixing of culture, modern and traditional, but the proliferation of things and their networks that shaped the cultural environment of Oklahoma during Poolaw's day. These would include cars and cameras in addition to the countless social and material hybrids that fed American expansionism: the technologies of transport, communication, surveillance, incarceration, and lethal power; the administration of politics; the institutions of social science; and the management of capitalist economy, among so many others. Such networks brought automobiles, tourists, and leopard prints to Anadarko in the 1920s, tours for enterprising fancy dancers employed by the shows, art-world opportunities for the Kiowa Six painters, and—not least—World War II, which gathered up many of Anadarko, such as Jerry Poolaw, into the service, and sent them out into the world to return again in uniform, as evidenced by this description of the Indian Expo of 1945, the year of VJ Day:

> Every day during the Exposition, a long train of big army trucks rolled into town with visiting soldiers from Fort Sill. Many young Indian men and women in army or in navy uniforms, home on furlough, were seen visiting with their families.[15]

It was a moment like this, very likely, that Poolaw captured in the photograph of his son Jerry in his sailor's uniform, wearing a feather headdress, standing next to a canvas tipi. Poolaw, who remained largely rooted to his Oklahoma community, shows how the world arrived there, via countless networks and pathways, and how his fellow citizens incorporated the resulting worldliness into their lives. It becomes difficult, futile really, to look for distinctions between modern and tradition in such networks of connections: first horse, first treaty, first census of tribal enrollees? A definitive break between tradition and modernity cannot be located. Instead, we can trace only the proliferation of networks, connections, and pathways between the Kiowa and other people, places, and things.

The traditions of representation characterized as the vanishing Indian, such as Catlin paintings, Curtis photographs, and even the Kiowa Six paintings, tend to conceal and repress visual traces to topicality and attempt to evoke instead a notion of timeless "tradition." Poolaw's images of this period stand out in contrast due to their seemingly earnest engagement with the details of topical life, the proliferation

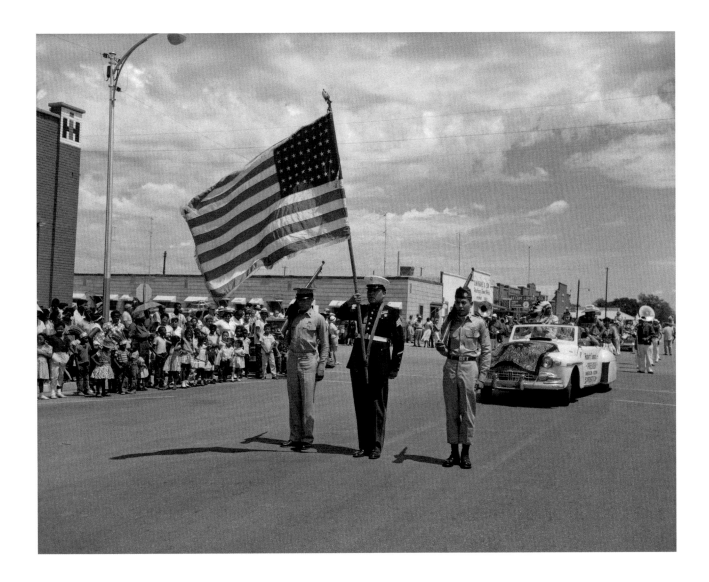

65. American Indian Expo parade. Left to right, walking: Robert "Corky" Poolaw (Kiowa/Delaware), George Botone (Kiowa), Bill Valliere (Kiowa); in car: Robert Goombi, Sr. (Kiowa). Anadarko, Oklahoma, 1959. 45EP21

of hybrid networks in and around the Anadarko community that connected it and all who lived there to the fabric of American life and burgeoning globalism. There is little suggestion of fragile tradition captured and preserved within the images' frames. Poolaw's subjects pose no danger of vanishing; they are firmly fixed to the world around them, their connections to the events and circumstances of their day articulated by the visual evidence of telephone wires, automobile license plates, and social identities that eschew generalization as simply American Indian and insist instead upon their individuality. In a nation of the early twentieth century that saw value in Indians only as relics of its pre-modern foundation, Poolaw's images offered a visual alternative that many, perhaps, were not yet prepared to see: American Indians as self-determining participants, rooted in American life.

"AN AGE OF PICTURES MORE THAN WORDS"
Theorizing Early American Indian Photography

NED BLACKHAWK

AMERICAN INDIANS FACTOR CENTRALLY in the development of American visual and cultural history. "From the very beginning," writes literary historian Phillip H. Round, "Native peoples and Europeans . . . related to each other by and through the book," as methods of recording and transmitting knowledge became central both to colonization and to the emerging colonial public sphere. As early as 1663, missionary John Eliot published an Algonquian translation of the Bible, making it the first printed book in British North America.[1]

In Europe, American expeditionary accounts similarly shaped the printing industry, fueling sixteenth- and seventeenth-century publishing efforts. Such notable forms of transatlantic circulation include the illustrations of Flemish engraver Theodor de Bry (fig. 66). De Bry's thirteen-volume collection, *America*, was an unprecedented publishing project that began in the 1590s and spanned four decades. The accompanying imagery of Native peoples within these accounts circulated so widely that, according to art historian Michael Gaudio, it "served into the nineteenth century as a visual prototype for the North American Indian." In 1812, when John Adams wrote to fellow former president Thomas Jefferson asking where he might learn about American Indian traditions, Jefferson suggested de Bry's *America*, three volumes of which were held in Jefferson's personal library at Monticello. Despite this recommendation, Jefferson himself nonetheless "remained somewhat suspicious of de Bry's mingling of 'fact and fable.'"[2]

Such age-old traditions of textual production serve as helpful reminders of the ubiquity of Native Americans within American visual culture throughout the eighteen hundreds. By century's end, radical new technologies communicated visions of Native peoples across time and space and did so in uncommon ways. Ethnographic collections and staged Indian village exhibitions at world's fairs attracted millions in Chicago, Atlanta, and St. Louis, while fueling the rise of museums of natural history. The growth of advertising and the mass circulation of serials similarly carried symbols of nationalism and modernity into domestic and public spheres, while new recreational forms like Wild West shows and theme parks amused urban dwellers in both traveling and seasonal forms.[3] Arguably at no other point in the nation's history had such methods of visual communication so heavily impacted everyday life. And above all other new technologies, photography filled the nineteenth-century visual world with endless forms of meaning, inscription, and representational power.

The 1890s became a pivotal time for developments in visual technology. As historian Theda Perdue (Cherokee) relates, it was in the 1890s that "the final 'battle'

66. Theodor De Bry (1528–1598), "A cheiff Lorde of Roanoac," *Travels through Virginia*, from De Bry's *America*, Vol. I, 1590. Engraving after a drawing by John White.

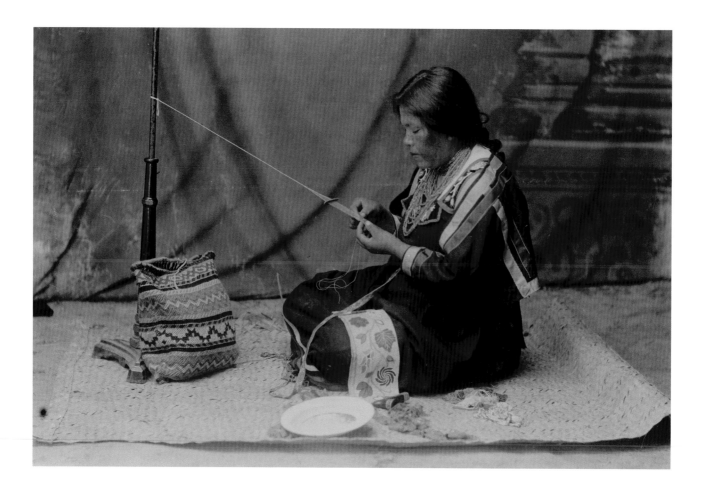

67. Ojibwe woman (probably Leech Lake) demonstrating beadwork at the St. Louis World's Fair: The Louisiana Purchase Exposition. St. Louis, Missouri, 1904. Photo by Charles H. Carpenter (1859–1949). NMAI P22761

of the Indian wars took place at Wounded Knee, the census confirmed the closing of the frontier, southern states rewrote constitutions disfranchising African Americans, the Supreme Court decided that racial segregation was constitutional, and the United States embarked on overseas expansion in the Spanish American War." Further, Hawai'i was illegally annexed, and new constellations of non-white subjects were added to the American republic. From Cuba to Hawai'i, and from the Philippines to Alaska, millions of non-European subjects and non-English speakers complicated the racial construction of the American republic. Coming in the aftermath of Reconstruction, Perdue suggests, the events of the 1890s established racial hierarchies that many white Americans believed to be "scientifically rational, morally justifiable, imminently practical, and even divinely ordained."[4]

How did photography shape American culture during these pivotal years? What role did indigenous peoples play in such developments, and what strategies existed for those increasingly objectified within this new media? Drawing upon recent studies of African American photographic history and American Indian visual studies, we are able to more effectively contextualize the works of Horace Poolaw and other early twentieth-century American Indian photographers, whose artistic and creative practices remain indelibly marked by American race relations.

During the late 1800s and into the early twentieth century, the visual culture of the United States built upon and exponentially expanded racially driven constructions of Native peoples (fig. 67). Moreover, such representations permeated American cul-

68. John Gast (1820–1877), *American Progress*, 1872. Oil on canvas, 29.2 x 40 cm.

ture in broad and formative ways; by visually juxtaposing American Indians against narratives and visions of modernity, the emergent photographic culture crystallized long-standing discursive practices about the "vanishing" presence of Native peoples in American life and culture. Photography (and soon motion pictures) quickly became the ultimate medium for communicating many assumed truths about America and, ominously, for erasing Native peoples from visions of the nation's contemporary public sphere. American photography, in sum, projected visions of Indian peoples that reinforced many of the broader intellectual currents that undergirded American systems of racial inequality and established presumptions about Native peoples that still endure.

The Racial Underpinnings of American Modernity

Racialized visions of American Indians not only characterized but constituted the emergent visual culture of the United States. From the rise of anthropology and its methodological practices of "salvage ethnography" to the tourist economies of California and the American West, images fueled America's modern development. In particular, familiar representations of defeated, noble, and "disappearing" Indians anchored celebratory theories of American history and fostered new forms of civic identity for newly arrived European immigrants (fig. 68).

Frederick Jackson Turner most notably articulated such visions in "The Significance of the Frontier in American History,"[5] which many consider to be "the most influential single history essay ever written."[6] In it, Turner outlined broad characteristics of American history in order to distinguish the United States from Europe. Writing at a time when historical study remained virtually synonymous with the European past, Turner first delivered his famous "frontier thesis" in 1893 in Chicago, just as the city's

World's Columbian Exposition commemorated the four-hundredth anniversary of Columbus's arrival in the Western Hemisphere. In his address, he not only identified American expansion as the singularly most important variable in the country's history, but did so using a now-famous series of visual imperatives that he believed encapsulated American history:

> Stand at Cumberland Gap and watch the procession of civilization, marching single file—the buffalo following the trail to the salt springs, the Indian, the fur-trader and hunter, the cattle-raiser, the pioneer farmer—and the frontier has passed by. Stand at South Pass in the Rockies a century later and see the same procession with wider intervals between.[7]

For Turner, like so many generations of American historians, American Indians represented anterior stages of American development. Like the buffalo and the fur trader, Indians remained actors within the earliest chapters of a national story, not living, vibrant, and challenged communities confronting a shared destiny with the nation. Products of the past, Native peoples resided outside the temporal and spatial parameters of contemporary American society and outside the nation's future.

Yet Turner also worried about the "closing" of this frontier, a concern that revealed tensions within late nineteenth-century American culture. This apprehension about the future—the onset of urban life, growing forms of concentrated capitalist influence, rapid technological developments, and swelling immigrant communities—communicated particular visions about America, and they notably did so in under-recognized relation to American Indians, the unquestioned first Americans.

In an era during which millions of non-Anglophones amassed upon urban seaboards, Turner worried about how such new immigrants might become assimilated into American society. The 1890 census had identified, for the first time, the absence of available and unincorporated western lands to which immigrant communities could settle. Before the close of the frontier, expansion had not only defined American history but also provided generations of frontier settlers the self-governing impulses that fueled US democracy outside of corrupting spheres of concentrated wealth and power. Now with the frontier officially closed, posits Turner, where and how might such new immigrants become Americanized?

As in the colonial era, images of American Indians circulated widely as part of the process of Americanization. Like other Americans, immigrants in urban centers encountered representations of Indians in local taverns, on newly acquired commercial products, and across wide spheres of leisure and entertainment. These representations both communicated visions of America and inculcated immigrant communities into the representational history of the nation. To be an American implicitly was to know its first peoples, as visual images of Indians helped to establish the American public sphere.

The ubiquity of Indians in fin-de-siècle American visual culture was linked with the larger transformations underway across the nation. As historian Philip J. Deloria (Standing Rock Sioux) suggests, images of Indians within American history have grown more pronounced during times of economic and political disruption, providing reassurance and even forging cultural linkages between disparate regions and communities.[8] Such dialectics are apparent across American culture during this time period. With the genesis of the National Park Service, for example, many Native

69. An Indian camp, probably hop pickers, near Puget Sound, Washington, ca. 1893. Photo by Frank La Roche (1853–1936).

communities became simultaneously dispossessed of their ancestral homelands and recognized symbolically as anterior ecological stewards.[9] Indians thus helped to establish both the physical and rhetorical foundations of the nation's parks. Similarly, railways marketed their western routes not only with visuals of Native peoples but also staged exhibitions of Native peoples at railway depots across New Mexico and Arizona. As filmmaker and author T. C. McLuhan observes, "the Golden Era of railroading overlapped considerably with the Golden Era of photography," and like photographs, informal markets for Indian curios, baskets, blankets, crafts, carvings, and other material objects arose across the country.[10] Increasingly, tourists also photographed Native people at work, at home, and in travel. Indian bodies, material objects, and images thus fundamentally contributed to efforts aimed at seeing and knowing America.

Commercialization of Indians and their cultural products often took an ironic, everyday form, especially after the advent of readily marketable, handheld cameras. Historian Paige Raibmon's research documents how weekend onlookers often stopped at seasonal Northwest Coast Indian labor camps to photograph Indian workers.[11] Gathered together from across Washington and British Columbia, agricultural laborers often charged white photographers to take their photos; even Indians who were working away from their homes still remained objects of desire (fig. 69). Similar photographic "episodes of encounter" replayed themselves endlessly across the country and did so outside of more institutionalized forms of corporate or governing authority.

As Native people became enduring subjects within the emergent, vernacular forms of America's iconography, it would ultimately be photography's more commercialized offspring—motion pictures—that would broaden visual influences even further. Soon, and in much more expanded form, American Indians became the lead antagonists in the most recurring tale about American life and history: the Western. By the middle of the twentieth century, when Horace Poolaw was still active as a photographer, Westerns would become a mainstay of an even newer visual medium, television, which quickly replaced radio as the most dominant and commonplace broadcasting mechanism of the time. Indeed, the motion picture revolution emerged from, and dramatically expanded, the photographic revolution of the previous century. Such practices developed even firmer and more fixed associations about Indians, images that Native peoples ever since have had to endlessly endure and constantly challenge. Film studies professor Denise Cummings suggests that American Indian artists and intellectuals have confronted such "visualities" for quite some time, and indigenous forms of aesthetic production have particularly explored "the concept that individual and collective identities are constituted through systems of knowledge production in visual forms."[12] In short, the visual sphere has both pervaded and helped to establish both contemporary American and American Indian cultural identities. Recognizing the mutually constitutive and graphic nature of these constructions provides supportive context for the insights and motives behind Horace Poolaw's photographs.

Resisting the Objectifying and Racial Gaze

Photography's influence on American race relations was felt broadly throughout the nineteenth century, particularly among African Americans. Assessing how African American civil rights leaders, artists, and authors reflected on the advent of photography provides critical perspectives on photography's capacity to discriminate and objectify.

Many African Americans deliberated upon photography's limits as well as its potential, but few more than Frederick Douglass, a former slave turned statesman whose speeches and writings span over half of the nineteenth century. According to scholars Maurice O. Wallace and Shawn Michelle Smith, Douglass not only recognized photography's power but also "understood that the new age was one of pictures more than words." He lectured widely on the media's varied forms and strategically appropriated portraiture photography for his own purposes. "One cannot," claim Wallace and Smith, "overstate the importance Douglass accorded pictures."[13]

Douglass drew particular attention to what he termed the "picture making faculty" inherent in photography's evolution. He believed that unlike any other media, photography exposed broader cultural attributes that, as Wallace and Smith describe, "fundamentally determined what it meant to be human." Moreover, Douglass asserted that the intertwined processes of "observation and contemplation" allowed individuals to envision better lives for themselves. The mechanism of photography was one of awesome and endless power, particularly in the struggle for racial justice, and Douglass quickly registered how it could visually humanize African Americans during the struggle against slavery. This new medium captured both the injustice of slavery and the dignity of African Americans, resonating far beyond

70. Frederick Douglass (1818–1895), ca. 1850. Quarter-plate daguerreotype, 5.5 x 4.2 in.

the written or spoken word. Following its mid-nineteenth-century development, photography became an essential new tool in the fight for racial equality.[14]

As with print culture and the growing genre of captivity narratives, photography provided mechanisms for contesting the racist logic of African American inferiority that undergirded slavery. Cultural studies scholar Laura Wexler suggests that Douglass "was interested in pictures of family sentiment but at his most intense he looked to photography for kindling rather than for kinship." Douglass instinctively noted the political power of photographic images, hearing "in the click of the shutter a promise of the shackle's release."[15] Douglass not only lectured on the idea of capturing, harnessing, and redirecting the representational power of photography's gaze,

but also, importantly, sat for portraiture throughout his life—defiant, dignified, and impeccably attired (fig. 70). His visage, dress, and comportment seemingly embodied the struggle for freedom and equality in America.

Douglass remains unparalleled in contemporary scholarly assessments of photography and the making of African American identity. Studies of African American social movements, like those by African American studies scholar Leigh Raiford, have also highlighted how photography was employed to subvert representations of African Americans as ineligible for national citizenship. At the same time, photographs could be used to "visually assert an image of worth, dignity, and self-possession."[16] Early photography thus became both a powerful representational technology and a potential arena of resistance, a medium for articulating alternative meanings, symbols, and, ultimately, individual and communal identities.

Horace Poolaw and Early American Indian Photography

American Indians became particularly reified within America's nineteenth-century visual culture. Indeed, few peoples have ever been so systematically and swiftly incorporated into new sets of ethnographic, political, and visual taxonomies. During this time, governmental and cultural realms became deeply interconnected by photography, which emerged as a technological medium of objectification as well as an arena of potential contestation.

Horace Poolaw's works provide incomparable insights into these interconnections. As a Native photographer, he registered dominant visions of Native peoples and sought to refashion them. Unlike his Euro-American contemporaries, Poolaw projected rooted, tribally precise, and everyday forms of American Indian life and culture. Most notably, he photographed contemporary Indian peoples living in modern America and their tribal communities. His subjects stand in sharp contradistinction to those found in the objectifying gaze of celebrated non-Indian photographers of the time. The sheer extent of Poolaw's oeuvre, the fact that he worked for so many decades, and the lack of existing studies on his images make assessments of his career vitally needed in order to place him firmly in the greater fabric of American photographic history.

Poolaw's visions of Indian peoples and of America challenge not only his photographic contemporaries but also the visual culture of his time. In subtle and enduring ways, he subverts the representational power of early American photography, challenging the naturalized and timeless suggestions made about Native peoples. His subjects smile, drive cars, and, like Douglass, appear well attired with current fashion and hairstyles (fig. 71). Neither defeated nor despondent, Poolaw's Indians appear firmly grounded in a shared public sphere with other Americans and do so in ways that disrupt the national erasure of Native peoples from American life and culture.

Poolaw's 1928 photograph of three Kiowa youths from Mountain View, Oklahoma, for example, highlights the "weird" intersecting modernities of Native peoples and America more broadly (fig. 72).[17] With two young women profiled outside a new automobile and one man sitting inside, the photograph introduces fashionable Native women whose hair and dress relate to national trends of the 1920s. The Jazz Age of flappers, bohemians, and urban style, Poolaw suggests, also resides in Carnegie, Oklahoma. The frame centers on a Kiowa man seated in what is presumably

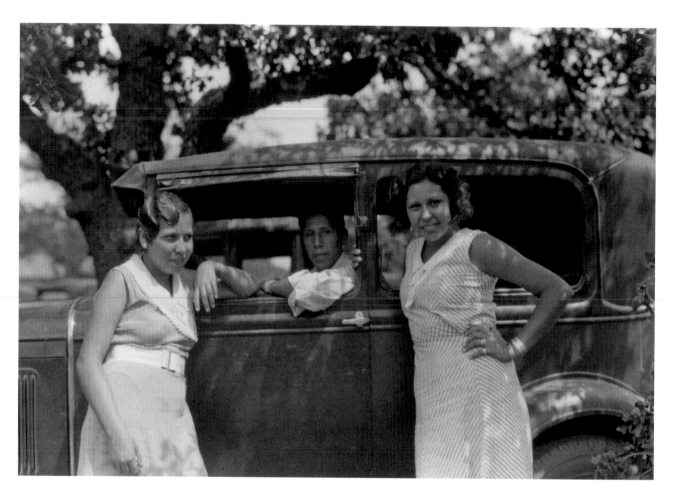

72. Left to right: Lela Ware
(Kiowa), Paul Zumwalt (Kiowa),
and Trecil Poolaw (Kiowa).
Carnegie, Caddo County,
Oklahoma, 1928–35. NMAI
P26509

his automobile—another image of not only twentieth-century American modernity but also individualism and financial self-sufficiency, key rhetorical tropes in the US government's campaigns of assimilation from the era. By relaying the ways in which contemporary forms of American mobility, youth culture, and gendered consumption are received within Kiowa society, Poolaw redraws the terms of these heavily weighted American cultural categories.

While seemingly shared with the larger society around them, such habits, dress, and consumerism take on different meanings when viewed within the context of federal governmental policies of the era, which actively promoted the forcible assimilation of American Indians. Boarding schools, religious and cultural oppression, and divisive land policies had devastated communities across the continent, and photographs—particularly of Indian youth—became a visual component as well as an archive of these processes. Native people, in the government's view, were supposed to distance and disassociate themselves from their communities, not reuse the technologies of modernity for their communal self-empowerment. As in so many of his other works, Poolaw's Native subjects challenge the logics of assimilation by refashioning the objects of American material culture around them and do so from a space of productive engagement.[18]

Throughout the corpus of Poolaw's work, such contemporaneity remains among the most identifiable features of his vision of Native America. His subjects live in a world that is indelibly modern and Native; there is no negative tension between being simultaneously Indian and American. Neither hybrid nor in-between, his America remains inherently indigenous, as Native peoples appear as constitutive members of the surrounding nation. Through military service, holiday parades, and notably in their ongoing maintenance of cultural forms and practices, Indians appear unquestionably as everyday Oklahomans as well as the longest-standing members of their regional community. Following Wexler's metaphor, one might suggest that with every click of the shutter, Horace Poolaw reinserted Native peoples into the mosaic of contemporary America.

As Indian arts scholars have explored with other American Indian visual artists, a revolutionary aesthetic potential is inherent to American Indian cultural production.[19] By resisting the dominant representational forms around them—forms that have ideological genealogies rooted in European conquest and colonization—Indian art has historically challenged both convention and form. The styles, intentionality, and traditions that scholars have identified particularly within post–World War II Native arts communities are also identifiable in the photographic works of Horace Poolaw. His work revolutionarily asserts the vibrancy of Native communal life and did so at a time when American visual culture both castigated Indian peoples and relegated them away from the centers of national identity.

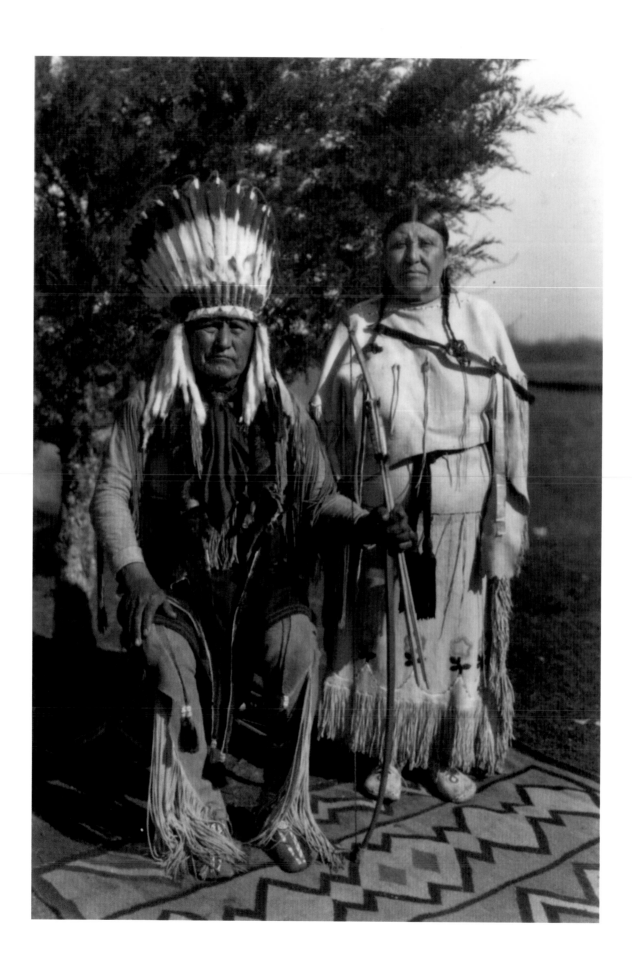

BEADED BUCKSKINS AND BAD-GIRL BOBS

LAURA E. SMITH

Kiowa Female Identity, Industry, and Activism
in Horace Poolaw's Portraits

DESPITE TODAY'S WIDESPREAD ASSUMPTIONS about the death of "authentic" Native culture after the nineteenth century, Poolaw's images affirm the perseverance of Kiowa people, due in large part to female industry and activism. Kiowa women retained a high level of political autonomy in the early twentieth century, regardless of the United States' colonial system.[1] Under the auspices of the assimilation program begun in the 1880s, federal reformers established various institutions bent on eradicating indigenous lifeways and worldviews. As late as 1926, Kiowa Agency Superintendent John A. Buntin expressed despair that Kiowa women continued to pursue beadworking enterprises. He felt this took valuable attention away from housecleaning, laundry work, and cooking, endeavors that for him expressed an Indian woman's progress toward modernity.

> I herewith inclose [sic] you a communication received from Mrs. Susie C. Peters relative to having a Christmas bazaar in Anadarko and Carnegie, Oklahoma. At the bazaar she would exhibit Indian work, a part of which would be sold. . . . There is only one objection to the bazaar and that is the fact that it centers the attention of the Indians to a considerable extent on bead work, trinkets and things of less value than the care of children, sanitary conditions, cooking, sewing, laundry work, prevention of the spread of contagious diseases, etc.[2]

The women's persistence despite government pressure to stop infused the practice with subversive power.

Two of Poolaw's portraits of Kiowa women wearing beaded clothing exhibit their determination to live life on their own terms. The first is of his mother, Xó:mà, along with his father, Cûifò:làu (Mature Wolf, also called Kiowa George), standing in the front yard of the Poolaw family home in Mountain View, Oklahoma, in 1928 (fig. 73). The circumstances surrounding this photo are unknown, but it may have been taken at a special family gathering because they are wearing their best clothing.[3] The juniper that still stands at the house made frequent appearances in Poolaw's portraits of his family. Both Xó:mà and Kiowa George pose formally, torsos erect and still. They gaze solemnly and intently at the photographer. While their postures and demeanor are at rest for the moment, the picture frames a dynamic indigenous assertion over space and self.[4] Their feet rest on an Indian rug that lies upon their land. Kiowa George grips his bow with authority and sets it down firmly upon the earth. The bow and arrow are signs of his high social position, in addition

73. Cûifò:làu (Kiowa George, Kiowa) and Xó:mà (Light-Complected Woman). Mountain View, Oklahoma, 1928. 57FGC4

to his expert ability to craft these weapons. He was born in 1864 near the Wichita Mountains. His granddaughter Linda Poolaw recalls,

> He hunted, participated in war parties, and celebrated in Sun Dances. He was also a scout for the army at Fort Sill. In his later life he became a sweathouse doctor and a skilled maker of bows and arrows. While he was a scout he was taught to draw on paper, and this led to his keeping a Kiowa calendar.[5]

All of these roles contributed to Kiowa George's status as a prominent Kiowa leader. Guns and arrows appear in many of Poolaw's early photographs, most commonly as symbols of power rather than as tools of violence. With or without weapons, though, both of Horace's parents assertively occupy this landscape. Xó:mà's presence in her revered beaded buckskin dress significantly connects Kiowa female authority to homeland.

Before the reservation period, a Kiowa woman's craftsmanship was vital to her family's health, comfort, and prestige. The community particularly rewarded female creative ingenuity in tipi and clothing production.[6] According to master beadworker and cultural historian Vanessa Jennings (Kiowa Apache/Gila River Pima), a Kiowa woman showed her status by the way she set up her camp, and the way she dressed herself and her family.[7] Linda Poolaw remembers that even in the mid-twentieth century, people held great reverence for women who maintained an orderly household (like their camps) and were highly skilled at beadwork. Her grandmother Xó:mà probably never learned how to bead, but managed the home affairs very effectively, fed the family, and was tremendously supportive of Kiowa George. The dress Xó:mà wears in the 1928 photo was one she owned but was made by someone else, most likely a relative. None of Horace's children know who crafted it or how it was acquired.[8]

After 1890, distinguished Kiowa women preferred to wear beaded and painted buckskin outfits—mostly for important occasions, as by the reservation period buckskin had become difficult to obtain and was therefore valuable. Ethnologist John Ewers states that by the 1820s and into the 1880s, the dresses of important Kiowa women were more commonly made of trade cloth and ornamented with elk teeth.[9] The dramatic influx of glass beads to the reservation in the 1880s influenced a change in the use of elk teeth as decorative elements to convey affluence. Sporadic periods of cash income provided the occasional means to produce extravagant beaded designs on Kiowa clothing and cradleboards.[10] Scholar Jacki Thompson Rand (Choctaw) attributes the enhanced elaboration of Plains Indian clothing with beads to colonial resistance.

> Women's beadwork . . . throughout the last quarter of the nineteenth century was, in the context of federal policy, a political act. Colonial codes and Western-style institutions served to undermine tribalism, even going so far as to outlaw some aspects of Indian culture. The persistence of women's beadwork and other labor patterns defied the US attack on tribalism.[11]

Vanessa Jennings has commented that "after so many years of some missionaries forbidding Kiowas and others to dress in traditional clothing, putting on those dresses . . . was a way to defy those orders and affirm your right to dress, and express your pride in being Kiowa or Indian."[12] By 1928, when Xó:mà put on her dress for her son's photograph, many federal agents, like Buntin, continued to pressure Kiowa women to abandon pre-reservation cultural practices and industries, but to no avail.

74. Left to right: Sindy Libby Keahbone (Kiowa) and Hannah Keahbone (Kiowa). Oklahoma City, Oklahoma, ca. 1930. 57PC2

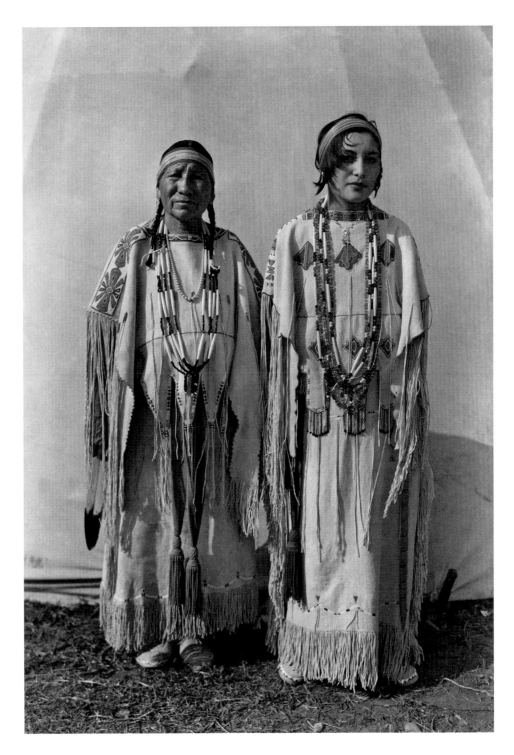

Kiowa women were changing, however, just not in the ways that Buntin cared about. As is evident in many of Horace Poolaw's photos, not all of the standards for female behavior and self-presentation lay in the past or in federal mandates for Indian women's "progress." Contemporary fashions and film stars of the 1920s inspired some young Kiowa women to alter their clothing, hair, and lifestyles.[13] This is notable in Poolaw's portrait of Sindy Keahbone and her daughter Hannah, probably taken at a public event near the Oklahoma City Farmers Public Market (fig. 74).[14] While Sindy

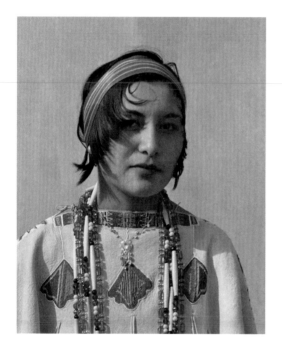

75. Clara Bow (1905–1965) in a publicity portrait for the film *It*, 1927. Photo by Paramount/ Getty Images.

76. Hannah Keahbone (Kiowa), detail. Oklahoma City, Oklahoma, ca. 1930. 57PC2

conservatively wears her hair in the standard long braids, Hannah somewhat coyly engages the photographer from behind short locks of the popular, flapper-style bob.

Reportedly, Hannah was a rebel. Vanessa Jennings remembers that she defied temperance laws and the field matrons from the Anadarko Indian Agency. She wore makeup and

was known to have a small metal flask held in place by the tight roll of her stockings, just above her knees. She was bold and beautiful. The rules for women and their physical appearance at this time [were] harshly regulated by the field matrons at the Anadarko Indian Agency. You were supposed to be dressed like a super-modest white woman and NO makeup.[15]

Among many American women in this period, the adoption of the bob hairstyle signified a rejection of Victorian demureness and confining modes of appearance and behavior. Modern women found short hair easier to maintain. They also preferred corsetless dresses for freer movement. This flapper fashion responded to the interwar-period woman's push for social and political liberation.

The film star Clara Bow popularized the new, unrestrained American female type. According to film scholar Sara Ross,

This modern girl [Clara Bow] was sexually aggressive. She would smoke, drink, and neck her way through films, wearing revealing clothing and making suggestive remarks while attending wild parties and dancing to . . . jazz bands or driving roadsters at dangerous speeds.[16]

Jennings recalls that "every woman in America wanted to be Clara Bow" (fig. 75). Similar to Bow's portrait, Hannah loosely tied her tousled, bobbed hair back with a headband. Each woman greets the viewer with a sultry, half-smile by raising the right corner of her mouth. The eye-shadow and dark mascara enhance the size and seductiveness of Bow's eyes; Hannah's eyes, although unadorned here, equally enchant by peeking out from behind the shadows of her long, side-pulled bangs. Her saucy gaze allies her with that female transgressor of white, middle-class polite society. Hannah additionally challenges standards for Kiowa female respectability, represented by her mother's expressive restraint. Most other elder women in Poolaw's portraits from this period follow Sindy's example.

Poolaw's picture of the Keahbones provides a rare glimpse of the somewhat dissonant but coexistent, emboldened Kiowa female identities. Not simply responding to federal authorities, twentieth-century Kiowa mothers and daughters negotiated the terms for female identity among themselves. Of the few published records of Kiowa women's conversations in this period, two create severe contrasts between the generations. In her 1927 book *Kiowa Tales*, ethnologist Elsie Clews Parsons noted that tensions between some Kiowa adults and their children related to modes of dress

and social conduct. In the introduction, Parsons describes an "incredibly great" gap "between the Kiowa generations." Focused on her informants Sendema and her daughter Katie, Parsons illustrated their differences through clothing. Katie, who "was a widow and out of hand," "disdains" her valuable buckskin dress, while her mother "lovingly" folds hers in cloth as she packs it away in a trunk. Parsons further describes how Katie was looking forward to buying a fur coat.[17] Another ethnologist working among the Kiowa in the 1930s, Alice Marriott, also wrote about elder Kiowa women's concerns over contemporary fashions, particularly the shortening of skirts. Only "bad" women or white women chose to wear short dresses.[18] Parsons conveyed her concern about the younger generation of Kiowa who "are either ignorant of the tribal past or ashamed of it." She claimed the elders with whom she worked also shared her worries. In choosing to begin her book with stories of conflicted youth, Parsons effectively suggests the future of Kiowa culture may be doomed.

Poolaw's portrait of the Keahbones frames what surely must have been a more nuanced conversation. Despite her bad-girl bob, Hannah Keahbone dons a beaded buckskin dress, not a fur coat or knee-high flapper dress. A daughter stands resolutely with her similarly dressed mother against the backdrop of a tipi. The Keahbones are ultimately united by intergenerational signs of Kiowa female authority and self-determination. A more expansive visual testament to divergent Kiowa female identities is apparent in Poolaw's portrait of women from the Rainy Mountain Kiowa Indian Baptist Church in Mountain View, Oklahoma (fig. 77). Here, as in the other portraits, Kiowa women appear uniquely engaged with their present as well as with their heritage. The complexity of women in Poolaw's imagery reflects the reality of conflicted identities within the contemporary context of colonization. Yet it also generates a sense of the creative, self-determining life force that is the Kiowa female legacy. While the varied faces of the women in Poolaw's portraits certainly preserve Kiowa memory for the community, they have further substantial value in their contribution to the global consciousness of Native American vitality in the twentieth century.

77. Rainy Mountain Church women's group. Mountain View, Oklahoma, ca. 1928. 57R5

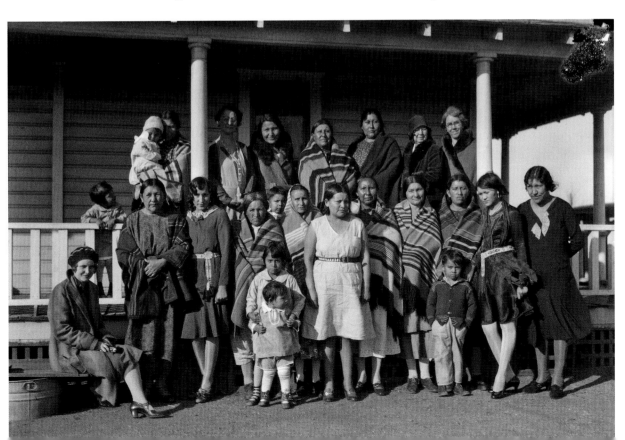

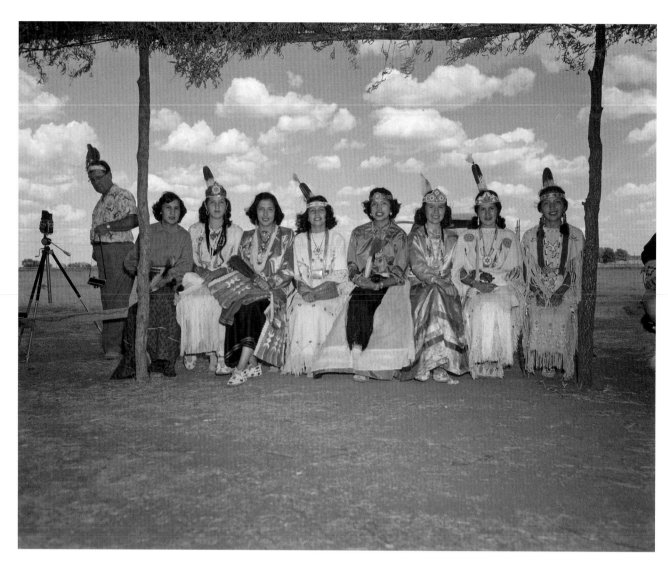

78. American Indian Exposition,
n.d. 45EXCW42

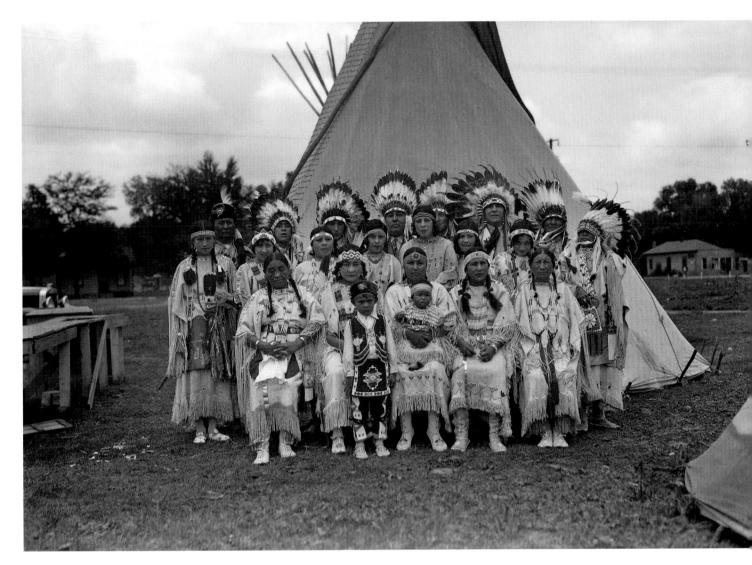

79. Opening of the Farmers Public Market in Oklahoma City. Left to right, back row: Caroline Bosin (Kiowa), Belo Cozad (Kiowa), Gladys S. Parton (Kiowa), unidentified, Myrtle Berry (Kiowa), Raymond Paul (Penobscot), Barbara Louise Saunkeah (Kiowa), Jasper Saunkeah (Kiowa), Rosie Ellis, Frank Bosin (Kiowa), Nell Pappio (Kiowa), Bruce Poolaw (Kiowa), Hannah Keahbone (Kiowa), Enoch Smoky (Kiowa), Susie Zumwalt; front row: Mrs. Frank Bosin (Kiowa), Blossom Smoky (Kiowa), Newt Keahtigh (Kiowa), Jeanette Mopope (Kiowa), LaQuinta Santos (Kiowa), Martha Koomsa (Kiowa), Sindy Keahbone (Kiowa). Oklahoma City, Oklahoma, 1928. 57LE20

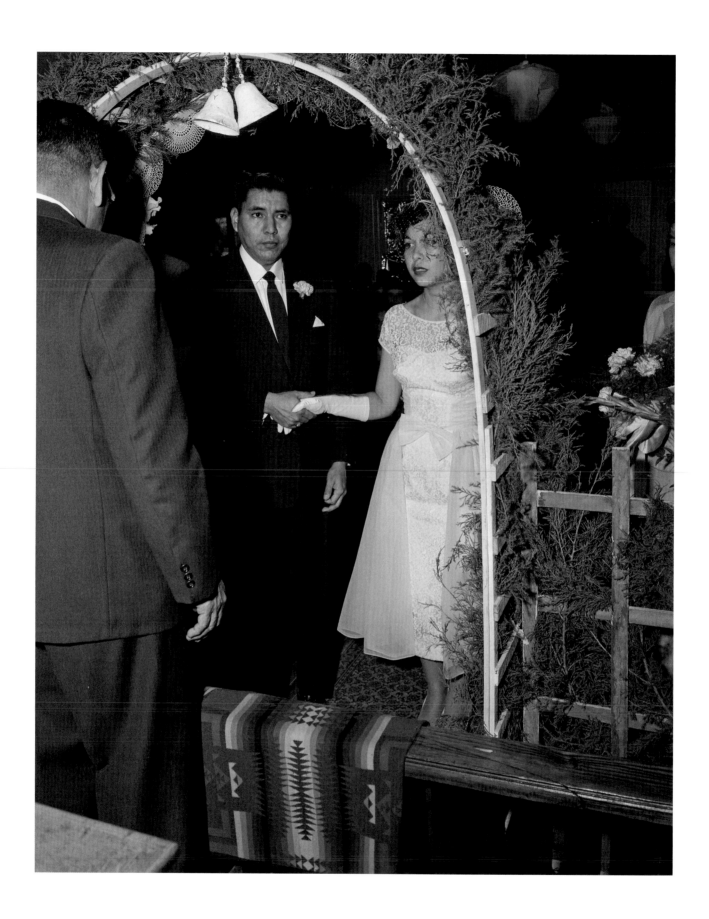

HORACE POOLAW
"Pictures by an Indian"

NANCY MARIE MITHLO

HORACE POOLAW'S PHOTOGRAPHS POIGNANTLY EXPRESS what it meant to be a global citizen of the twentieth century, living life as an American Indian. Born in 1906, Poolaw witnessed the multiple ways America came to define itself: a nation fighting two world wars, developing massive industrialization, exploding in urban growth, and extending the right to vote to women, African Americans, and American Indians. The twentieth century saw unprecedented technological developments in the speed and efficiency of communication, manufacturing, and transportation with equally unparalleled environmental consequences. The Great Depression, the United Nations, the atomic bomb, and space travel all manifested during Poolaw's lifetime. These changes wrought deep anxieties in the American psyche about racial divides, class aspirations, gender equality, and, ultimately, humanity's role as an agent of survival and destruction.

An awareness of these broader significant shifts in perspective and meaning while one is caught up in the details of day-to-day life is uncommon. Poolaw's gift was his ability to recognize these historic events as they happened. Whether documenting the discovery of an oil field, a hurricane's devastation, veterans returning from war, or everyday events, his images convey a self-awareness, a weight, a certainty. Importantly, he recognized not solely his own experience but the experience of his people, the Kiowas, and the Native nations surrounding Anadarko, Oklahoma. He was a man of his time, aware of his times.

For American Indian people, the developments of the twentieth century had a unique resonance, one formed by the complex histories of encounter, trade, and conflict with foreign colonial nations. At the time Poolaw was born, the Kiowas, Comanches, and Apaches of the southwestern Great Plains had only recently emerged from active warfare with the United States, which sought to control Native lands and lives. The Medicine Lodge Treaty, signed in 1867, assigned Kiowa and Comanche people to reservations, and Chiricahua Apaches were still prisoners of war at Fort Sill in nearby Lawton, Oklahoma, when Poolaw was a youth. The historic weight of US aggressions against the tightly knit Indian community of Anadarko, Oklahoma, and surrounding areas was surely felt in the early 1920s when Poolaw began to photograph. His images however, are not the somber and pensive portraits that viewers have come to associate with photography of Native Americans.

What we see in Poolaw's photographs is not the harsh aftermath of war but resilient Native people in innocuous settings. In Poolaw's world, Indian people dress well, go to movies, ride in nice cars, and get married in country churches. They visit

80. Wedding of Charlotte Clayton (Caddo) and Rupert Thompson (Kiowa) at J. J. Methvin Memorial United Methodist Church. Reverend Ted Ware (Kiowa), at left, officiating. Anadarko, Oklahoma, ca. 1960. 45EW9

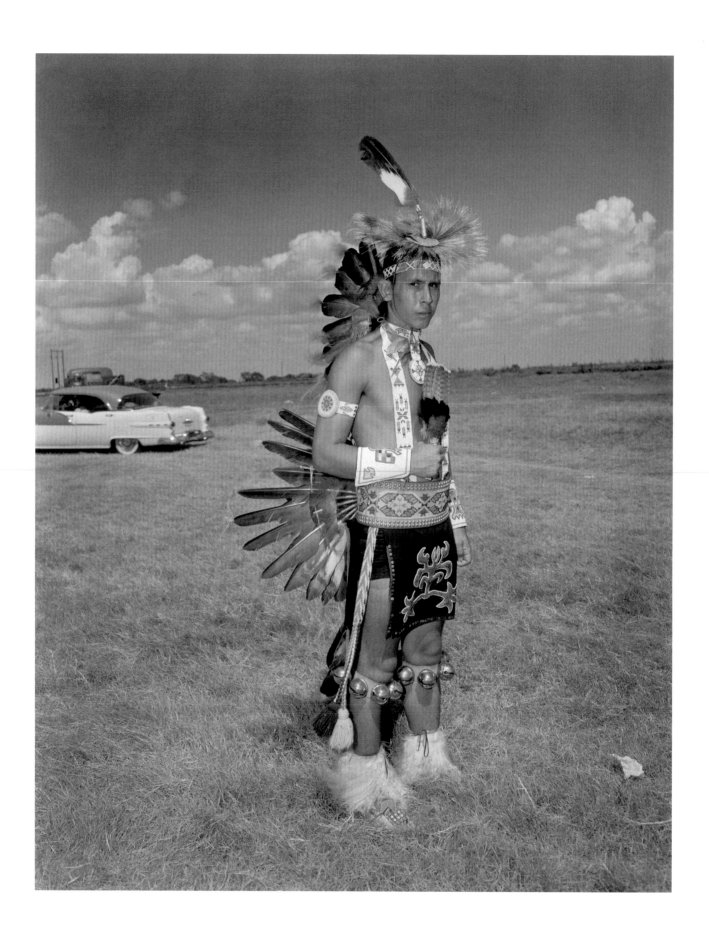

with family and neighbors on front porches, can fruit for country fairs, play base-ball, smoke a cigarette with friends after church, graduate from high school with their parents standing proudly nearby, flirt with boys driving fashionable cars, send photographic Christmas greetings of their families, and proudly serve in the military, Boy Scouts, and civic organizations. Photo historian Cheryl Finley describes this quality of photographic aims and outcomes as the "aesthetics of affirmation"—a celebration of one's own secure place in society; a place of meaning and internal logic and comportment; a cultural world rich with significance, beauty, and resonance.[1]

A national belief in the superiority of American technology and progress in comparison to indigenous people and lifeways has historically served to make American Indians into one-dimensional points of contrast. The primitive and the civilized, the traditional and the modern, the authentic and the new—these divisions have been visualized, reenacted, and memorialized in the arts, film, architecture, and advertising as eternal and almost preexisting categories of thought. Poolaw challenged these divides when he took up the camera in 1926. His simple act of artistically documenting the cosmopolitanism of Indians powerfully broke staid notions of Native people as ahistorical objects of comparison. Poolaw's body of work offers ample evidence that the nations of the southern plains were and are simultaneously tribal and modern, of tradition and of the contemporary. In fact, American Indian life, as documented by Poolaw, demolishes the power of this contrast altogether, making even the words and concepts "traditional" and "modern" meaningless, flimsy, and unreasonably obtuse. A close look at key examples of his portraits and landscapes amply demonstrates how these divides are collapsed.[2]

The photograph of a yet-unidentified youth starkly conveys the power of Horace Poolaw's aesthetic (fig. 81). The young man in Plains dance regalia stands alone in the windy dry grass of late summer on the southern plains. He is no doubt participating in the American Indian Exposition, a long-standing annual civic event sponsored by and for the tribes of western Oklahoma during the first week of August. A highlight of the "Expo," as it is known locally, is the opening parade featuring the tribal nations that surround the town of Anadarko, including the Arapaho, Caddo, Cheyenne, Delaware, Kiowa, Kiowa Apache (now known as the Apache Tribe of Oklahoma), the Fort Sill Apache, Osage, Otoe, Pawnee, Ponca, Wichita, and Comanche—as well as dignitaries such as the thirteen tribal princesses, each a youth representative of their tribe; the Rush Springs Watermelon Queen; and the notorious and somewhat secretive "mud men." The dancer Poolaw has photographed is likely scheduled to compete with others in a traditional powwow at the main arena near the fairgrounds.

The sun is high, as we can see by the shadows cast from the dancer's roach headdress falling across his forehead, yet Poolaw uses flash lighting—his signature style for portraying subjects as monumental, even sculptural in scope. The youth clutches his feather fan almost defensively as he warily eyes the viewer on the other side of the lens. He is caught a bit off guard, his expression conveying a quality I know well. My father used to call it "that angry Indian look"; it is a trait he greatly admired in all his children and grandchildren (in our family, it was specifically the "angry Apache" look).[3] This to me is a gaze of intelligence. He is saying, "I am observing you before I fully trust you."

This moment negates the idea of Indians living in another space and another time. Our subject makes direct eye contact, alerting you to the fact that he registers your presence; he is aware that he is being viewed and the gaze is mutual, it is reciprocated. Social scientists Catherine A. Lutz and Jane L. Collins call this the "return gaze." The authors speculate on the significance of direct eye contact as an indication of power, even confrontation, or alternately a sign of openness and accessibility.[4] In this instance, it is clear that this moment is not candid but one in which the photographer and the youth are mutually framing the outcome of the encounter. We sense a negotiation between equals, a mutual recognition of the other's humanity. It is the sign that is exchanged on the sidewalk when one is courteous to an elder, the visual fist-bumping of peers engaged in a common struggle, the casual nod of recognition.

Poolaw's composition here appears straightforward but upon closer examination is actually quite complex. He has created two intersecting diagonals—one of the horizon line pointing slightly downward to the left of the frame (he has adjusted his camera so that the figure is straight and the horizon is slightly off), and the other a diagonal formed by the automobile, the dancer, and what appears to be a piece of trash to the right of the frame. These additional features—the car, the youth, and the trash—could all have been easily eliminated, either during the act of taking the photo (Poolaw might have removed the trash or reframed the image to avoid the car) or afterward in the darkroom (though he rarely cropped his photos). His diagonal lines create a tension, an excitement, yet in the midst of these visual complexities his subject is perfectly grounded and exudes that discernible air of presence that Poolaw is known for capturing. He is in his space and of his time.

Poolaw has situated the young man in relation to the very embodiment of America—the automobile—almost as if the fashionable two-toned car is an accessory to the man's elaborate feather- and beadwork outfit. These juxtaposed modern trappings are not entirely celebrated, however, as signaled by the electrical poles and trash. The dancer is not "caught in two worlds" or "struggling to enter the mainstream," nor is he "in transition" from traditional to modern. Rather, he is both traditional and modern; in occupying that space, he defies the terms and their utility. Poolaw's images give us—both Natives and non-Natives—permission to rise above these stale conversations. This handsome young man encourages us: "Move along now, I've got it taken care of here."

Close attention to Poolaw's compositions reveals an affinity for modernist aesthetic forms, such as geometric patterning, a flatness of plane, and a sharp focus. These formal attributes, including a preference for abstraction, are consistently present in Poolaw's work.[5] The modern is expressed both by obvious physical objects—such as the car or trash, and Poolaw's framing of his subjects—and by how the photograph presents as an overall canvas of shapes and arrangements.[6] Poolaw's modernist approach is not simply an appropriation of Western artistic codes; it also reflects indigenous thought and creativity.[7] Abstraction—in this case, the simplification of line, form, and meaning—serves Poolaw's intent to tightly control his composition. The subject, placement, lighting, and framing conspire to tell his story uniquely.

This 1928 scene was taken when Poolaw was only twenty-two (fig. 82). Once again, Poolaw has shifted the camera ever so slightly, toying with the scene's reality and enhancing our reading of the photograph by bringing the dark foreground more

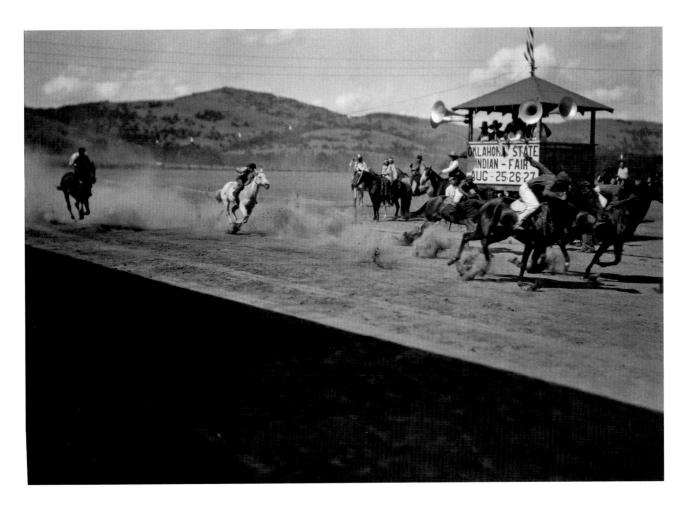

82. Craterville Park Indian Fair horse races. Near Cache, Oklahoma, ca. 1928. 57CR6

sharply into the frame. The intense triangular shadow emphasizes the speed of the horses while inversely mirroring the peaks of the Wichita Mountains in the background. This modernist design sensibility is echoed by the horizontal electrical wires that frame the scene, the triangular shapes of the grandstand roof, and the punchy graphics of the sign below.

It is a hot, dry day in late August and the taste of the flying dry dirt from the horses' hooves is palpable. The sun is high, and it appears that most of the onlookers have taken refuge in the shadows of the grandstand behind Poolaw or in the announcement booth. The five riders are caught in midflight, but it is the one on the white horse who catches our attention. Unlike the cluster of three riders in the lead, he appears to be without the standard white jodhpurs and riding cap. He is the ordinary guy, maybe even the underdog, in his cowboy hat and dark trousers. We sense he has farther to go than the others, that he is trying harder. The spectators closest to him, those in traditional dress, appear almost as otherworldly witnesses to his struggle. Two women, in full buckskin dresses and wearing the Kiowa headband fashionable at that time, sit gracefully astride parallel horses, looking distractedly at the winners, while a man holding a feather fan and traditional hat stands as if at guard.

As viewers, we are caught in the immediacy of the moment. We are brought into a magical world where racers and spectators seem to float effortlessly across the horses' backs as naturally as one would sit on a chair. The people and their horses

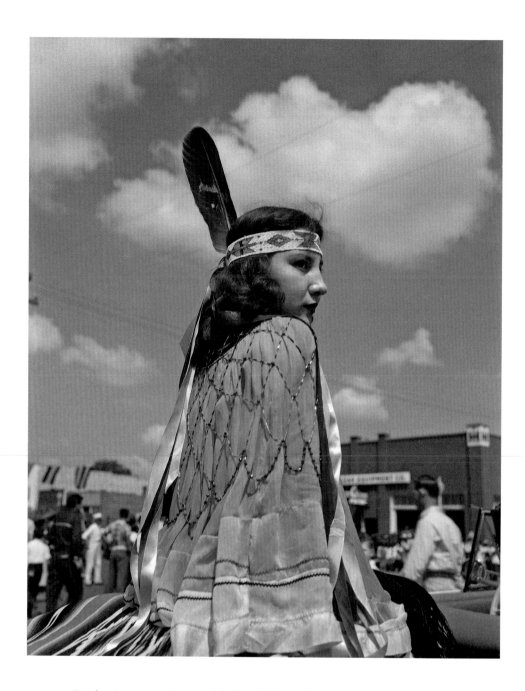

are one. Poolaw's success is rooted in his ability to lure us into this scene completely; he brings us close to the action so that we care about the individuals we observe. This immediacy is accomplished by both his strong design sensibilities and his understanding of the events unfolding in front of his lens. In the words of Yuchi photographer Richard Ray Whitman, "I'm not a visitor to my experience and I don't see my people as merely subject matter. I didn't arrive on the street and make the images and leave."[8] This indigenous sensibility runs counter to established photographic mores that historically assume the separateness of subject and viewer.

Photographer Henri Cartier-Bresson coined the term *picture story* to refer to that moment when things fall into place in the viewfinder in such a way as to convey the essence of the scene. "Sometimes there is one unique picture whose composition

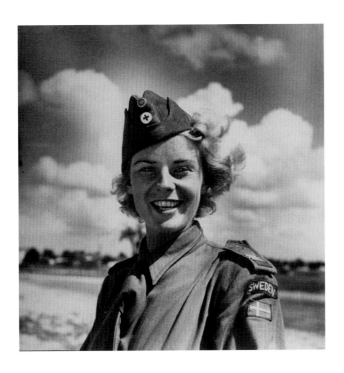

84. Swedish Red Cross worker Ingrid Jarnald, used on the cover of *Life* magazine in September, 1950.

possesses such vigor and richness, and whose content so radiates outward from it, that a single picture is a whole story in itself."[9] Poolaw's photographic record certainly bears out this philosophy. A review of his catalogue reveals very little framing of multiple shots, but rather one image taken at what Cartier-Bresson calls the "decisive moment." Unlike Cartier-Bresson, however, who stated, "In whatever picture-story we try to do, we are bound to arrive as intruders," Poolaw had the advantage of being a cultural insider to the world he captured on film.[10] This unique perspective defines his legacy in such a way that one must approach the material with this framework centrally in mind.

In the 1952 American Indian Exposition parade shot of Seminole princess Eula Mae Narcomey Doonkeen, Poolaw employed a monumentalist aesthetic, framing his subjects against the high plains skies of Oklahoma (fig. 83).[11] Doonkeen is positioned in a grandiose manner, jutting above the landscape in the style of a significant architectural feature or a commemorative monument. Poolaw seems to be saying to the viewer, "See how important this woman is. Witness her beauty." Yet he has also made specific choices about how we see her. The tribal princess is photographed from behind, emphasizing her profile and sending the eagle feather into the central space of the composition.

Wearing an eagle feather in Native American contexts is not a decorative feature but a significant spiritual practice, as her countenance suggests. The feather carries with it deep cultural and religious significance that demonstrates and enhances Doonkeen's role in this context of display and ceremonial performance. The young woman has been chosen as a representative of her people. While the conventional usage of the term "princess" indicates crass consumerism in mainstream America, on the plains of southern Oklahoma the role of princess serves as a type of modern coming-of-age ceremony. She is valued not only for her beauty; she embodies the central maternal figure of many of the tribes of western Oklahoma: a matriarch, a Madonna, or even as in the Apache tradition, the "bringer of all life."[12]

Consider a similar image: this portrait of Ingrid Jarnald, a Swedish Red Cross worker featured on the cover of a 1950 *Life* magazine (fig. 84). Composed using the same photo conventions as that of Poolaw's Seminole princess, the image shows the young woman loftily situated above the horizon line outdoors. She, too, bears markers of her role (hat and uniform) and can be read as archetypical, monumental, and revered for her beauty and status. She is turned to a three-quarter profile yet makes direct eye contact with the viewer and displays an open and inviting smile. Western readers might view this countenance as appropriate for her position, a fresh and youthful aid to the greater good.

In contrast, Poolaw's female icon is reserved, her eyes averted. Unlike her *Life* magazine counterpart, she refuses to make eye contact with the photographer. A

typical Western cultural reading might conclude that eye avoidance signifies subservience or perhaps a subject who avoids direct engagement is weak and would not confront or engage her equals directly.[13] Avoidance of eye contact can even indicate the subject is sneaky, up to no good, or untrustworthy. Eye avoidance in many American Indian communities, however, is considered appropriate for young Native women, especially in public contexts. Indirectness indicates modesty, respect, and a proper understanding of age and status differentials.[14] To see the image as Poolaw did, the viewer must know something of American Indian transitions from youth to adulthood, must respect the use of the feather in plains cultures, must comprehend a non-patriarchal worldview, and must reject the status of Native women as objects of consumption alone.

We know little about the circumstances of gathering, but it appears to be a political event involving military from nearby Fort Sill (fig. 85). A Kiowa minister, an elderly former white captive named Millie Durgan, and the famous Kiowa leader Hunting Horse all appear in this and associated photographs taken near Carnegie, Oklahoma, in the 1930s. Under Poolaw's editorial hand, we see no evidence of how the crowd has arrived to this location (no cars, buggies, or buses), nor do we see any indication of Western conventions for controlling the movement of people (lines of chairs, security ropes, a platform, or a lineal arrangement from speaker to audience). Instead we see a circular and organic meshing of people within the land, as a part of the land—not monumentally situated above it as in the portrait of the tribal princess, but seemingly growing out of the earth as a field of corn or wheat might. The humans are dwarfed by the immenseness of the southern plains as the low mountain ridge keeps a careful watch in the far distance.

This spectacular shot cannot be said to be strictly a composition of American Indians alone, for the frame is filled with people of various ages, genders, and backgrounds, commingling in an endless variety of poses and attitudes. Yet the image evidences American Indian beliefs about the equal importance of humans and the environment. This is a landscape that owns its inhabitants; in turn, the people are subject to a complex of reciprocal relationships that are not only imagined but also enacted and sustained by ceremony and legal struggles over land ownership and rights.

In another remarkable photograph, Irene Chalepah Poolaw (Kiowa Apache) receives the flag at the funeral of her husband, First Sergeant Pascal Cleatus Poolaw, Sr., (Kiowa) at Fort Sill, Lawton, Oklahoma, in 1967 (fig. 86). Pascal Poolaw is famed as the most decorated American Indian soldier in US history. He was awarded four Silver Stars and three Purple Hearts for bravery in three wars: World War II, Korea, and Vietnam.[15] It is well known how much Horace Poolaw admired him.[16]

In this image, people crowd the frame. The mourners in the background appear stunned; women clutch handkerchiefs to their face, and many hide their emotions behind dark sunglasses. Shadows of the onlookers fall across the polished coffin in hazy lines. Pascal's four sons, all active in the military, sit close together; their combat boots and dress shoes reflect Poolaw's flash brightly. A woman in traditional dress, perhaps a relative of the deceased, is present beside the young men; we see the rich fringe of her shawl fall across her knees. Most central perhaps, besides the African American soldier with white gloves at attention directly beside the coffin, is the man adjacent to the sons in a gray suit, out of focus; he is our guide. Poolaw

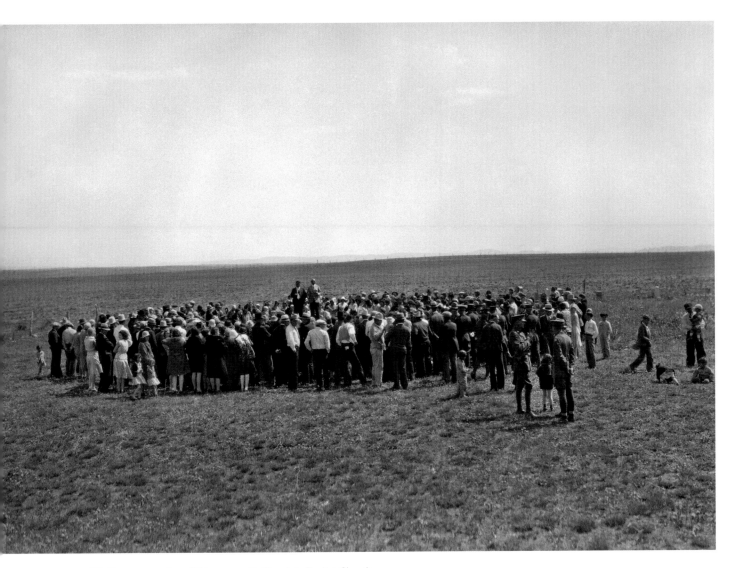

85. Commemoration of Sain-
toh-oodie's (Millie Durgan
Goombi) life as a "white cap-
tive." Included in crowd are
George Hunt (Kiowa), Durgan's
son-in-law and deacon of Sad-
dle Mountain Baptist Church
(center left) and Tsatoke,
or Old Man Hunting Horse
(Kiowa, center right). Saddle
Mountain, Oklahoma, ca. 1931.
57RCEM9 —A. H., C. G.

86. Irene Poolaw receives the flag at husband Pascal Cleatus Poolaw, Sr.'s (Kiowa) funeral. Seated, left to right: Donald Poolaw (Kiowa), Lindy Poolaw (Kiowa), Pascal Poolaw, Jr. (Kiowa), Lester Gene Poolaw (Kiowa), Irene Chalepah Poolaw (Kiowa Apache). Fort Sill, Lawton, Oklahoma, 1967. 45UFN5

has chosen this figure to stand beside us, the viewer, in this crowded arbor just at the moment the white-gloved hands draw back from the mourning widow draped in a black lace scarf. This is the decisive moment.

Compositionally, we see Poolaw's trademark fascination with abstract geometric lines—the diagonal edge of the carpet against the dark earth juts toward the gloved hands offering the flag, while the horizontal lines of the tent poles intersect and point toward our gray-suited guide on the left. As a relative and trusted insider, Poolaw could have selected any number of angles to compose this intimate shot. His choice to include the shoulders and frame of the large figure at left is a means of informing the viewer that they are beside another insider who allows us access to the most immediate and personal part of the funeral service. We are not simply voyeurs; we do not have the luxury of thinking this is an objective documentation. Rather, we are thrust into the tent on this cold day in late fall as an insider. We feel the weight of the moment. We mourn as well.

Poolaw's means of attending to both design sensibilities and interpretative codes is nowhere more evident than in his use of a third-eye perspective.[17] Poolaw escorts the viewer into his world by providing an additional viewpoint within the frame in the form of a guide who stands beside or engages the viewer with direct eye contact.[18] This purposeful compositional technique occurs frequently throughout Poolaw's oeuvre. While the convention may serve to visually balance the composition, I argue that the strategic inclusion of an additional viewpoint within the frame serves a higher-order purpose. Here I draw from the work of film scholar Fatimah Rony who uses the third eye as a means to signal the recognition of multiple viewpoints, especially those of the observer observed.[19] This perspective conceptually brings the viewer of the photograph into an intimate sphere, one where indigenous codes of hospitality and generosity are at play.

The relationship between photographer, subject, and viewer is often a complex and fraught process that defies the simplistic urge to document or capture images, people, and places for posterity. In Horace Poolaw's work, we see the active participation of a cultural insider in crafting a means for us today to understand how life was in this particular time among the people in these specific communities. His generosity of spirit is apparent in the care of and sensitivity to the people he photographed.

Poolaw's photographic archive allows us to witness the vibrancy of a time when American Indians not only survived but also thrived amid unprecedented changes. In these images we see Native people as active participants in the making of American history, not passive victims. America's birth as a global superpower occurred simultaneously with American Indians' emergence in the public sphere as culturally specific peoples with important contributions to make politically, militarily, and artistically. Poolaw's photographs are crucial evidence of American Indian rights and recognition in the twentieth century, but more importantly they are a record of his place, his time. This deep sense of belonging is succinctly captured in the stamp he used to author his photos:

A POOLAW PHOTO
PICTURES BY AN INDIAN
Horace M. Poolaw
Anadarko, Okla.

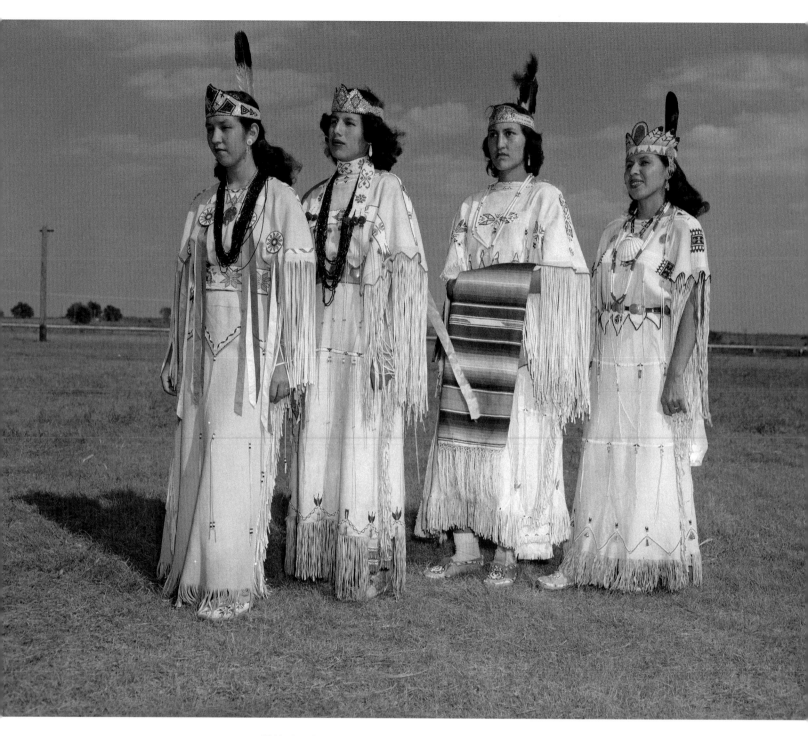

87. Unidentified tribal princesses
at the Indian Expo. Anadarko,
Oklahoma, ca. 1955. 45EXCW34

88. Kiowa Ohomah dancers,
twins Alvin Burke Deer (on
left) and Melvin Blake Deer
(Creek/Kiowa). Anadarko,
Oklahoma, ca. late 1940s.
45EXP62

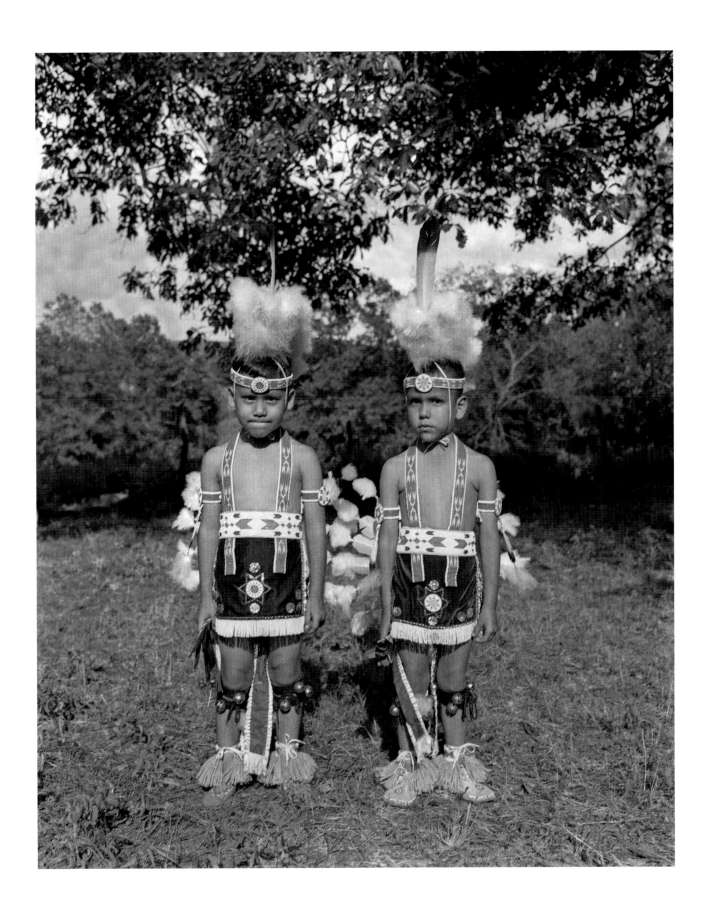

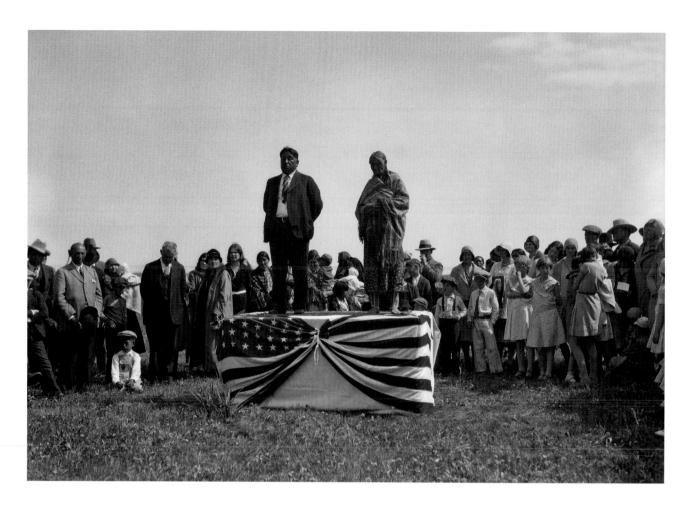

89. Commemoration of Sain-toh-oodie's (Millie Durgan Goombi) life as a "white captive." Pictured are Tsatoke, or Old Man Hunting Horse (Kiowa), second from left; George Hunt (Kiowa), Goombi's son-in-law and deacon at Saddle Mountain Baptist Church, on pedestal; Sain-toh-oodie, on pedestal. Saddle Mountain, Oklahoma, ca. 1931. 57D2 —A. H., C. G.

90. Sain-toh-oodie (Millie Durgan Goombi), at center. Saddle Mountain, Oklahoma, ca. 1931. 57D6—A. H., C. G.

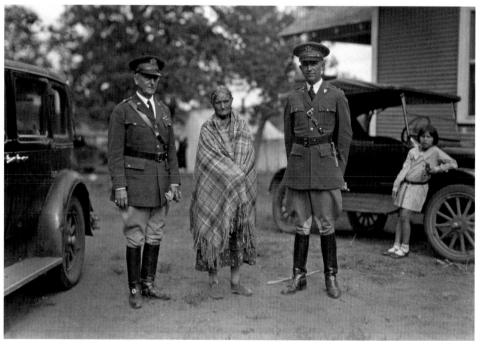

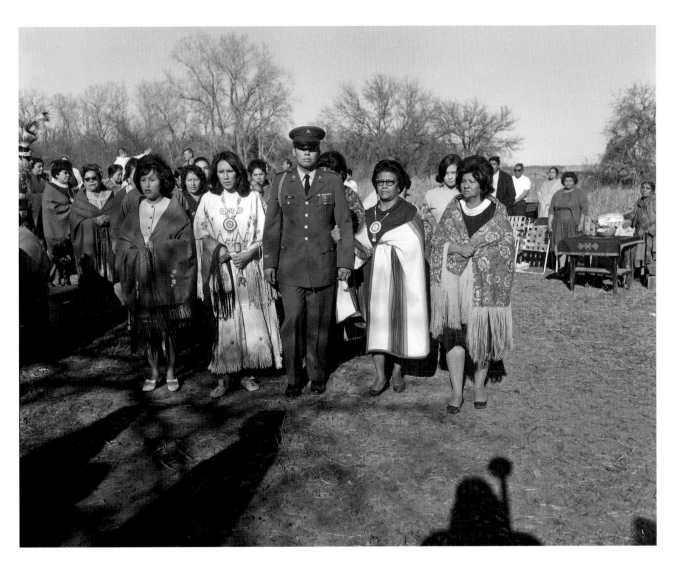

91. Honor dance at Bill Campbell's Dance Ground, celebrating Virgil Swift's (Wichita) return from service. The women in the dark shawls at left belong to the Wichita Service Club (WSC), an organization of women devoted to serving the Wichita people, often through Veterans' honorings and events. Left to right: Cecil Campbell (Wichita), unidentified, Patricia "Potato" Ware; (in front row) Sandra Paddlety (Kiowa), Rose Sharon Archilta (Kiowa Apache), Virgil Hume Swift (in uniform), Nettie Laura Standing (Kiowa), LaVera Mae Swift Reeder (serviceman's mother, Wichita); (background) Sylvester "Sy" Luther (Wichita), Eva Guy Luther (Caddo), Corinne Williams Stevenson (Caddo), Eunice Swift (serviceman's grandmother, Wichita). North of Anadarko, Oklahoma, ca. 1969. 45POW80 —L. P.

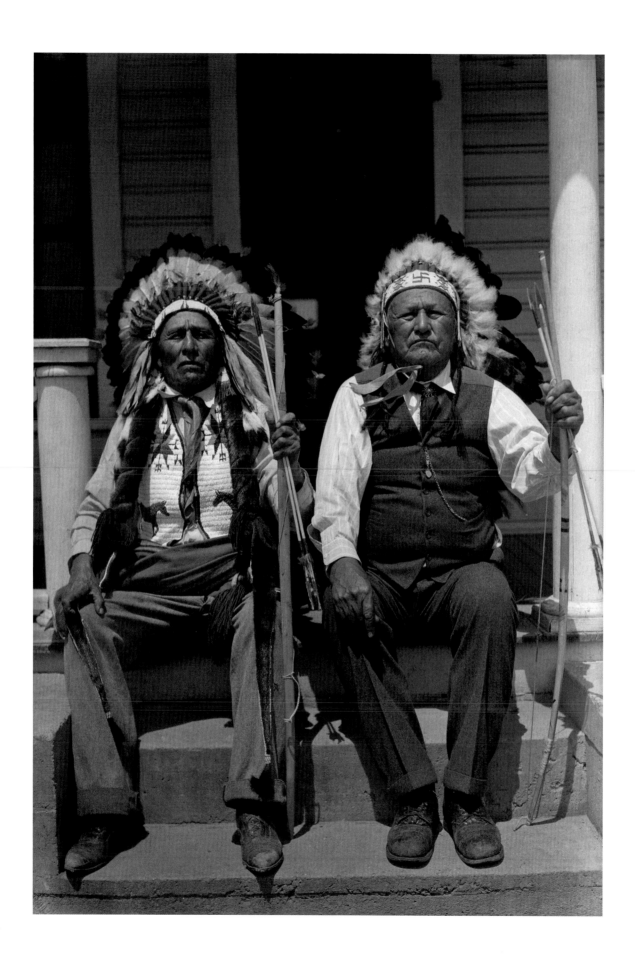

INSIDER KNOWLEDGE

TOM JONES

HORACE POOLAW'S CAPACITY TO RECORD THE INTRICACIES of modern American Indian life with his camera is an enduring gift to the world of photography and to Native America. As a photographer with insider knowledge of Kiowa culture, he was simultaneously a spectator and a participant who offers the viewer a unique vantage point from which they immediately become part of the photographic moment. Poolaw was a witness, accurately recording the ever-adapting ways of American Indians in twentieth-century Oklahoma.

Culturally, American Indians approach situations with rules that they must follow; it is inherent in our lives. When I was asked to write about Horace Poolaw with regard to my own work and experience, I immediately froze. Speaking about oneself is not a Ho-Chunk trait. We are taught to be humble. This hesitancy to talk about myself is something I struggle with in my career as an academic and one that I must face as I write this essay. This internal dialogue is common among many American Indian professionals whose work involves sharing their culture with a public audience. Since I was young, my mother, JoAnn Jones, has asked me, "What are you going to do with your life in order to help others?" This perspective considers the whole community and not just the individual.

As I began to write this essay, though, I was struck by the similarities that Poolaw and I share in maintaining a relationship with our communities and their needs. I first became familiar with Horace Poolaw's work while doing research in graduate school at Columbia College. As a Native photographer, I had very few role models who reflected my values and perspectives. At this time in my career I was beginning to photograph my own tribe, and Poolaw's work inspired me. His documentation of his own and neighboring tribes gave me the motivation to continue my work. Since then, I have photographed my own community, concentrating first on the elders, followed by veterans, children, families, historical reenactors, and gatherings. I have always aspired to serve my community in my work; Horace Poolaw's commitment to his own stands as a model for other Native professionals.

Significantly absent in both of our work is the representation of ceremony. For Native photographers, it is important to know and respect the limitations of what is acceptable to photograph. "Generally, my father said that he was never refused a picture," observes Linda Poolaw, Horace Poolaw's daughter, "and he had enough sense not to take a picture during certain ceremonies or rituals."[1] This cultural sensitivity is another trait common to American Indians working in their own communities. It is essentially more meaningful to be a participant in than a documenter of a ceremony.

92. Left to right: Rainy Mountain Charlie (Kiowa) and Kiowa George Poolaw (Kiowa). Mountain View, Oklahoma, ca. 1930. 57FGC2

Historically, the relationship between Native Americans and photography has been complicated. But in Poolaw's work, the Native photographer and Native sitter collaborate. Artist and educator Gail Tremblay (Onondaga/Mi'kmaq) writes, "A Native photographer coming to image-making in this climate must ask, 'What shall I take pictures of, who shall I take pictures for, what will my images communicate to the world?' Every image a Native photographer makes relates and reacts in very complex ways to this history of forced assimilation, and to the history of images of Native Americans."[2]

Kiowa George Poolaw, Horace's father, was a respected Kiowa historian who maintained a calendar, known in the Kiowa language as *sái:cùt*, meaning winter marks or winter pictures.[3] Traditionally, Kiowa calendars consist of pictographs painted on buckskin as a means of recording significant annual events.[4] With Kiowa George, this record-keeping changed from drawings on hide to paper, and changed yet again as it passed from father to son. This time, through the modern technology of the camera, Horace painted with light to become the new visual historian of the tribe. The shift from painting with pigment on hide to creating images with a camera is a smoother adjustment than one might think. In taking up a new medium, Poolaw continued an age-old tradition of innovation practiced by Native artists throughout history. Legal historian Rennard Strickland (Cherokee/Osage) addresses the interconnectedness of art and culture, stating that "Native American art is an integrative social phenomenon, a complex creative collage of song, dance, ceremony, myth, prayer, and vision. The visible 'art object' is but a small part of this cultural experience."[5] "Properly viewed," writes educator Larry Abbott on the same theme, "Native arts should not be divorced from the complex totality of the *cultures* out of which they arise. At the same time, it must be remembered that the unmediated culture did not produce the artwork; an *individual* artist did."[6] It is intrinsic to American Indian life that the artist adapts to new mediums and makes them his or her own.

Many scholars stress the experiences of transition and assimilation endured by American Indian cultures during Poolaw's lifetime. This approach, however, fails to recognize that Indians have always been active participants in change, embracing the best of modern conveniences. Culture is never stagnant, but is constantly evolving and growing—and this is neither a negative nor a positive thing. My mother describes it poignantly: "As Indians we have not assimilated, we have adapted." In other words, we have not simply integrated ourselves into non-Indian society, but instead have adjusted ourselves both for survival and for the advantages offered by new technologies. Poolaw's images show members of his community incorporating these technologies on their own terms.

When I think of how innovative Horace Poolaw's work was as an example of constantly evolving traditions, I think most of my Cooka (Ho-Chunk word for grandfather, pronounced "choka"). My portrait of Cooka, *Jim Funmaker with Fawn Hide, 1999* (fig. 93), records the act of tanning a hide—a centuries-old practice. Cooka was a traditional Ho-Chunk who lived to be one hundred years old. He would often say to me, "I am still in Head Start," or, "I am always learning something new every day." I returned home from work one day to find him tanning a fawn hide. I took note of the tools he had assembled around it. There was the hide, stretched out on a plywood board, a crow bar, two sanders, a pot full of pig

brains, and an aerosol potpourri spray. He told me to rub the brains on the hide. As I did this I kept thinking, Why does he have potpourri? After completing my task, flies instantly covered the hide. Cooka casually picked up the can of potpourri and sprayed the hide, dispersing the flies. I looked back and forth between him and the hide in amazement. How had he ever figured this out? This was a wise man who in a very small way showed me the meaning of cultural adaptation.

John Szarkowski, former curator of photography at the Museum of Modern Art, spent his life questioning the definition of a photograph. "Is it a mirror, reflecting a portrait of the artist who made it, or a window through which one might better know the world?"[7] Horace Poolaw captured both qualities within his photographs. He gave us a portrait of himself and his tribe, allowing us to observe the visual evolution of the Kiowa in the twentieth century. Many photographers overlooked American Indian peoples during this period in history because they had adopted the mannerisms of other American citizens. Horace Poolaw opens our eyes to a unique section of American life and gives viewers a truthful look at American Indian life in Oklahoma. However, the photographic legacy that Poolaw created for his people extends far beyond his tribe and community; it affects all of Indian Country and the world.

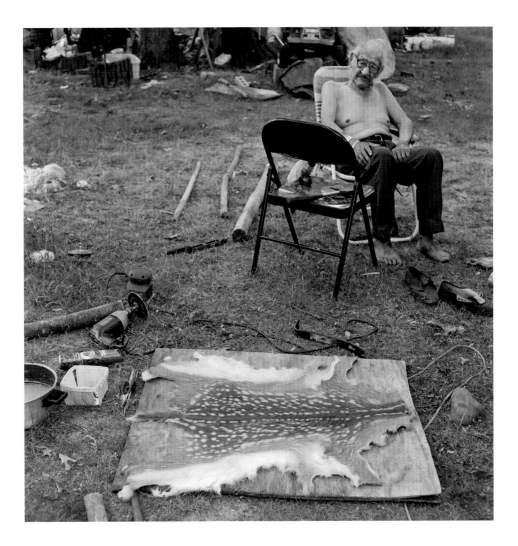

93. Tom Jones (Ho-Chunk, b. 1964), *Jim Funmaker with Fawn Hide*, 1999. Black River Falls, Wisconsin.

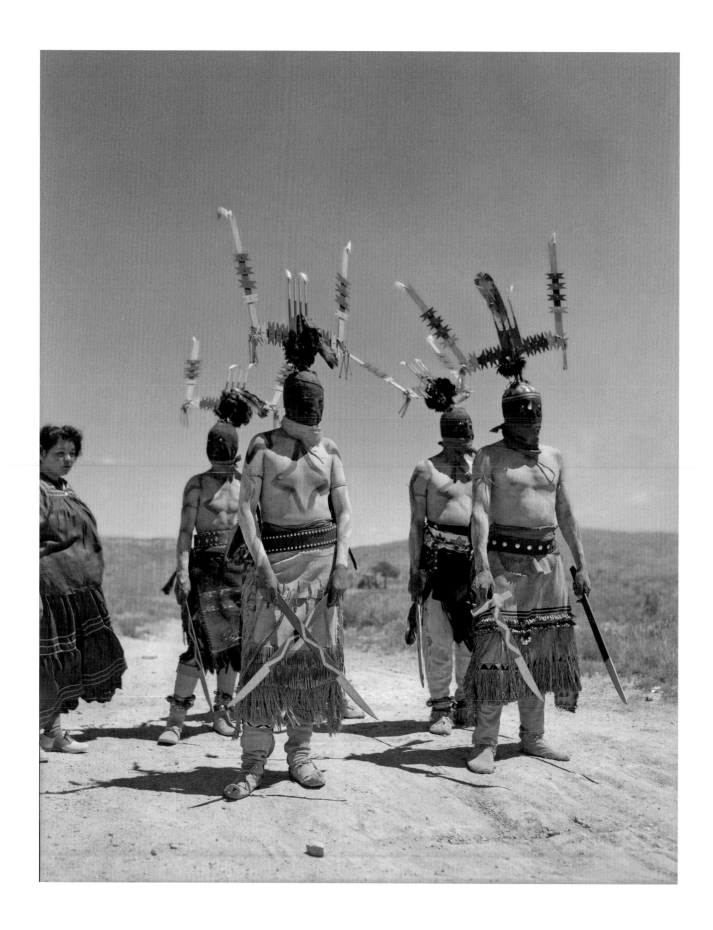

LEFT: 94. Apache Fire Dancers
at the Gallup Inter-Tribal In-
dian Ceremonial. Gallup, New
Mexico, ca. 1949. 45PWEG2

95. Fancy dancers at the Gallup
Inter-Tribal Indian Ceremonial.
Gallup, New Mexico, ca. 1949.
45LE52

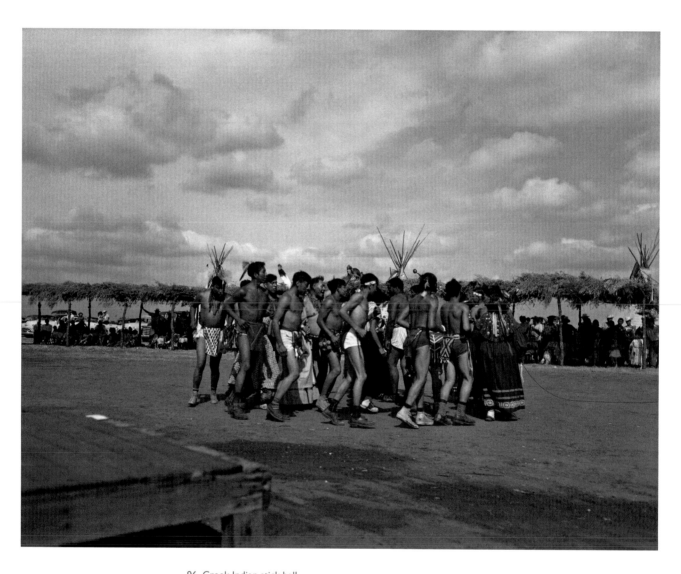

96. Creek Indian stick ball
players stomp dancing at the
American Indian Exposition.
Anadarko, Oklahoma, ca. 1950.
45PWEG27

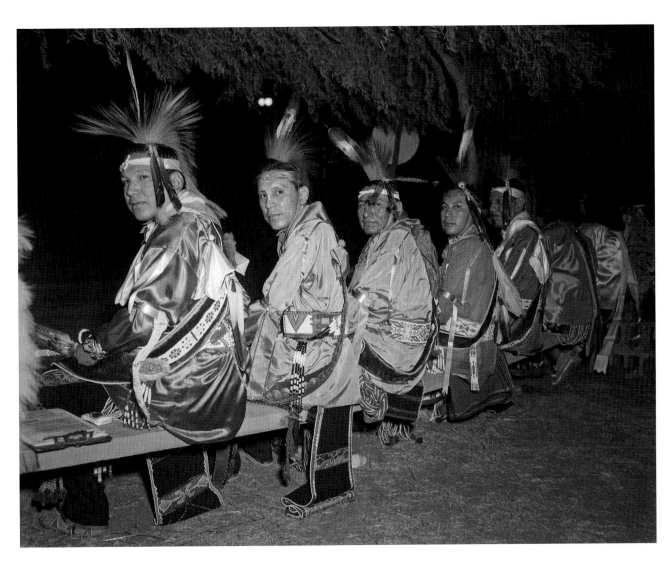

97. Osage dancers at the American Indian Exposition. Anadarko, Oklahoma, ca. 1952. 45PWEG14

98. Memorial Day at Rainy
Mountain Cemetery. Kiowa
County, Oklahoma, ca. 1927.
57RCEM13

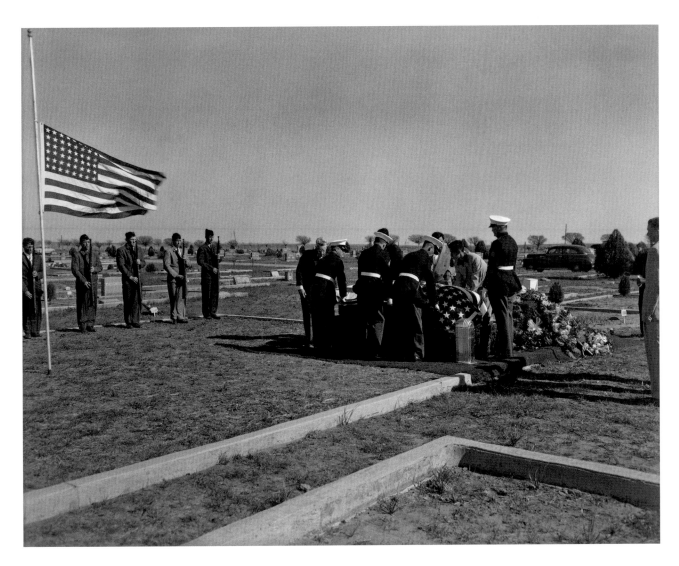

99. Funeral of Alfred Gene
Unap (Kiowa). Carnegie Cem-
etery, Carnegie, Oklahoma,
1953. 45UFN30

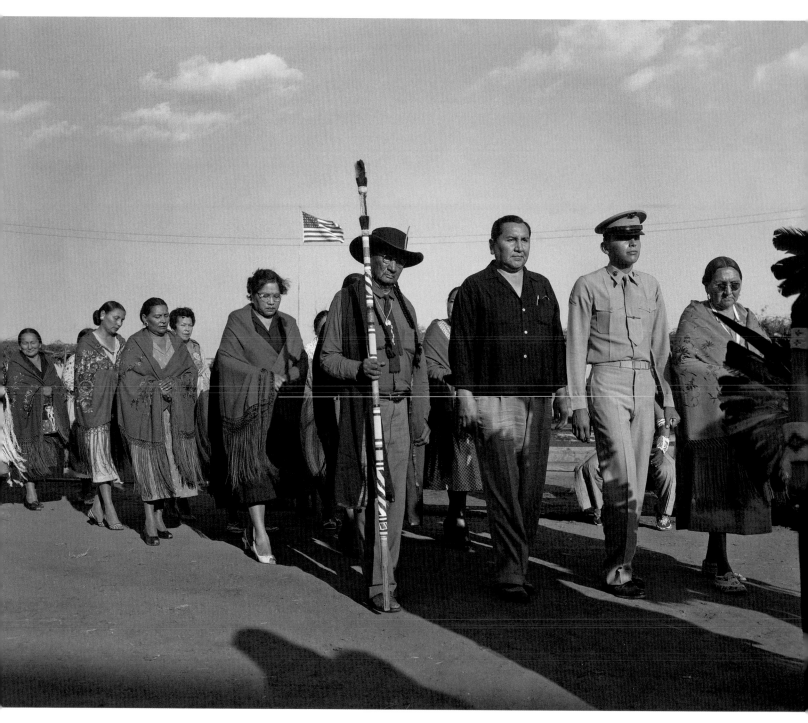

100. Honor dance for Arthur Unap, Jr. (Kiowa), during his leave from peace time duty in Guam. Left to right: Mary Big Bow Tartsah (Kiowa), Lucille Big Bow Poolaw (Kiowa), Pearl Big Bow Kerchee (Kiowa), (?) Ware, Lorene "Ella Faye" Horse (Kiowa), Abel Big Bow (Kiowa), center, carrying staff, unidentified, Arthur Unap, Sr. (Kiowa), Arthur Unap, Jr. (Kiowa), Agnes Big Bow (Kiowa). Anadarko, Oklahoma, 1958. 45POW93

BREAKING THE BOUNDS
OF DOCUMENTATION

DAVID GRANT NOBLE

ART HISTORIANS AND CRITICS often draw a line between documentary and art photography. Sometimes the distinction is legitimate and easily noted, as when the informational value of a body of work clearly outweighs artistic merit. Horace Poolaw was primarily a documentarian; his principal and invaluable contribution lies in the record he made of the everyday lives and evolving culture of his people. In some cases, however, the line between documentary and fine-art photography is blurred or vanishes, and the two traditions merge. This holds true in many Poolaw images.

In figure 100, the Kiowa photographer recorded a procession marking the homecoming of a soldier. The solemnity of the occasion shows in the facial expressions and somber clothing of the slowly moving participants, as well as in the seeming quietness of the scene. That's what is *happening*. Now look at how Poolaw composed his picture: the procession moves from left to right, as do the clouds and waving flag. The people's shadows, on the other hand, stretch from right to left. All these movements are grounded by the central strong, upright decorated staff, and, next to it, the flagpole and flag. These symbols of tribal and national authority also speak of stability. Clouds and shadow contain the image top and bottom, respectively. Note, too, how a woman in the background steps into the scene while a ceremonially dressed man exits in the foreground. They frame the side borders of the photograph and suggest that more is happening beyond our view. Poolaw's picture contains a future and a past, anticipation and memory.

Some of these compositional sensitivities also are present in Poolaw's photograph of the Inter-Tribal Indian Ceremonial parade in Gallup, New Mexico (fig. 101). Here are similar active elements: the parade marchers striding from distance to foreground while crowds of spectators gaze from left to right. To lend additional dynamism, Poolaw tilted his camera, throwing everything slightly off balance. Again, he included temporal and spatial anticipations and memories—people coming and going. Important, too, is the half-child at the right edge of the frame; her partial presence pulls our attention outside the image to the unseen. Poolaw extends our mind's eye and challenges our imagination. He also documents, at the center of our attention, a cultural surprise and puzzlement: a young girl wearing a feathered war bonnet, a headdress traditionally worn only by high-status adult men. In this detail, we also see what occupies the photographer's mind (and what he is known for)—the record of ever-shifting cultural traditions.

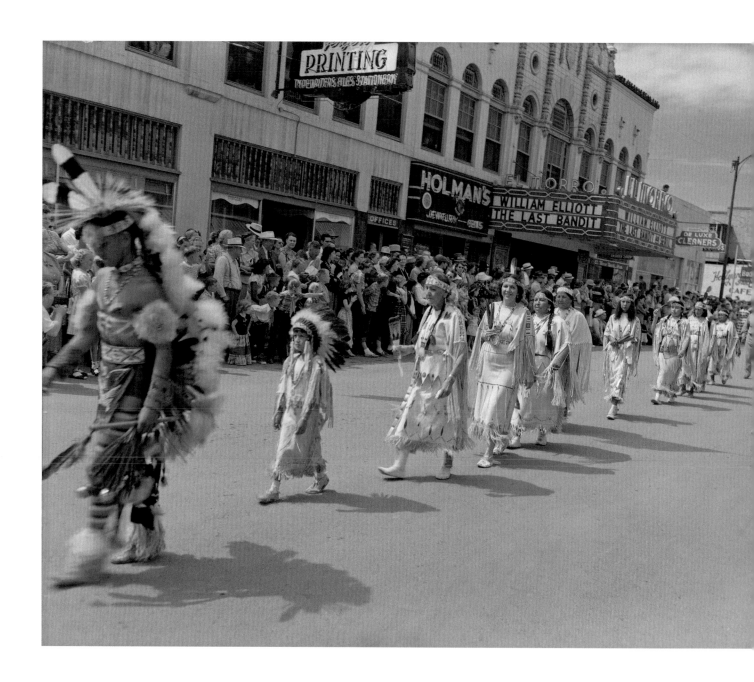

101. Marching in the Gallup
Inter-Tribal Indian Ceremonial
parade. Linda Poolaw (Kiowa/
Delaware), second from left.
Gallup, New Mexico, 1949.
45EP30

Perhaps in no other photograph do these compositional and dynamic elements come together more compellingly than in Horace Poolaw's picture of a horse race in Craterville Park, Oklahoma (fig. 82). The deep static shadow at the base of the scene lifts our attention to the action above it. At the same time, the shadow's edge, interfacing with full sunlight and streaking upward from right to left, creates a dynamic counterpoint to the full speed, left-to-right dashing of horses and riders. In its recording of a fast-moving scene, this photograph is a marvel of framing, timing, and control of light and shadow. We see in it the full breadth of Horace Poolaw's talent as both artist and documentarian.

102. Audience watching Old Man Whitehorse on horse at the Medicine Lodge Peace Treaty Pageant. Medicine Lodge, Kansas, 1941. 45LE4

103. Shalah Louise Rice Rowlan (Pawnee/Otoe/Sauk and Fox), left, war dancer in the American Indian Exposition parade, with her sister, Jessie Rice Tofpi. Anadarko, Oklahoma, ca. 1950. 45EP110

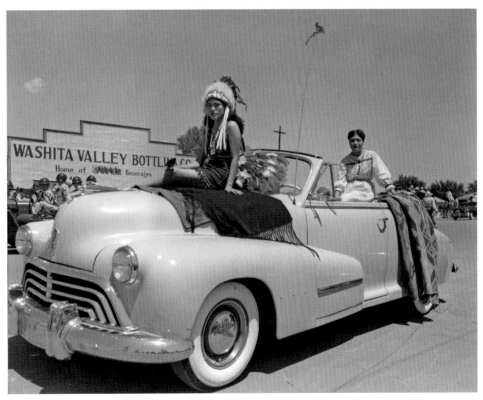

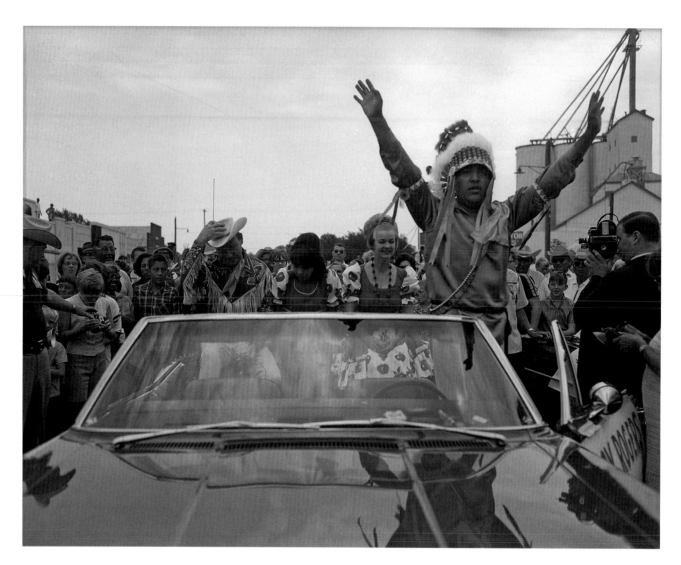

104. American Indian Exposition parade. Left to right: Roy Rogers (Choctaw), Maria Doty (Navajo), Dale Evans, Robert Goombi, Jr. (Kiowa). Anadarko, Oklahoma, 1967. 45PWEG37

105. Governor Johnston Murray, watching from the grandstand at the American Indian Exposition. Left to right: unidentified, Robert Goombi, Sr. (Kiowa), Willie Roberta Emerson Murray, Governor Johnston Murray. Anadarko, Oklahoma, ca. 1951–55. 45PWEG43

106. The first car in the Indian Expo parade. Left to right: Jasper Saunkeah (Kiowa) on horse; Robert Goombi, Sr. (Kiowa) seated in back seat, center; Red Bird (Cheyenne) holds lance adorned with eagle tail feathers. Anadarko, Oklahoma, ca. 1958. 45EP36

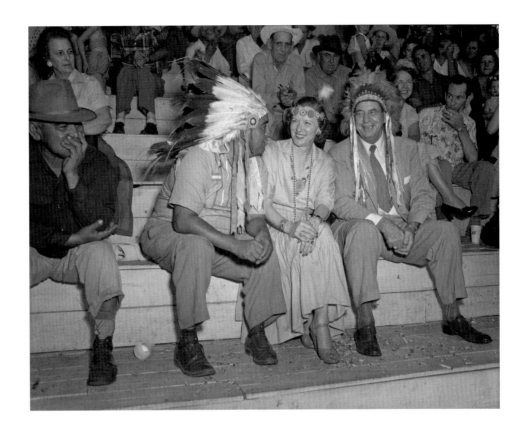

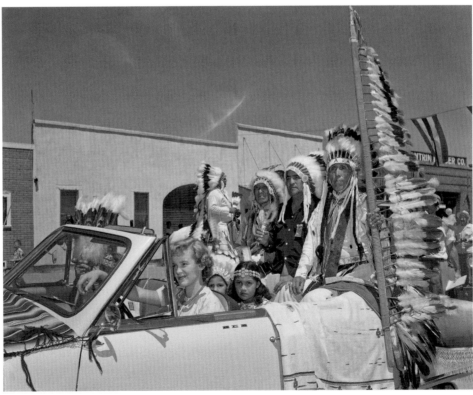

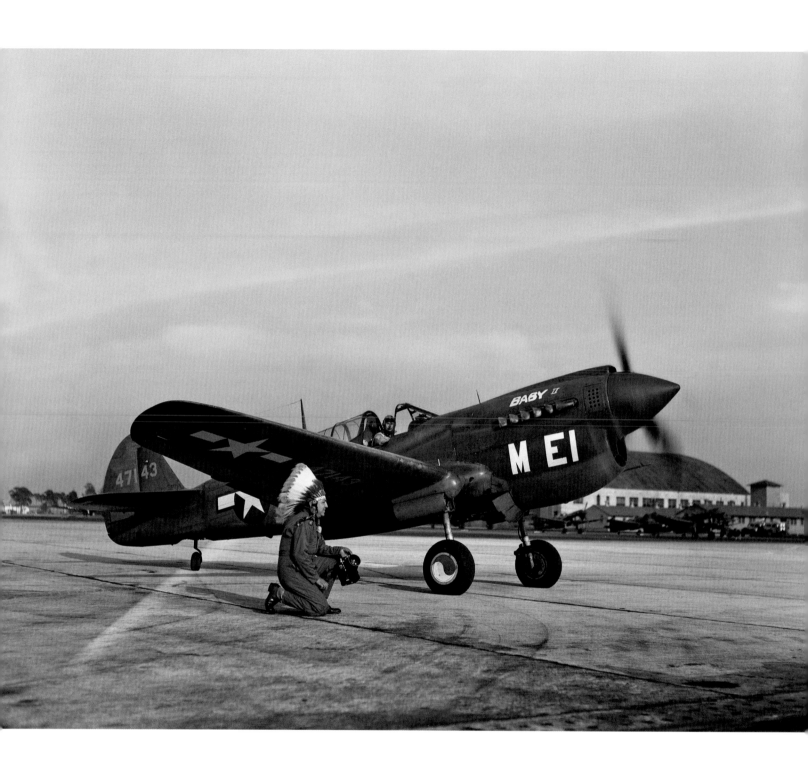

PLANES, FLAGS, AND AUTOMOBILES
Horace Poolaw's American Legacy

AMID THE BACKDROP OF ANADARKO'S CHARACTERISTIC ROLLING PLAINS, expansive skies, and bustling main street, Horace Poolaw created a unique photographic archive of American Indian life in the mid-twentieth century. Documenting the daily activities and special events in the lives of family, friends, and noted leaders, his vision was not only consistent but prescient and modern, blending symbolic representations of so-called tradition with equally symbolic representations of America at midcentury. In Poolaw's archive, performances of Kiowa identity are set against America's emergence as a global superpower, revealing a form of bricolage that is both empowering and instructive. Native and non-Native displays of life and culture reinforce one another in their borrowing, blending, and eventual transformation. His images offer a new way to visually understand the interdependence of American Indian and American culture while revealing Poolaw's intent to document American Indian patriotism.

A noted aerial photographer during World War II, Poolaw documented himself and other American Indian enlisted men at work at MacDill Field in Tampa, Florida, in the mid-1940s. In one photograph, he kneels in front of a P-40 Warhawk with the propeller whirling (fig. 107). Poolaw's profile stance, with camera in hand, is clearly meant to accentuate the majesty of the feathered headdress he wears and validate his role as an aerial photographer in the US Army Air Forces. In another image, taken inside of a B-17 Flying Fortress with side gunner Gus Palmer, Poolaw poses once again in a symbolic profile, asserting his place of belonging as well as his particular expertise (fig. 115). Inside the plane, he and Palmer—while operating the camera and gun, respectively—wear headdresses that complement the concentric bands of welded steel of the rounded hull. Poolaw's photographs at MacDill Field unify American Indian and American symbols of identity and pride in a remarkable claim for power and agency.

The American flag is visible in a number of Poolaw's photographs, whether at Indian Expositions, dance grounds, or funeral services for fallen soldiers. In his gleaming portrait of Carla Tahmahkera Wildcat, a Comanche princess at the American Indian Exposition, an American flag waves against a cloudy sky in the near distance (fig. 108). The smiling Wildcat is illuminated brightly by Poolaw's flash as she stands before a tipi, with various pieces of her regalia picking up the reflection of the flash. The flag is also seen draped over the caskets of fallen American Indian soldiers in funeral processions documented by Poolaw, including the funeral of Alfred Unap (fig. 110). Unifying American Indian and American symbols of identity, pride, and

107. Horace kneels in front of a P-40 Warhawk at MacDill Field. Tampa, Florida, ca. 1944. 45UFL59—A. H.

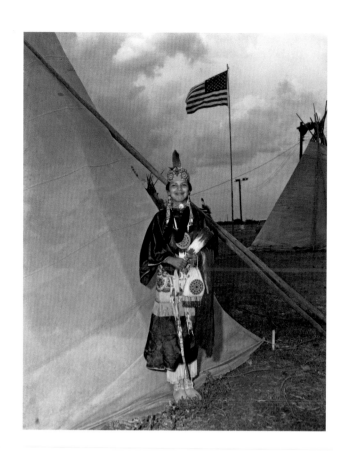

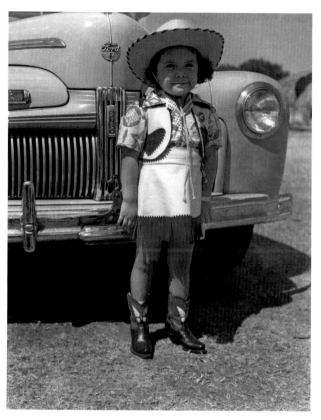

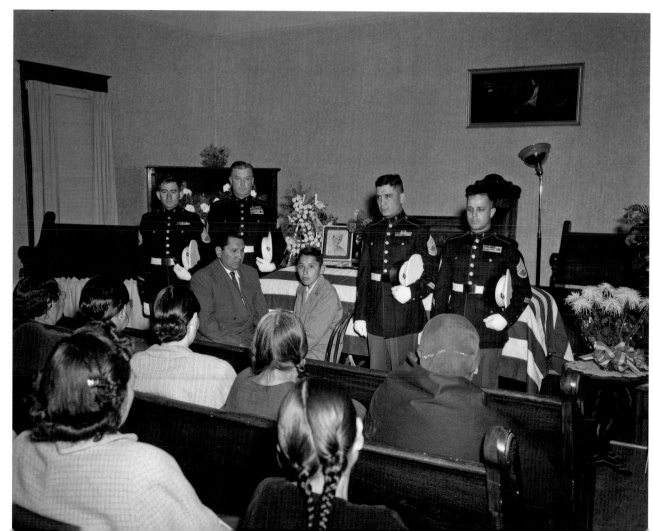

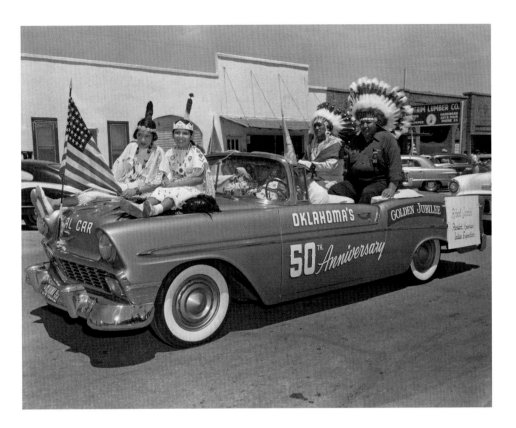

patriotism, these works also show the grief of war mothers, sisters, and brothers, and provide incisive contemporary commentary on historical and political relations.

The prevalence of the automobile in Poolaw's oeuvre cannot be overlooked. A recognized symbol of the American dream, by midcentury the automobile experienced a national, if not global, resurgence for its distinctly American design, marketing savvy, and manufacturing ingenuity. At times, Poolaw used the automobile as a prop or a backdrop for portraits, such as the one of little Vivian Big Bow posed in front of the grill of a Ford at the Indian Expo (fig. 109). More elaborate photographs of Expo parades in Anadarko show the automobile transformed: women pose on top of, almost accessorize, cars that also become highly decorated floats, a scene that borrows from both American Indian and American car iconography (fig. 111).

Poolaw's photography upholds a community both at home with and prideful of its culture, practices, and beliefs, while fully participating in mainstream American life. In these images, cars, headdresses, parades, tipis, flags, and military machines contribute to a visual legacy that challenges and changes perceptions of American Indians—and Americans themselves—at the mid-twentieth century.

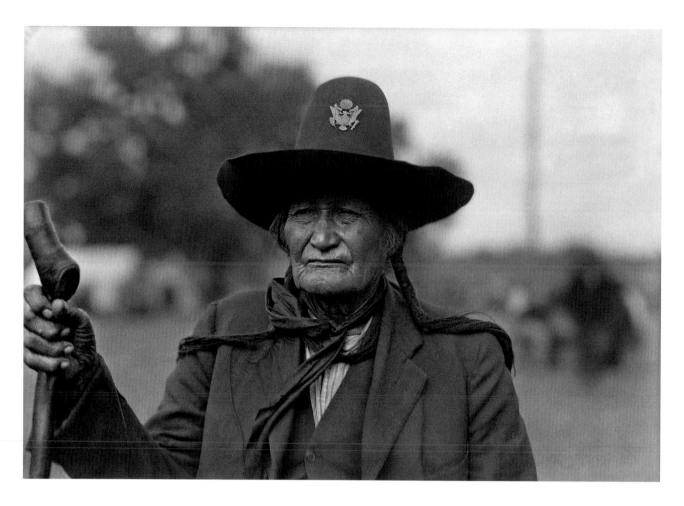

112. Unknown, possibly Kiowa George (Kiowa), with US Army emblem on hat, 1935–37. 57Z13 —L. P.

113. Giveaway honoring Pascal Cleatus Poolaw, Jr.'s (Kiowa), in uniform, on left, upcoming deployment to Vietnam. American Indian Exposition, Anadarko, Oklahoma, ca. 1965. 45POW32

114. Left to right: Irene Chalepah Poolaw (Kiowa Apache), Pascal Cleatus Poolaw, Jr. (Kiowa), and Pascal Cleatus Poolaw, Sr. (Kiowa), at the American Indian Exposition. Anadarko, Oklahoma, ca. 1950. 45POW36

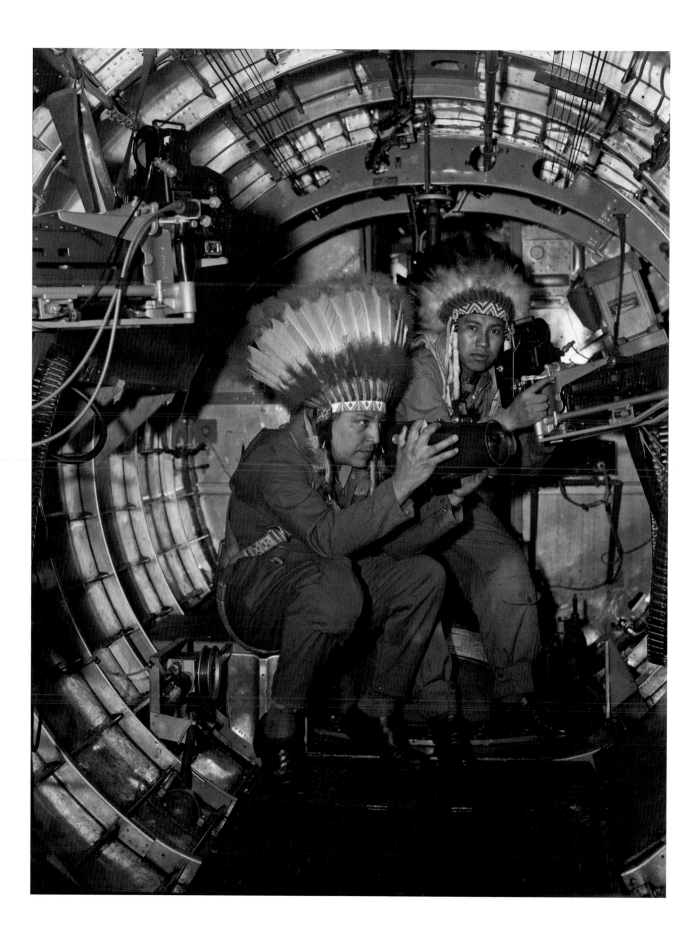

TRUTH AND HUMOR

115. Horace Poolaw (Kiowa), aerial photographer, and Gus Palmer (Kiowa), side gunner, inside a B-17 Flying Fortress. MacDill Field, Tampa, Florida, ca. 1944. 45UFL12—A. H.

IN 1943, POOLAW, THEN IN HIS LATE THIRTIES, enlisted in the United States Army Air Forces during World War II. He served three years as an aerial photography instructor at MacDill Field in Tampa, Florida. In this constructed photograph, Poolaw turns the camera on himself and fellow Kiowa Gus Palmer. Truth, humor, and stereotypes collide, as each man dons a jumpsuit and war bonnet for the camera, ready for warfare in the twentieth century. Poolaw and Palmer display the tools of their trade: the camera replaces the gun, the plane replaces the horse, and the jumpsuit replaces the leather leggings and breechcloth. Framed by the circular ribs of the plane's interior, Poolaw is intent on the sights of his camera in his hands as Palmer casually acknowledges the photographer. Each man, with his finger on the trigger, displays the newest instrument of warfare. This is not a contradiction but a reality for Horace Poolaw in his time; nevertheless, it is cloaked in humor.

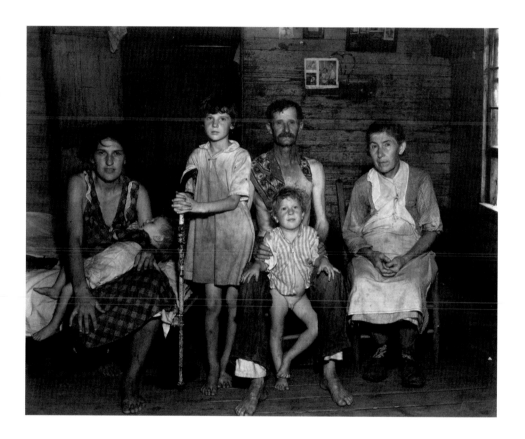

116. Walker Evans (1903–1975), *Bud Fields and Family in Bedroom, Hale County, Alabama*, 1936. © Walker Evans Archive, The Metropolitan Museum of Art. Image source: Art Resource, NY.

HORACE POOLAW'S PHOTOGRAPHY IS OFTEN REMINISCENT of the work of photographers for the Farm Security Administration (FSA), such as Walker Evans (1903–1975). It is unfortunate that the FSA did not use Poolaw's skills for its project, considering there are so few images of American Indians represented within the collection and Poolaw's style of photographing followed Roy Stryker's (head of the FSA's Information Division and creator of the documentary photography movement in that organization) philosophy of exposing honesty within the photograph.[1]

Poolaw was not living in a vacuum in Oklahoma; he was an avid consumer of images. In particular, we know he paid attention to the photographers of *Life* magazine. Nearly half of the sixteen photographers working for the FSA also worked for *Life* magazine. At the time, *Life* was generating tremendous interest in photography throughout the United States with its photo essays. Poolaw's daughter Linda remembers of her father, "He could not wait till the next issue would arrive."[2]

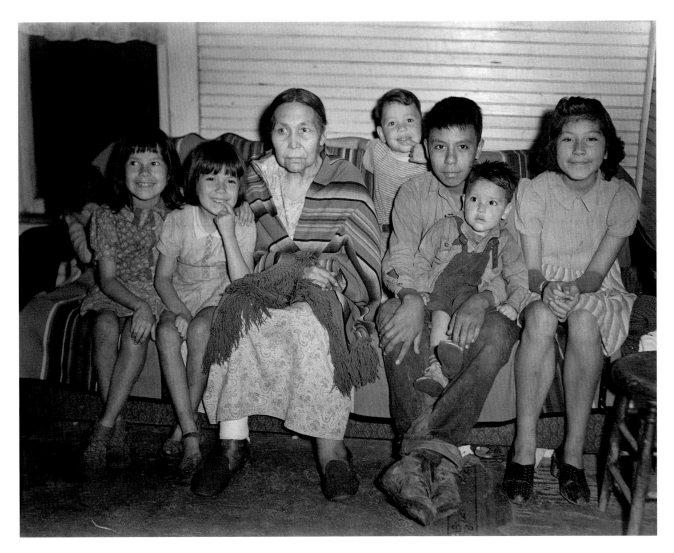

117. Family at their Mountain View home. Left to right: unidentified child hiding face, Margaret Paddlety Lewis (Kiowa), Patricia Paddlety (Kiowa), Dorothy Poolaw Ware (Kiowa), unidentified, Justin Lee Ware (Kiowa), Earnest Paddlety (Kiowa), Carol Paddlety (Kiowa). Mountain View, Oklahoma, ca. 1945. 45HPF183

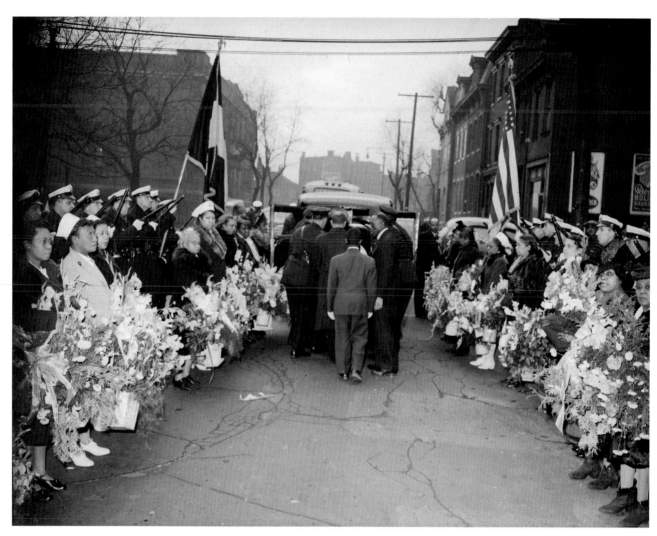

118. Charles "Teenie" Harris (American, 1908–1998), *Police officer pallbearers carrying casket from Ebenezer Baptist Church, with women holding flowers, and police officers with raised guns*, ca. 1944. Black and white, Ansco Safety Film, 4 x 5 in. Carnegie Museum of Art, Pittsburgh, Pennsylvania, Heinz Family Fund, 2001.35.31351.

POOLAW OFTEN CAPTURED HIS SUBJECT WITH ONLY ONE EXPOSURE, much like Charles "Teenie" Harris (1908–1998), who photographed his own African American community in Pittsburgh, Pennsylvania. Both photographers had a familiarity with their communities that contributed to their sure-shot confidence. "He would meticulously place people in as perfect a setting as possible," describes Linda Poolaw of her father's method, "then he took ever so long to make just one or two exposures. Years later, I finally realized that he took such special pains because he didn't have the means to use expensive film. His few exposures had to be perfect."[3] Photography then, as today, was not a cheap endeavor; it is a true gift that Poolaw continued shooting.

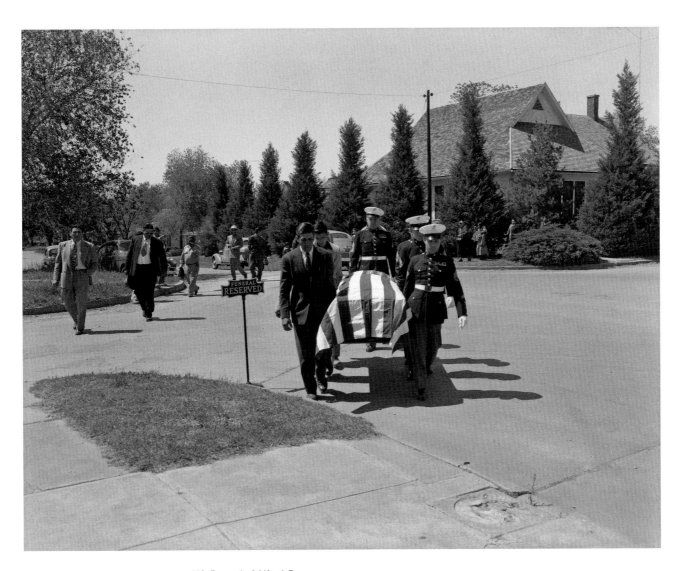

119. Funeral of Alfred Gene
Unap (Kiowa), walking toward
First Baptist Church on Carne-
gie Street. Carrying casket, left
to right: Justin Poolaw (Kiowa),
George Poolaw (Kiowa), three
unidentified honor guards.
Carnegie, Oklahoma, 1953.
45UFN27

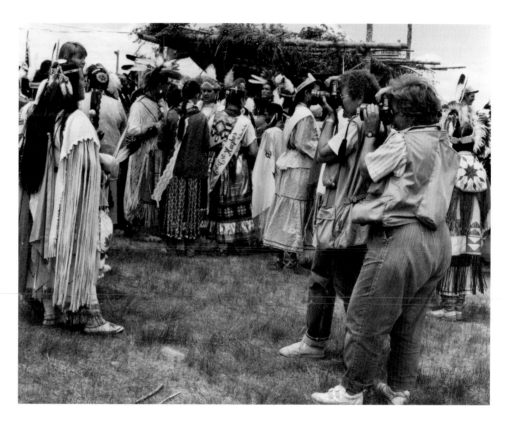

POOLAW WAS WELL AWARE of how the camera had affected American Indians throughout the history of photography. He critically exposed the insider/outsider conflict he observed, specific to Euro-American tourists who photographed Indians dressed in their dance regalia. Poolaw's photographs featuring non-Indian photographers, taken at Indian Expositions from the 1940s to the 1970s, poignantly document the process of representation by outsiders. The "Expo," as it is known today, is one of the few fairs managed exclusively by Indians and has a unique place in the history of Oklahoma.

In this scene, the non-Indian spectators stand or crouch on the left side of the image, pointing their array of cameras toward a small group of Indian children dancing on the far right. Poolaw chooses to point his camera at the spectators in the grandstands, which are filled to capacity. The crowd acts as a physical backdrop to the dancers. Native artist Zig Jackson, in his 1991 series *Indian Photographing Tourist Photographing Indian*, shows that the exploitation of Native people by intrusive tourists is much the same today as it was in Poolaw's time.

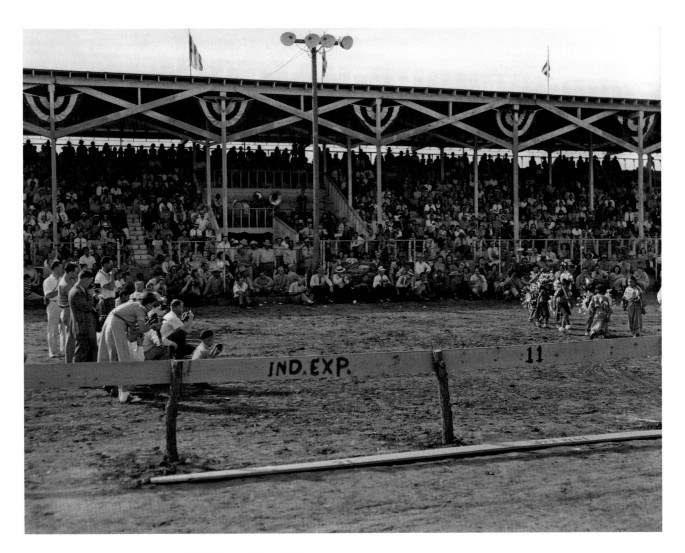

121. Photographers taking
pictures of children dancing at
the American Indian Exposi-
tion. Anadarko, Oklahoma, ca.
1950. 45EXP1

STYLISTICALLY, HORACE POOLAW'S PORTRAITS are similar in composition to those of his peer August Sander (1876–1964), a contemporaneous photographer who worked in Germany. Sander was interested in the human phenotypes of specific German working-class peoples and, like Poolaw, chose to depict his subjects within their environments. The similarities in posing are most obvious when considering Sander's photograph *Confirmation Candidate*, alongside Poolaw's portrait of an unidentified boy. The focus in these portraits for both artists is on the individual; the subject takes center stage and fills the frame. Each photographer employs a short depth of field in order to keep the viewer engaged with the subject, who stoically offers a direct gaze. While this approach blurs the details of the background, enough information remains to place the subjects firmly in the context of their environments.

The stereotype of the "stoic Indian" was perpetuated by photography, more because of the mechanics of the early large-format cameras rather than the sitter's race. In order for a photograph to be in focus, the sitter was required to remain very still for the long exposure in order to have the picture turn out sharply in focus. In his earlier work, Poolaw used a five-by-seven-inch view camera, which hindered a spontaneous portrait.

122. August Sander (1876–1964), Confirmation Candidate, 1911.
August Sander: © 2014 Die Photographische Sammlung / SK Stiftung Kultur - August Sander Archiv, Cologne / ARS, NY.

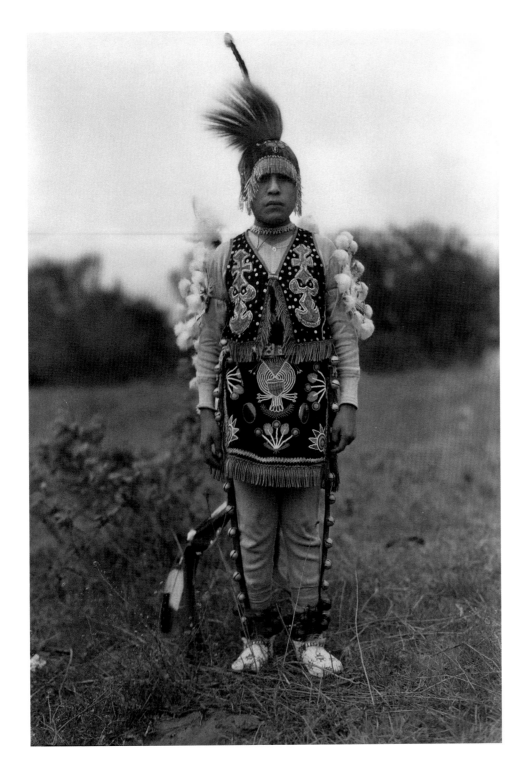

123. Unidentified dancer.
Mountain View, Oklahoma, ca.
1925. 57FPMC7

124. Howard Edwards (Delaware), Horace's brother-in-law. Anadarko, Oklahoma, ca. mid-1950s. 45HPF120

POOLAW'S INDIAN BRAND OF HUMOR spills over in the photograph of Howard Edwards. He is dressed in a double-breasted suit, a pair of wingtip shoes, and a hat. This scene is, for me, the epitome of a photograph that is absolutely Native thought at work. The average viewer would not know this person is Native; there are no stereotypical visual clues that identify him as such. The gesture of placing a handkerchief to his face heightens the obscurity of his identity. Looking through Native eyes, I see Indian humor and mischief at work in this photograph. He seems to be playing the part of Sendeh, a cultural hero of the Kiowa tribe. Sendeh is consistently depicted as a human—a man, not an animal form like that of the trickster in other tribal stories. Sendeh causes mischief, gets into trouble, and behaves in humorously inappropriate ways. He is generally a benign character that does not commit villainous acts and often helps the Kiowa people.[4] Poolaw uses his trademark on-camera flash to illuminate the subject in this act of mischief. Edwards seems to be caught off guard as he stands on a road against dark silhouetted woods. He sports sunglasses that remind me of the *Spy vs. Spy* cartoon characters from *Mad* magazine. I can only imagine the plan that had been hatched.

125. Bruce Poolaw (Kiowa) at the Medicine Lodge Peace Treaty Pageant. Medicine Lodge, Kansas, ca. early 1940s. 57FBCHN7

POOLAW'S PHOTOGRAPHIC ARCHIVE contains many photographs of his brother Bruce, a vaudeville entertainer known as "Chief Poolaw." Bruce married a fellow entertainer named Lucy Nicolar, a Penobscot Indian mezzo-soprano whose stage name was "Princess Watahwaso." Bruce Poolaw was a performer both in life and for the camera. In both of these images, he is positioned in three-quarter portrait style, wearing similar pinstripe pants and the same beaded garters and cuffs. In the first portrait, he reads as a nonchalant, dashing Hollywood movie star, adorned with a buffalo headdress. He stands in front of a tipi with his arms crossed, looking off into the distance as the sun sets. In the second photograph, he blatantly plays the stereotypes to an extreme; all the viewer can do is chuckle. He gazes directly into the camera, head tilted slightly upward, wearing a full-length feathered headdress. He is bare-chested, with his hands on hips, appearing to thrust out his chest and suck in his stomach while holding his breath. For many non-Indians, the act of Indian-playing-Indian complicates the negative stereotypes. Many American Indians throughout the United States at this time were playing into the stereotypes as a means of economic survival.

126. Bruce Poolaw (Kiowa), ca. 1928. 57FPMC11

127. Bruce Poolaw (Kiowa). Mountain View, Oklahoma, ca. 1930. 57FPMC16

128. Robert "Corky" Poolaw (Kiowa/Delaware) in eagle dance outfit. Anadarko, Oklahoma, 1955. 45HPF13

129. Medicine Lodge Peace Treaty Pageant. Left to right: Ernie Keahbone (Kiowa), Oliver "J. O." Tanedoah (Kiowa). Medicine Lodge, Kansas, ca. 1943. 45EXP11

130. Photographer taking
pictures of a group of Kiowa
dancers. Gallup, New Mexico,
ca. 1949. 45LE34

131. Lucy "Princess Watah-
waso" Nicolar (Penobscot) on
stage at the Medicine Lodge
Peace Treaty Pageant. Medicine
Lodge, Kansas, 1946–47.
57LE10

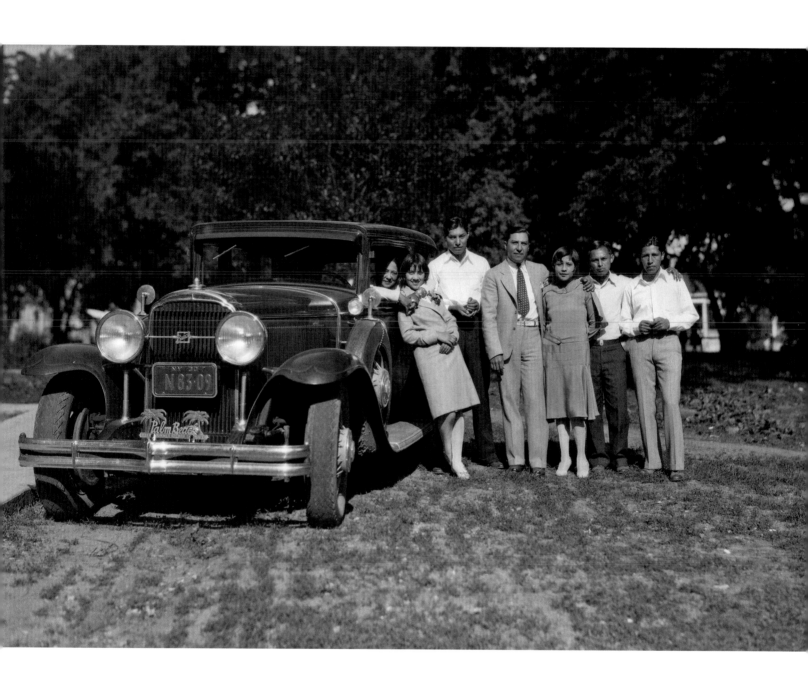

FANCY

JOHN POOLAW

WHEN I WAS TWELVE YEARS OLD, my dad took me to look at my grandpa Horace's photos in Anadarko, Oklahoma. This was in 1989, and it was the first time I had heard that my grandpa was a photographer. I was very young when he passed away, and I don't have too many memories of him. I remember seeing all the black-and-white photos laid out on several tables in the dining hall of the old Palomino Restaurant. There seemed to be thousands of photographs.

Probably because I was young, I didn't really grasp the importance of my grandpa's photos, and I mostly scanned through them, looking only for the ones where I recognized my grandpa, great-grandma, or my dad. I remember one photo, however, that made quite an impression on me, and I still love it today (fig. 132). This is the photo of my handsome Grandpa Bruce standing next to a car with a group of his good-looking friends.[1] This photo stood out from the rest because the Indians I saw were all finely dressed with slick shiny hair, creased trousers, tailored clothes, and crisp white dress shirts. Until I saw this particular photo, the only others I had seen of Indians were the occasional images in textbooks, which were most often boarding-school portraits in which the Indians always appeared to be sad and stiff. I enjoyed seeing my grandpa's photo of sharply dressed Indians by a shiny car—they all looked so happy. This really surprised me because I thought Indians of long ago were all sad and pitiful-looking. I remember thinking that this photo should be titled "fancy" because everything I saw in the photo exemplified what "fancy" meant to me.

When I was very young, my dad introduced me to old classic movies and musicals; I loved them. My favorites featured Judy Garland, Fred Astaire, and Gene Kelly. When I watched Gene Kelly and Fred Astaire in top hats, three-piece suits, and ties, dancing around with umbrellas in shiny patent-leather shoes, I knew that not everyone looked (or danced) like this. These films introduced me to a fantasy world where everyone wore the finest clothes and accessories; to me, this was what it was to be "fancy," and Gene Kelly was the fanciest of all.

That day, I asked my aunt Linda about this photo. She told me that the sharp-dressed man in the center was my grandpa's brother Bruce and that one of the men was the owner of the car, who all the girls thought was "just wonderful." I remember thinking that they were all probably dressed up to go someplace fun and that I wished I could have gone with them. I remember admiring my grandpa's suit and tie and how I wanted to dress like him when I got older, and I still do today. I remember wanting my hair to look like the men's hairstyles I saw—and I still try to emulate that style. I remember thinking, One day I want a shiny car, and for people to think that I am "just wonderful," too.

132. Lucy "Princess Watahwaso" Nicolar (Penobscot), far left, Bruce Poolaw (Kiowa), fourth from left, Justin Poolaw (Kiowa), far right, with friends at Pawnee Bill's Wild West Show, on their way to New York City. Pawnee, Oklahoma, ca. 1930. 57NY20 —L. P.

It wasn't until I was older and more educated that I learned what the terms "assimilation," "decolonization," and "transition" meant, and I realized that these "fancy" Indians were among the very first to wear and dress in such ways among their people. Despite the fact that these Indians all probably spoke their native Kiowa language and probably all still carried out traditional Kiowa customs, I found it even more fascinating that they were able to do so and look so care-free, confident, and elegant in adapting to their changing worlds.

I am now thirty-five with a professional career as an educator at a tribal college, and in my office I keep this photo in a silver frame next to my desk. It has been twenty-three years since I first saw this photo, and I now know what it's like to live a professional life in both worlds: the modern *and* the traditional one. Yet I still look at this photo daily and think how special it is to succeed in both worlds and still be "fancy."

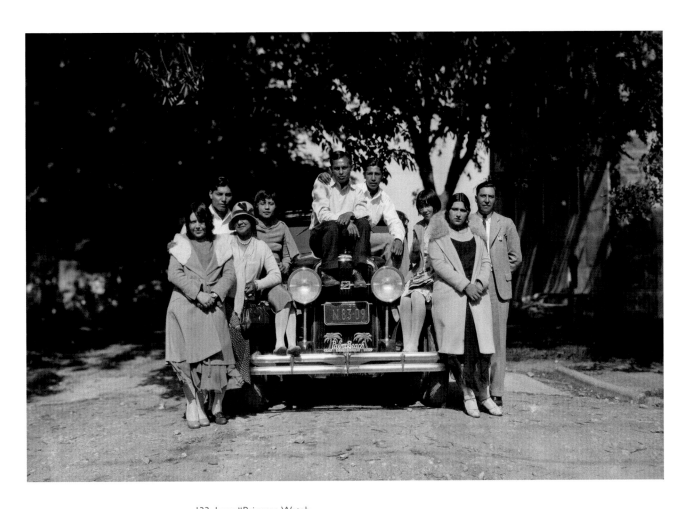

133. Lucy "Princess Watah-
waso" Nicolar (Penobscot),
third from left, Justin Poolaw
(Kiowa), center right on car,
and Bruce Poolaw (Kiowa), far
right, during a stop at Pawnee
Bill's Wild West Show, on their
way to New York City. Pawnee,
Oklahoma, ca. 1930. 57NY16
—L. P.

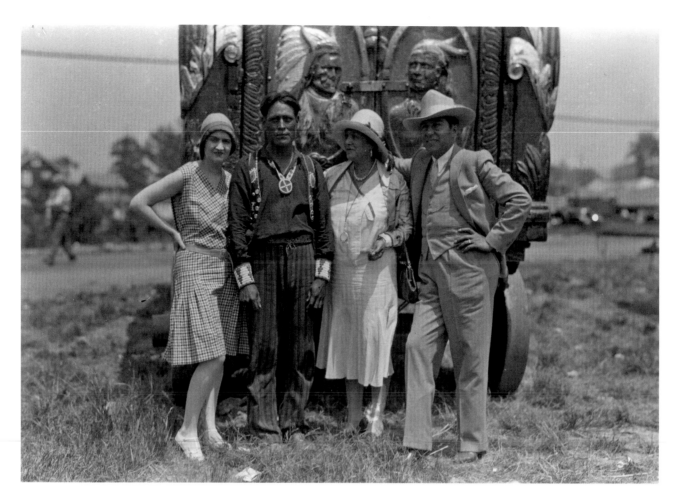

134. Group posing in front of a wagon at Pawnee Bill's Wild West Show. Left to right: two unidentified show performers, Lucy "Princess Watahwaso" Nicolar (Penobscot), and her husband Bruce Poolaw (Kiowa). Pawnee, Oklahoma, ca. 1928. NMAI P26506

135. Performers in Pawnee Bill's Wild West Show. Pawnee, Oklahoma, ca. 1928. NMAI P26505

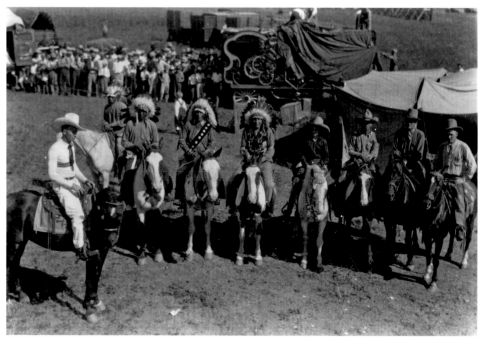

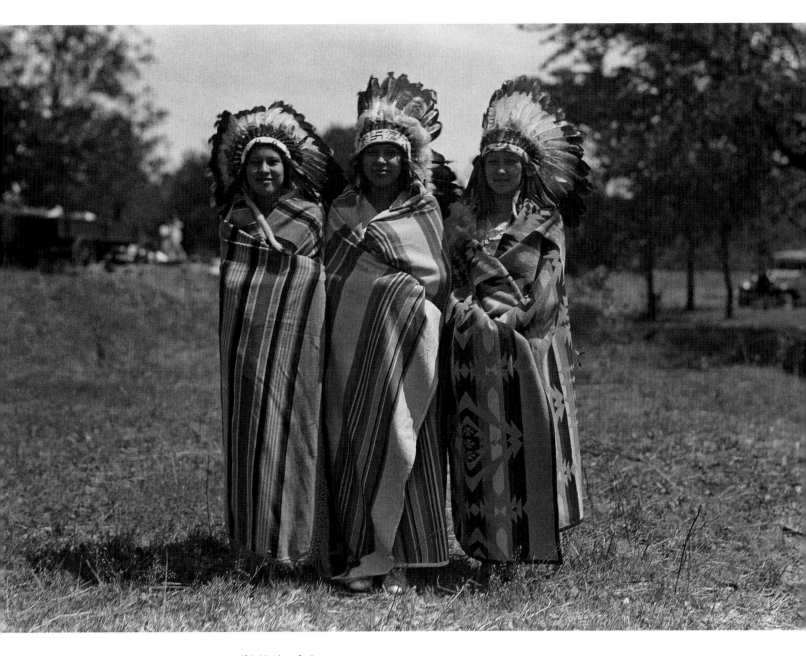

136. Unidentified women at
Pawnee Bill's Wild West Show.
Pawnee, Oklahoma, c. 1928.
57FGC7—L. S.

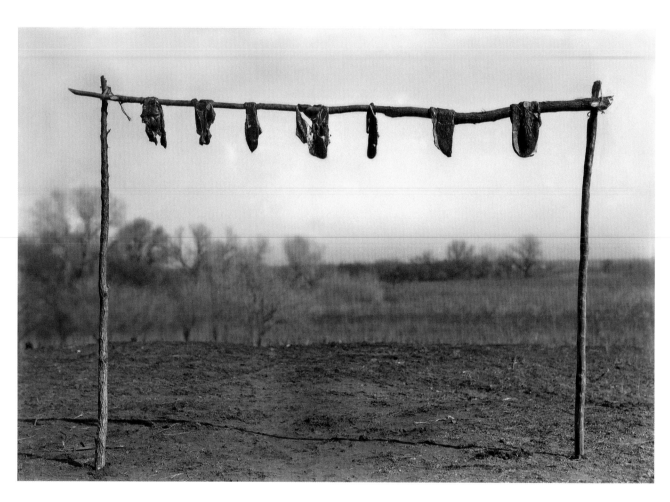

137. Dried buffalo meat. Mountain View, Oklahoma, ca. 1928.
57UM8

CITAPA:DAU.[1] THE KIOWA WORD DESCRIBES A TRADITIONAL RACK made of wooden poles, used for drying food. Horace Poolaw's photograph of the citapa:dau framing a sparse Oklahoma landscape pulls me into Poolaw's world at a fundamental level. Unlike most of his other work, this image contains no people, only the suggestion of human presence in relation to a physical structure long associated with survival—a simple construction for drying meat or other food for sustenance during times when fresh food would be scarce.

The photograph puts me in a memory stare, a meditative state that brings to mind people, places, events, and emotions. It pulls me through the frame to the unfocused landscape where I think through the ordinary, daily actions that ensure survival. The photo speaks to me both of hard times and of hope. It speaks to me of my own childhood. In my early years in Gypsy, Oklahoma, we had similar drying racks and used every available surface to sun-dry summer produce. My job was placing and attending to the strips of pumpkin that we dried on the roof of the lean-to kitchen behind our home. We dried meat and vegetables on the clothesline and on the fences. It was ordinary for us to preserve food in this way—ordinary and essential.

As a photographer, I appreciate this image for its stark simplicity. The drying rack delineates a rectangular structure within the camera's frame. The landscape is sparse but not empty, suggestive of mountains or something more in the haze. It invites imagination. Several years ago, I remember reading a series of articles about the health benefits of exposure to natural landscapes. Even viewing images of natural scenes produced a calming effect in study subjects.[2] I feel some of this while looking at the photograph, staring through the frame to the landscape beyond. It is meditative but also, in a way, mysterious. We don't know what these bits of dried meat represent—in terms of survival or cultural significance—to those who placed them there. Yet in the simplicity of the image I sense the spiritual component, the spirituality that is woven deeply through daily activities: cutting and drying meat, prayers, giving thanks for the sun and for the animals that offer sustenance.

The image shows a fragment of Kiowa history: a "seeing" toward the presence of what is unseen. It gives viewers their own turn-around space—space to find their own meaning. By using all of these frames of reference, I am inspired and moved to use my imagination and memory, my own associations and perceptions; I add my own overtones to the photo. It serves as a departure point for me to contemplate the referential quality of a real place—the importance of this particular place, this Oklahoma prairie, to the Kiowa people who chose this land.

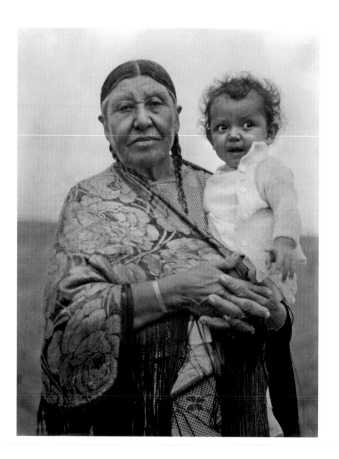

138. X<u>ó</u>:mà, Horace's mother, holding granddaughter Linda Poolaw (Kiowa/Delaware). Mountain View, Oklahoma, 1942. 45HPF28

Matriarch, timeless
Ancient like the earth herself
The mother of all mothers

She dresses us for ceremony,
For parades, socials, funerals
She teases us
She comforts us
She encourages us
She wants something good for us

The grandmother in Horace Poolaw's photo looks directly into the camera lens, confident, serene, at ease with the photographer and the photographer's mission. The impression is of a strong woman, her image an expression of humanity.

For me, in this image especially, it becomes clear that the photographer's role goes well beyond the recording of images. He is a participant in his own culture and known to those who appear in his photographs. The image illustrates an important difference between the photos that outsiders capture of Indian people and those made by artists or photographers who are of the same people as their subjects.

In my work as a photographer, my intention has always centered on the importance of interactions with my own people. My participation in their lives, and their participation in mine, provides a depth of relationship that can translate into photographic art. When I photographed the Indian people who were living on the streets of Oklahoma City for a series that I later titled *Street Chiefs*, I already knew many of the people whom I would ask to pause for a photograph (fig. 139). We visited. We laughed and sang. We talked of our home places and of our tribal affiliations and people. We talked of grief and joy. Those photos evolved as an extension of our relationships.

I can again recognize the importance of relationships in Horace Poolaw's photos, and that importance seems especially powerful in this image of a woman who is sure of herself and sure of her friend and relative, this photographer whom she trusts enough to share with him her honest, calm, and strong presence.

139. Richard Ray Whitman (Yuchi/Muscogee, b. 1949), *Street Family #1*, 1985. Black and white photograph, 6 x 9 in.

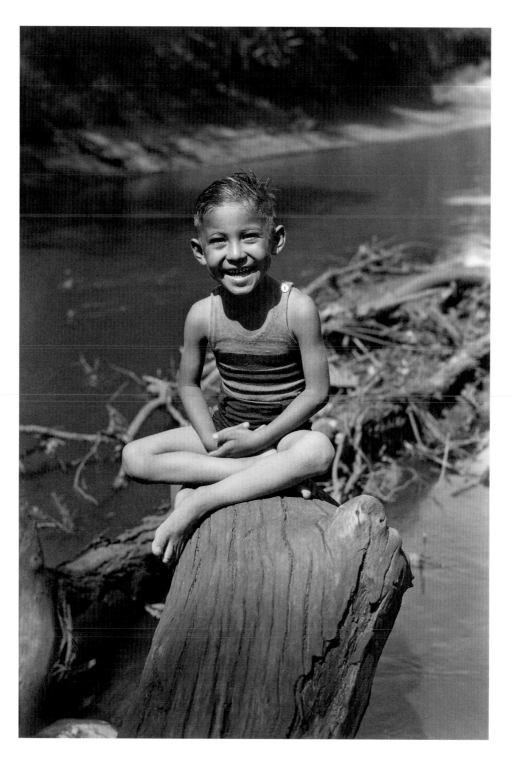

140. Horace's eldest son, Jerry
Poolaw (Kiowa), at the Washita
River. Mountain View, Okla-
homa, ca. 1932. 57FK14

141. Noble Starr (Kiowa
Apache), ca. 1930. 57HP42B

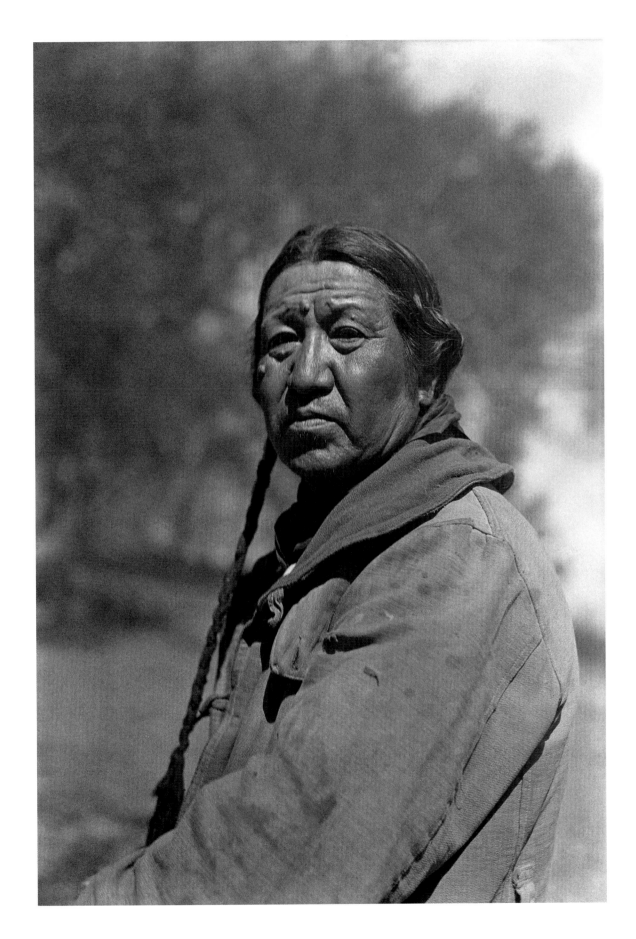

JUSTIN POOLAW COMES TO VISIT

<div style="text-align: right">VANESSA PAUKEIGOPE JENNINGS</div>

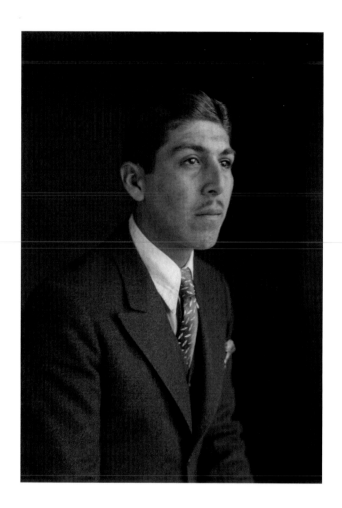

142. Pierce Justin Poolaw, commonly called Justin, (Kiowa), Horace's brother. Mountain View, Oklahoma, ca. 1929. 57FPN10

ONE DAY, MANY YEARS AGO, a beautiful visitor came to my front door. Her name was Martha Nell Kauley Poolaw. She commissioned me to make a beaded buckskin dress and leggings, which she would wear to honor her husband, Robert "Corky" Poolaw, a veteran. Kiowas have a strong warrior culture. Women used to dress to honor and reflect the status of the men in our tribe—this is an old custom that is slowly being forgotten. Before she left, Martha gave me a photocopy of the medals and ribbons awarded to her husband so that I could include them in the beadwork. This Marine was impressive. I considered the most important ribbons to be worked into beaded designs—the two Purple Hearts, the Bronze Star, and the Silver Star, all from his service during the Vietnam War. I prepared all of my buckskin hides, Czech-cut beads, and other supplies so I could begin my work. It is my custom to pray before I begin, so that night I said a short prayer and laid down to rest. I was happy; nothing tormented or worried me. I quickly fell into a wonderful deep sleep and began to dream.

In my dream, I drove west on the Indian road between Fort Cobb and Carnegie under a brilliant blue Oklahoma sky, golden sunlight falling on the fields of wheat. I rolled the windows down to feel the summer breeze blow across my braided hair. Suddenly, I came upon a man on the right side of the road, waving his hat and hollering for me to stop. I pulled my little black Chevy to a halt. I noticed what a dapper dresser he was as he leaned on my window to talk, wiping the sweat from his brow. Although I recognized his voice, I was having trouble seeing who it was. I leaned forward and asked, "Is everything all right? Do you need help?"

The middle-aged Kiowa man adjusted the sport jacket on his arm and answered, "No, no, everything is good. My brother and his wife heard that you are going to do some work for their son. They wanted me to talk to you. He is my nephew, you know." Then he chuckled and said, "Whew! It sure is warm today! Let me catch my

breath! I was afraid you would not stop." He pushed his hat back and wiped his brow politely with a handkerchief. As he leaned forward on the car window to continue our talk, I recognized him: Grandpa Justin Poolaw!

"What are you doing way out here?" I asked, surprised.

"Well, you see, it's like this: my brother and his wife wanted me to talk to you because I know you. We are very proud of their son. When you work on this dress, it must be the best that you can do. Don't rush or take any shortcuts. Do you understand?"

As I recognized Justin Poolaw, I also realized that the three people standing a short distance behind him were Mrs. Justin Poolaw of Mountain View, Oklahoma, talking quietly with Mr. and Mrs. Horace Poolaw of rural Anadarko. I drew a sharp breath and asked him, "How can this be? I went to your funeral!" I immediately found myself sitting upright and wide awake. Justin Poolaw had appeared to me as a whole and healthy middle-aged adult, although he had been sick and passed away years before. It was wonderful to see this witty and interesting man again. With such important spirits conveying the message, I knew I must do my best work.

In our Kiowa culture, the physical body is temporary; the spirit is eternal. It is something that we accept. Our veterans and relatives, present and past, are close to us all the time. Our songs and ceremonies continue to honor our warriors as they have for generations. Our elders, like Horace Poolaw, encourage the maintenance of Kiowa traditions, culture, and art, even after they have passed. I see the photographs of Horace Poolaw in the same light as our traditional art: they are a visual record to guide the generations of unborn Kiowa. Horace Poolaw witnessed a great loss of our material culture. Within his photographs, as I strive to do through my own art, he preserves the culture and traditions so that we may have them for the future.

Óbàhàu (I am finished talking)

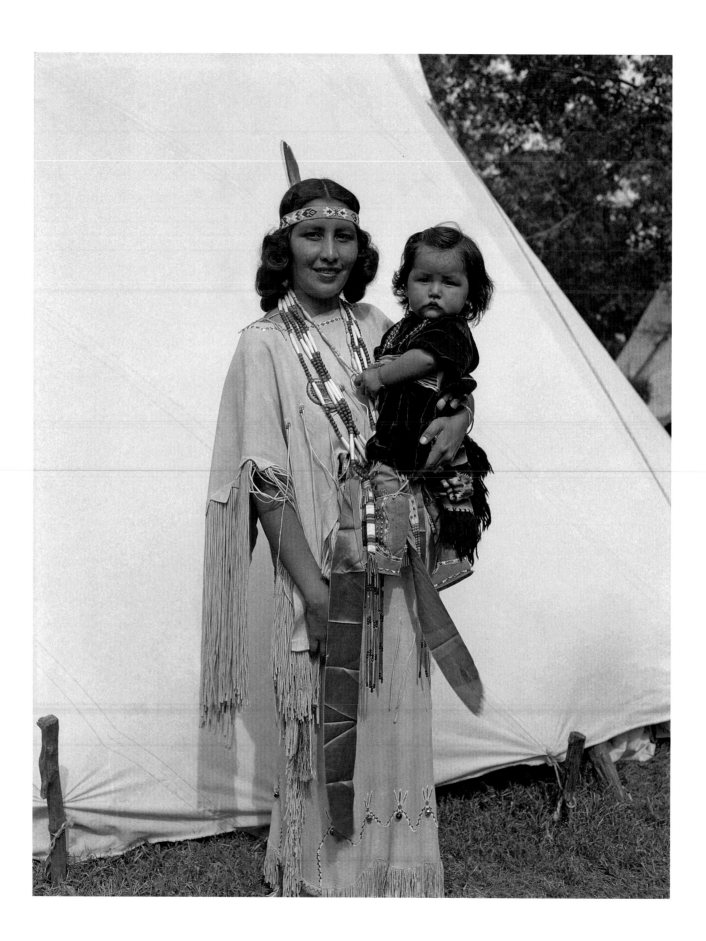

143. Lucy Whitehorse Beaver (Kiowa) holding daughter Donna Beaver (Kiowa). Medicine Lodge, Kansas, ca. 1955. 45LE40

LUCY WHITEHORSE BEAVER is wearing a traditional Kiowa beaded headband. An eagle feather, worn in the back of the headband, designates the wearer as an adult; a young girl would wear an eagle plume. This is an old Kiowa custom that has almost been forgotten with the incorporation of adornments such as the mirrors, rhinestones, and fourteen-inch beaded crowns that are worn at today's big contest powwows. Lucy wears a loop necklace made of bone and glass beads, and an exquisite beaded medallion necklace. She also wears a beaded pouch set, attached to the German silver belt and whip worn around her waist, that can be seen near the baby's knee. Her dress is made from five brain-tanned deer hides, with beaded lanes (narrow bands of beadwork) decorating the blouse and the skirt.

Baby Donna is wearing the most beautiful pair of leggings. The artistry and execution is the work of Lucy's mother, Maun-Kau-Guodle (Mable Hummingbird), Kiowa allottee 987,[1] born in 1886. Maun-Kau-Guodle was known and respected for her work among our Kiowas. The love for her daughter and granddaughter shows in her work.

—Vanessa Paukeigope Jennings

144. Dorothy Poolaw Ware (Kiowa) carrying son Justin Lee Ware (Kiowa) in a cradleboard. Mountain View, Oklahoma, ca. 1931. 57HP45A

IT IS OUR CULTURAL BELIEF that the greatest gift that God can give is life. That life is meant to be nurtured and protected. A woman will go without to make sure that her newborn or her children have food to eat and a safe home to live in. While a Kiowa man might use bois d'arc (Osage orange) wood to be made into a bow—an item that would be used to take a life from an enemy or animal—a Kiowa woman will take that same bois d'arc and use it in creating a cradleboard to honor the life of a newborn.

The making of a cradleboard begins with prayer. The tree is cut and the wood is prepared. The deer is killed and the hide scraped and prepared. Both actions require a promise that the lives of the tree and the deer will not be wasted. Both cutting the tree and shooting the deer are killing actions; the tree and deer give their lives to provide for a new baby. Also, if the infant dies, that cradleboard might serve as the casket. Your prayer includes the promise to use those two lives in a good way and not to waste them.

This is a photo of Dorothy Poolaw Ware carrying Justin Lee Ware. Dorothy wears a traditional Kiowa beaded-buckskin dress. Glass beads were made in Italy, France, England, and other countries in Europe. Traders imported them to Indian Country for sale to Native beadworkers. Cut beads from Czechoslovakia were, and still are, coveted by Kiowa families who commission these great works of art. These beads were reserved for use in important heirloom work, such as this woman's dress and leggings.

Our Kiowa culture teaches us that women are sacred vessels. They are taught that they are the link between the past and the future. Each one carries the destiny of an individual family and the songs, the culture, and traditions of unborn future Kiowa generations.

—Vanessa Paukeigope Jennings

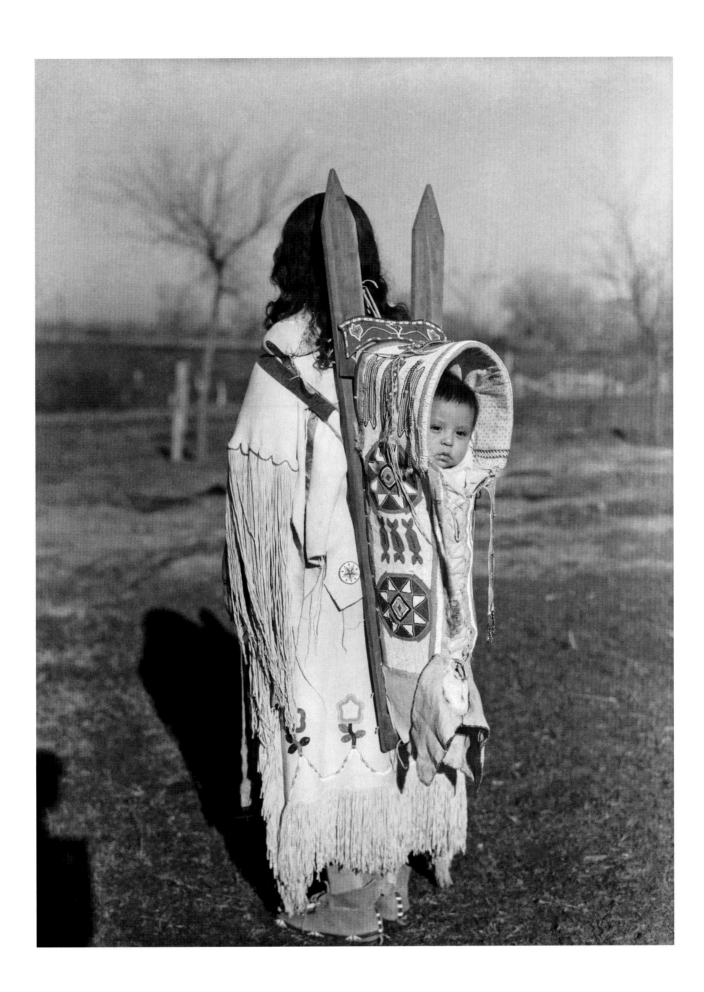

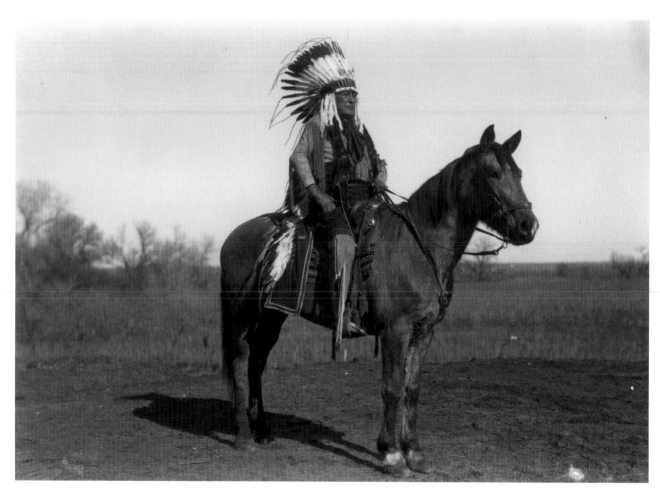

145. Cûifò:làu, or Kiowa
George (Kiowa). Mountain
View, Oklahoma, ca 1928.
NMAI P26503

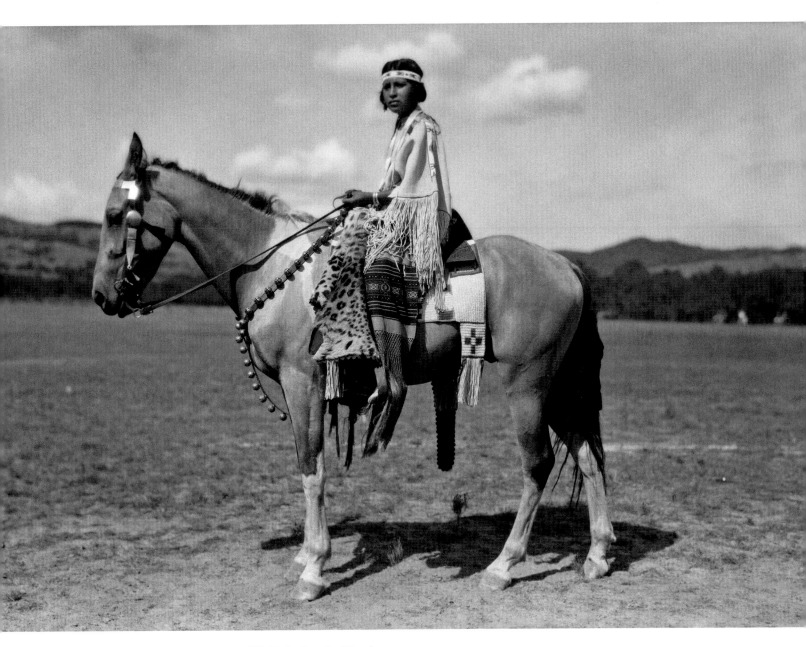

146. Gladys Komalty (Kiowa)
at the Medicine Lodge Peace
Treaty Pageant. Medicine
Lodge, Kansas, 1932. 57FPCW9

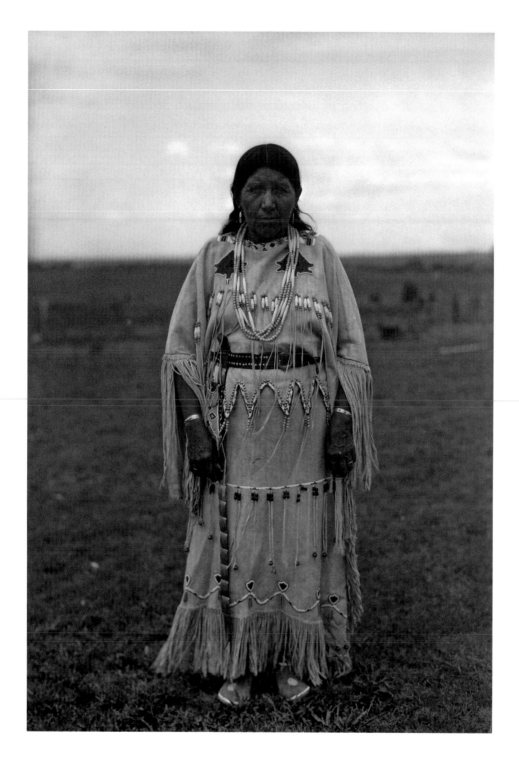

147. Tahdo (Mrs. Sam Ahtone, Kiowa), niece of Kicking Bird. Mountain View, Oklahoma, ca. 1930. 57FPCW2

148. Chief Frank Bosin (Kiowa). Anadarko, Oklahoma, ca. 1920. 57PC13

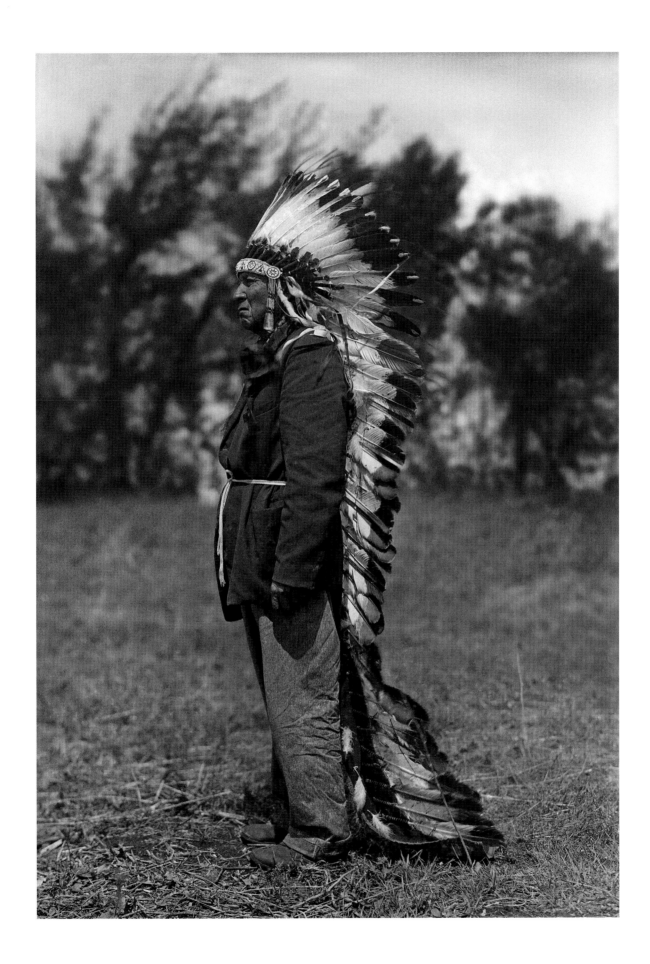

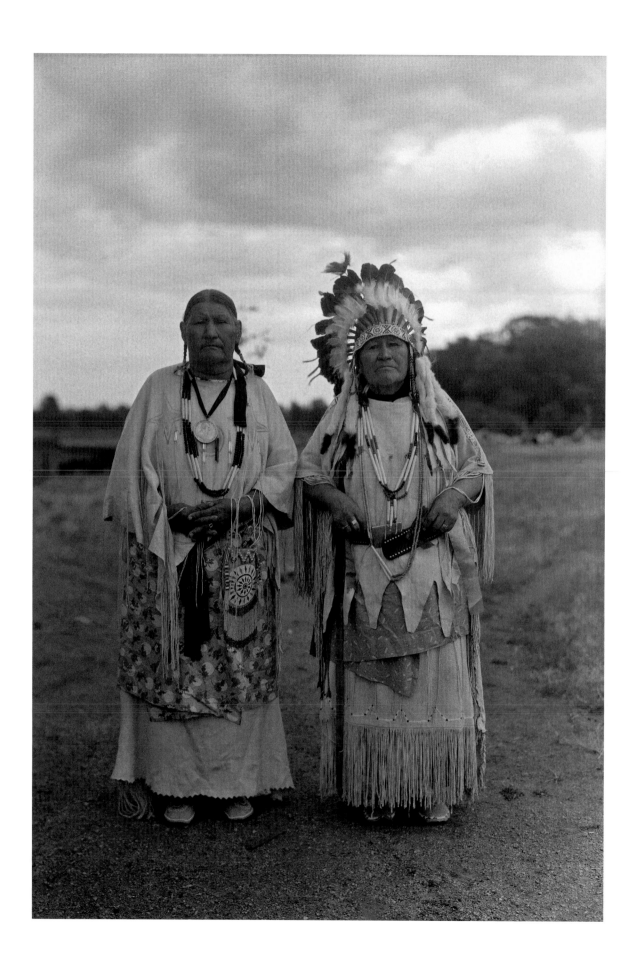

149. Left to right: Sau-to-pa-to (Mrs. White Buffalo) and Ah-tone-ah (Mrs. Unap), daughter of Satanta, both Kiowa, at the Medicine Lodge Peace Treaty Pageant. Medicine Lodge, Kansas, 1932. 57PC3

150. Robert and Ruby Botone (Kiowa). Medicine Lodge, Kansas, ca. 1945. 45LE44

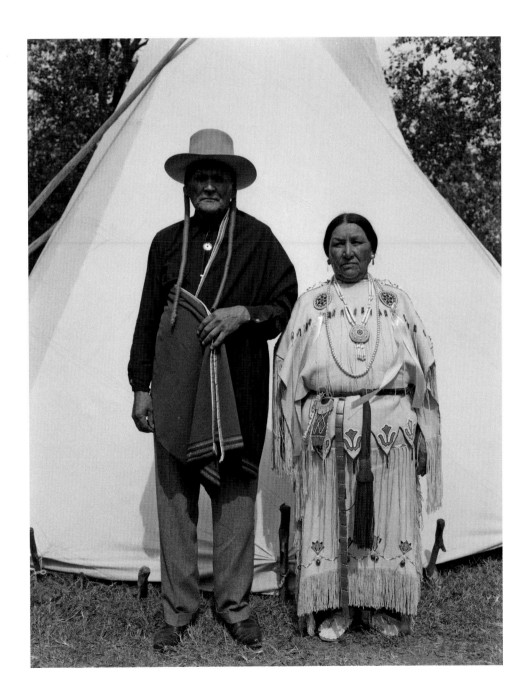

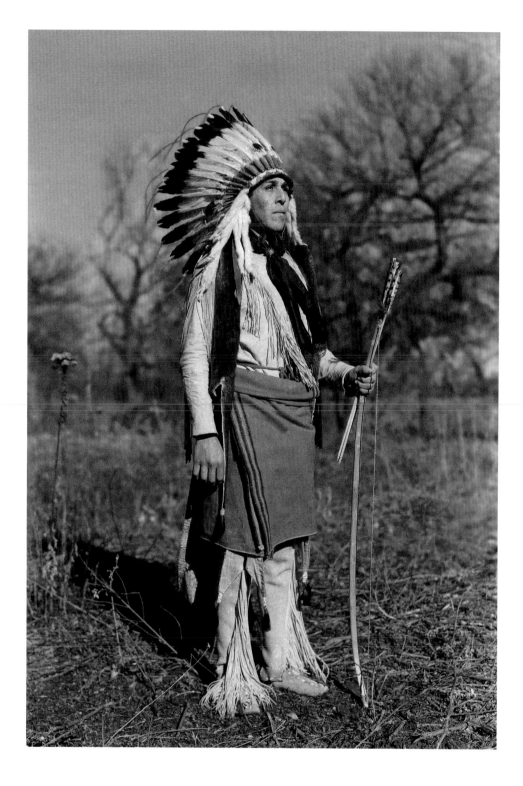

151. Justin Poolaw (Kiowa).
Mountain View, Oklahoma,
1932. 57FPMC3

152. Tom Poolaw (Kiowa/Dela-
ware, b. 1959), *Uncle, Grandpa*,
2010. Digital composition.

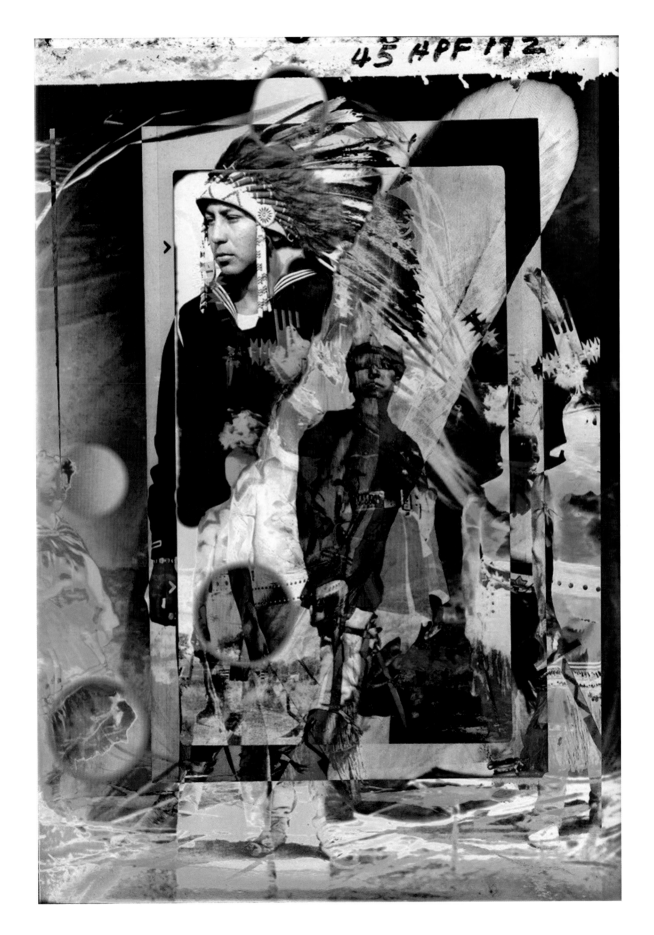

153. Robert "Corky" Poolaw
(Kiowa/Delaware) in the
garden with his mother, Winnie
Chisholm Poolaw (Delaware).
Anadarko, Oklahoma, ca. 1940.
45HPF11

THIS IS MY FAMILY

DANE POOLAW

TODAY, CÁUIGÚ (KIOWA PEOPLE) have less access to our own language than in previous generations due to its rapid decline in use. I estimate that between one- and two-hundred speakers remain, with varying degrees of fluency. Unlike the majority of the Kiowa speakers today, I have learned Kiowa as a second language, with English as my first. Because of this, I am just now beginning to understand why our Kiowa people say and do the things they do. It is this perspective that sets us apart culturally from any other people in the world. I also feel that I can express my feelings in a more straightforward and free manner in Kiowa. Although I still have much more to learn, I wanted to write this in Cáuijo:gyà (the Kiowa language) first, then translate it to English, to encourage Cáuigú and others who want to learn about their lineage and where they come from—it is definitely worth the time and effort. I have tried to put language, family, culture, art, and history all into perspective using my great-grandfather's photographs. Although these pictures only offer a glimpse of what happened at the time they were taken, each of them symbolizes so much more. The many individuals, families, and communities represented in these pictures reach beyond my own family; they will recall deep-seeded memories that future generations can share. I believe náu Tà:lí (my paternal great-aunt), Linda Poolaw, had this same vision to help all of our generations remember who they are and where they came from when she began to research her father's photographs. I wanted to do this in honor of all of my family for their foresight and the hard work they have done for their children, grandchildren, and beyond. I would like to give credit to náu Tà:cí (my maternal grandmother), Carole Botone-Willis, and náu Tà:lí (my paternal grandmother), Martha Nell Kauley-Poolaw, for aiding me in writing the following essay, ensuring that the Kiowa language would be pronounced correctly, and for giving me more family background about the selected photographs.

É:dè Jépjè:gàu Né Dàu

Horace Monroe Poolaw êlfà:bí é̠ dàu gàu Fà:bô Cáuik̠àu. Tháukâui àn bá jò̠:gyà "Great-Grandfather" nè Câui èm jáu:êl é̠ dàu, "Big Brother" bá t'áukáui:jò̠:gyà. À ì:váu:gyà:chàn è̠ hègáu hé̠: gyà dáu: áuhyáu:dèfè:dò háun é̠ hài:gàu. Hégàu òbâui:ètjè cút gyà áu:mè gàu gyát tò:dàu. Áu:gàu kó̠:hyò̠i ét cyái:bàjàu gàu ét áu:gyàdò. À tàlí:dâu: è̠ hábé:kì, àn gyát fó̠:àu:màu. Jó:cyà à qíá: è̠ náu êlfà:bí cútqàu, nàu jékì án gyà bónmàu.

Bà áun, náu êlà:byôi sáu:jègyà gyà sáu:mì nègáu náu ál é̠ tén:àumgyà étjè yá̠ hái:dèthàu. Sáut yá̠ hài:gyà, bétàu, áu:gàu Câuiqyàcòmdà gyà có:dó sàu:mìhêl. Kó̠:hyò̠i gàu étjé qyácômbàu á cùt, dè, háun náu hái:gàu. Áu:gàu sà̠:dàu étjè é gút nàu é:hàudèkì kó̠:gyóp gàu tà̠:cyòp á syán è̠ dé bò̠:. Hàundé è̠ há:vè. êlfà:bí étjè sáu:jègyà yán bó̠: nàu gyà có:dó sàu:mì áuihyàudèfè:dò é̠ ténàumgyà. Náu àl áupfáhàu: gyát máuhêmjàu bà áu:dèp. êlfà:byôi sáu:jègyà héjàu yá̠ hài:dèhàu gàu à sáumdàu. É:dè náu qyácômbàu né dàu.

À̠:kó!

Étjé Câuibì̠:dàu màuxá̠i:fà á cùt, áufáuhàu náu êlfà:byôi tà:lì ál cút, Cá̠u:ánàunjè Câuik̠àu:gyà án dàu:me (fig. 154). Có:bèmà dáu:mê gàu étjè á sà:dàu:mê. Jó:fá á̠:gyà gàu èm vé:báàumdò. Étjé tà̠u:jégyà án cò̠:dó sàu:mì.

É:dè náu kò̠:gì ák̠ò:jè á dàu gàu, Cûifòlàu: Câui k̠àu (fig. 155). Tháukâui háun gyá hái:gàu gàu háigyàhè̠ dáu kàum. Áuihyàudèfè:dò é:hàudèkì "Poolaw" è̠ k̠áu. Fá Câuigú "Kiowa George" àn á kàu:màu. M̠àyí kàulé:dè:dè átà:dè á dàu, X̠ó:mà k̠áu gàu náu kò̠:gí átà:lì á dàu. Cá̠u:ánàunjè ì:tà:dè dàu:mê. É:hàu è̠ Câui óibàjàu:dàu.

Náu tà:lyôidè á chàu:dè á dàu, Lucy Whitehorse Beaver k̠áu (fig. 156). Áuihyàudèfè:dò náu jàu:êl é̠ dàu. Á ì:tà máundò: nàu Donna Beaver k̠áu:. Câui èm náu tà:lí ál é̠ dàu:.

Étjè háun Câuigú á dàu:màu dè àl á cùtqùl. Á fà:bìdè tà: jáu:êl é̠ dàu, Á:dòmdèmà dáu:mè (fig. 153). É:dè náu jáu:êl gàu náu kò̠:gí, tàlí: dàu è̠ én é:qùtjàu. Á:dòmdè qyàcômbàu àn gyá è̠:qùtjàu dè, cháu á:dòmdètháu:gyà gyà dàu:.

É:gàu náu jèpjègàu náu dàu: gàu dè jétfátá:gù. Háyátjò cút bá bò̠:jàu gàu jépjégàu gàu có̠:bàu bét áu:gù:jàu, dè à áundàu. Cháu à áu:dèp.

Óbàhàu.

BOTTOM RIGHT:
156. Lucy Whitehorse Beaver (Kiowa) holding daughter Donna Beaver (Kiowa). Medicine Lodge, Kansas, ca. 1955. 45LE40

154. Cáu:ánàun (Goose That Honks), Horace's grandmother. Mountain View, Oklahoma, 1928. 57F2

155. Cûifò:làu (Kiowa George) and Xǫ́:mà (Light-Complected Woman), both Kiowa. Mountain View, Oklahoma, 1928. 57FGC4

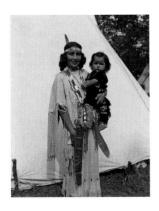

This Is My Family

Horace Monroe Poolaw is my Big Brother, and his Kiowa name is Fà:bô (American Horse).[1] In English we would say "great-grandfather," but in the Kiowa way he is my J̲áu:êl, or Big Brother. When I was born, he was already gone, so I never knew him. He took many photographs and left them behind with us. My family holds them in high esteem and keeps them protected. As a boy, sometimes my family would show the pictures to me. Every day growing up, I would look at the picture of my Big Brother that hung on the wall in my house.

I always thought my Big Brother's work was very interesting, and wished to learn more about it. I have only just begun to learn how captivating our Kiowa people really are. There are family members and many people in his photos whom I do not know. He took numerous pictures of his own children so that today I can see my grandfathers and grandmothers when they were young. How adorable they are! I have seen much of his work, and it is incredibly fascinating. For this reason I want to follow it and to understand it more fully. I feel I will learn much more. I am still learning more about Big Brother's work and am greatly interested in it. This is my family.

A̲:kó!

There are many elder Kiowa people in his photos. Here, my Big Brother took a picture of his grandmother (my great-great-great grandmother). Her name was Cáu:ánàun (Goose That Honks) (fig. 154). She was a captive and was very old when this was taken. She is sitting by the house and smiling. She has a very interesting story.

This is my grandfather's grandfather, and his Kiowa name was Cûifò:làu (Mature Wolf) (fig. 155). White people did not know his name, and those who did mispronounced it. Because of that, our family is named "Poolaw" to this day. Some called him Kiowa George. The woman standing with him is his wife, Xǫ́:mà (Light-Complected Woman). She is my great-great-grandmother, and she was the daughter of C̲áu:ánàundè. They are both dressed as Kiowas.

Here is my paternal grandmother's aunt, Lucy Whitehorse Beaver (fig. 156). That would make her my Big Sister (and Kiowa "great-grandmother"). She is holding her daughter, Donna Beaver, in her arms. In the Kiowa way, she is my paternal grandmother.

There were others who were not Kiowa who were also pictured in the photographs. According to Kiowa custom, my Big Brother's wife, Winnie Chisholm Poolaw, is my Big Sister (fig. 153). She was a Delaware woman. This picture is of her and my grandfather (Robert Poolaw, Sr.) tending to a garden. Delaware people were often gardening back then; that is their culture.

I'm speaking about my family. Maybe others will look at the pictures and find family and friends in them. It is what I am hoping. That is the way I am thinking.

That is all.

KIOWA NAMES AND THEIR PHONETIC SPELLINGS

Dane Poolaw, Kiowa language instructor at the University of Oklahoma, provided the names of the most frequently mentioned Poolaw family members in this book using the orthography, or style of writing language, developed in the 1930s by linguist Parker McKenzie (Kiowa). Additionally, to assist non-Kiowa speakers in how these names are pronounced, Poolaw has developed phonetic spellings for each. Because the Kiowa language contains consonantal sounds that are not found in English, Poolaw has indicated these sounds in the phonetic spellings with double consonants. For example, Pbah-bo begins with a consonant that combines both a "p" and "b" sound. In the same way, Kguwey-pbol-aw begins with a sound that combines "k" and "g."

Horace Poolaw: **Fà:bô** (American Horse)
Phonetic: Pbah-bo
Previous publications: Pahbo

Cáu:ánàun (Goose That Honks) or **Cáu:ánàunjè**
Phonetic: Kgawn-ahn-awn-tday
Previous publications: Kaw-aw-in-oin, Kaw-au-in-on-tay

Kiowa George: **Cûifò:làu** (Mature Wolf)
Phonetic: Kguwey-pbol-aw
Previous publications: Pohd-lohk, Gui-po-lau

Cí:dèémqí:gyài (A Person Coming Toward You)
Phonetic: Kgee-day-aim-k'ee-gyai
Previous publications: Kee-dem-kee-gah

Xó:mà (Light-Complected or Light-Haired Woman)
Phonetic: Ts'ohn-mah
Previous publications: Tsomah

Black War Bonnet Top: **Jánkò:gyà**
Phonetic: Tdahn-kohn-gyah
Previous publications: Tankonkya

NOTES AND REFERENCES

Foreword

1. Note that the decision to remove the outhouse from the image background was originally made by Horace himself. —T.J.

Sandweiss

1. Peter E. Palmquist and Thomas R. Kailbourn, *Pioneer Photographers from the Mississippi to the Continental Divide: A Biographical Dictionary, 1839–1865* (Stanford, CA: Stanford University Press, 2005), 446–67.

2. Julie Schimmel, "John Mix Stanley and Imagery of the West in Nineteenth-Century American Art" (PhD dissertation, New York University, 1983), 42–44, 47.

3. For more on the broader uses of nineteenth-century photographs of Indians, see Martha A. Sandweiss, *Print the Legend: Photography and the American West* (New Haven, CT: Yale University Press, 2002), 208–73.

4. For a survey of Native photographers as well as photographs of Native peoples during this period, see Alfred L. Bush and Lee Clark Mitchell, *The Photograph and the American Indian* (Princeton, NJ: Princeton University Press, 1994).

5. See, for example: Renée Sansom Flood and Shirley A. Birnie, *Remember Your Relatives, Yankton Sioux Images, 1851–1904*, vol. 1, ed. Leonard Bruguier (Marty, SD: Marty Indian School, 1985).

Haworth

1. Sovereignty "encompasses a system and philosophy of self-rule, in which each Native nation is preeminent in its own affairs, maintaining its own rules, laws, boundaries and responsibilities, just like any other independent, self-governing nation." Clifford Trafzer, ed., *American Indians /American Presidents: A History.* (New York: HarperCollins in association with the National Museum of the American Indian, Smithsonian Institution), 2.

2. 1940 United States Census, s.v. "Horace M. Poolaw," East McKinley Township, Caddo County, Oklahoma, ED 8-24 (Washington, DC: Bureau of the Census Microfilm Laboratory, accessed through 1940census.archives.gov), 4-A.—B.M.

3. It is unclear whether Poolaw's images were ever finally published in *Indians at Work*. According to scholar Mindy Morgan at Michigan State University, most photographers were never identified, and there are few archival records that reveal photographers' names. Laura E. Smith, e-mail conversation with Alexandra Harris, March 15, 2014.

4. Linda Poolaw, phone interview with Alexandra Harris, March 12, 2014.

5. Laura E. Smith, "Obscuring the Distinctions, Revealing the Divergent Visions: Modernity and Indians in the Early Works of Kiowa Photographer Horace Poolaw, 1925–1945" (PhD diss., Indiana University, 2008), 149. Smith's dissertation is a forthcoming publication by the University of Nebraska Press.

6. Tim Johnson, ed., *Spirit Capture: Photographs from the National Museum of the American Indian* (Washington: Smithsonian Institution Press in association with the National Museum of the American Indian, Smithsonian Institution, 1998), 24.

7. W. Richard West, foreword to *Spirit Capture*, xv.

Linda Poolaw

1. Please see the appendix for background on the Kiowa orthography used in this book, including phonetic spellings of names.

2. Research has uncovered different interpretations of this image, including that it may have been taken at the Guthrie Land Run of 1889 anniversary celebration in 1929. Other researchers have discussed Linda Poolaw's description of the image, such as Hadley Jerman, "Acting for the Camera: Horace Poolaw's Film Stills of Family, 1925–1950," *Great Plains Quarterly* 31, no. 2 (Spring 2011): 110–13.

Smith, . . . A Biography

1. Newton Poolaw, interview with the author, October 17, 2005. Jánkò:gyà's death in 1866 is noted in the Kiowa annual calendars. See James Mooney's *Calendar History of the Kiowa Indians* (Washington, DC: Government Printing Office, 1898), 318.

2. Linda Poolaw, "War Bonnets, Tin Lizzies and Patent Leather Pumps: Native American Photography in Transition" (lecture, Smith College, Northampton, MA, February 7, 2002). The Allotment (Dawes) Act was a late nineteenth-century federal strategy wrapped up in assimilatory Indian policies. The act broke up the reservations by assigning individual plots of land to each Indian. Before allotment, the Kiowa, along with the Comanche and Apache, lived on a 2.9-million-acre reserve in southwestern Oklahoma, a reservation created by the 1867 Medicine Lodge Treaty. For more on Kiowa life during this period of transition under the Allotment Act, see Blue Clark, *Lone Wolf v. Hitchcock: Treaty Rights and Indian Law at the End of the Nineteenth Century* (Lincoln: University of Nebraska Press, 1994), and Benjamin Kracht,

"Kiowa Religion: An Ethno-historical Analysis of Ritual Symbolism, 1832–1987" (PhD diss., Southern Methodist University, 1989).

3. Horace's marriage to Rhoda was short. They divorced shortly after Jerry was born. During this period, Horace also took a correspondence course on how to hand-color photographs through the Pictorial Arts Studio of Chicago. *Photography by Horace Poolaw* (US Department of the Interior, Indian Arts and Crafts Board, Southern Plains Indian Museum and Crafts Center, Anadarko, Oklahoma, May 27–June 27, 1979), exhibition brochure.

4. Linda Poolaw, "Horace Poolaw: Kiowa Photographer," *Winds of Change: A Magazine of American Indians* (Autumn 1990); Southern Plains Indian Museum and Crafts Center, *Photography by Horace Poolaw*.

5. Poolaw never had a studio. He took most of his photographs outdoors and set up a makeshift darkroom in his house.

6. Since 2010, the University of Science and Arts of Oklahoma's (USAO) Nash Library has stored the Poolaw negatives that are known to exist. The Poolaw family controls the copyright to all of Horace Poolaw's materials.

7. Many of Poolaw's postcards have been identified in several Oklahoma photography collections. The majority of the postcards at the Oklahoma Historical Society were printed in the late 1920s or 1930s, as determined by the manufacture dates of the paper stock. Some local businesses reprinted the postcards and sold them without compensating Poolaw, obtaining his permission, or identifying him as the photographer. This lack of proper attribution makes it difficult at this point to assess how far and in what kind of numbers his postcards traveled outside of the state. Linda and Robert Poolaw, interview with the author, Anadarko, Oklahoma, October 2005; Southern Plains Indian Museum and Crafts Center, *Photography by Horace Poolaw*; Jim Cooley, "A Vision of the Southern Plains: The Photography of Horace Poolaw," *Four Winds* (Summer 1982), 71.

8. Linda and Robert Poolaw, interview with the author, Anadarko, Oklahoma, October, 2004. In 1937, he worked for the Oklahoma Highway Patrol in Tulsa for a year and a half. He also worked for the DuPont Powder Company in 1942. See Southern Plains Indian Museum and Crafts Center, *Photography by Horace Poolaw*. For further discussion on the significance of Poolaw's postcard production beyond its economic significance, see Laura E. Smith, "Modernity, Multiples, and Masculinity: Horace Poolaw's Postcards of Elder Kiowa Men," *Great Plains Quarterly* 31, no. 2 (Spring 2011): 125–45.

9. Linda and Robert Poolaw, interview.

10. Horace married Winnie Chisolm in 1937. Their first child, Robert, was born in 1938.

11. See Linda Poolaw, Alice Marriott, and Stanford University, *War Bonnets, Tin Lizzies, and Patent Leather Pumps: Kiowa Culture in Transition, 1925–1955* (Stanford, CA: Stanford University, 1990). Some of the venues for the Poolaw traveling exhibit co-sponsored by Stanford and the Eastman Kodak Company before 1995 were the Natural History Museum of Los Angeles County, CA, February–April 1992; the Smithsonian's National Museum of American History in 1992; the Heard Museum in Phoenix, AZ, October 1993–January 1994; the Gilcrease Museum in Tulsa, OK, July–September 1993; the Kiowa Tribal Museum and Resource Center in Carnegie, OK, June–August 1994; and the Loveland Gallery, Loveland, CO, October–December 1994. Scholar Nancy Marie Mithlo and photographer Tom Jones have continued this important preservation and research work on Horace Poolaw's images. See http://nancymariemithlo.com/poolaw2008.htm.

12. Jeanne M. Devlin, "Horace Poolaw: An American Life," *Oklahoma Today* (July–August 1993).

Bibliography

Clark, Blue. *Lone Wolf v. Hitchcock: Treaty Rights and Indian Law at the End of the Nineteenth Century*. Lincoln: University of Nebraska Press, 1999.

Cooley, Jim. "A Vision of the Southern Plains: The Photography of Horace Poolaw," *Four Winds* (Summer 1982): 67–72.

Devlin, Jeanne M. "Horace Poolaw: An American Life," *Oklahoma Today*, July–August 1993.

Kracht, Benjamin. "Kiowa Religion: An Ethnohistorical Analysis of Ritual Symbolism, 1832–1987." PhD diss., Southern Methodist University, 1989.

Mooney, James. *Calendar History of the Kiowa Indians*. Washington, DC: Government Printing Office, 1898.

Photography by Horace Poolaw. US Department of the Interior, Indian Arts and Crafts Board, Southern Plains Indian Museum and Crafts Center, Anadarko, Oklahoma, May 27–June 27, 1979. Exhibition brochure.

Poolaw, Linda. "Horace Poolaw: Kiowa Photographer," *Winds of Change: A Magazine of American Indians* (Autumn 1990): 46–51.

———. *War Bonnets, Tin Lizzies, and Patent Leather Pumps: Kiowa Culture in Transition, 1925–1955*. California: Stanford University, 1990.

Poolaw, Linda, and Rayna Greene. "War Bonnets, Tin Lizzies and Patent Leather Pumps: Native American Photography in Transition," video recording of lecture, Smith College, Northampton, MA, February 7, 2002.

Smith, Laura E. "Modernity, Multiples, and Masculinity: Horace Poolaw's Postcards of Elder Kiowa Men," *Great Plains Quarterly* 31, no. 2 (Spring 2011): 125–45.

Penney

1. David W. Penney, Lisa A. Roberts, and Nancy Barr, *Images of Identity: American Indians in Photographs* (Detroit, MI: Detroit Institute of Arts, 1994).

2. "Strong Hearts: Native American Visions and Voices," *Aperture* no. 139 (Summer, 1995): 3.

3. Lois Smoky, the lone woman of the group, is often not included among the "Kiowa Five" group, which would make them six. In order to reduce confusion, this essay will use the term "Kiowa Six" when discussing this group of Kiowa painters of the early twentieth century. See Dorothy Dunn, *American Indian Painters of the Southwest and Plains Areas* (Albuquerque: University of New Mexico Press, 1968).

4. About the larger trope of "vanishing," see Brian W. Dippie, *The Vanishing American: White Attitudes and U.S.*

Indian Policy (Lawrence: University Press of Kansas, 1982).

5. George Catlin, *North American Indians* (Philadelphia: Leary, Stuart and Company, 1913), 3.

6. T. C. McLuhan, "Curtis: His Life" in *Portraits from North American Life* (New York: A&W Visual Library, 1975), viii.

7. For the relationship between childhood and Indians in early twentieth-century scientific thought, see David W. Penney, "Indians and Children: A Critique of Educational Objectives," *Native Americas: Akwe:kon's Journal of Indigenous Issues* 10 (Winter 1993): 12–18.

8. This is the broad thesis of Bruno Latour, *We Have Never Been Modern*, trans. C. Porter (Cambridge, MA: Harvard University Press, 1993).

9. Clyde Ellis, *A Dancing People: Powwow Culture on the Southern Plains* (Lawrence: University Press of Kansas, 2003), 135–56.

10. Candace Green of the National Museum of Natural History pointed these details out to me.

11. Ellis, 111–16.

12. This is the direction of the excellent recent dissertation by Laura E. Smith, "Obscuring the Distinctions, Revealing the Divergent Visions: Modernity and Indians in the Early Works of Kiowa Photographer Horace Poolaw, 1925–1945" (PhD diss., Indiana University, 2008), who draws from a discussion of modernity in Colleen O'Neill, "Rethinking Modernity and the Discourse of Development in American Indian History, an Introduction," in *Native Pathways: American Indian Culture and Economic Development in the Twentieth Century*, ed. Brian Hosmer and Colleen O'Neill

(Boulder: University Press of Colorado, 2004), 1–26. For discussions of modernity in American Indian art history, see Bill Anthes, *Native Moderns: American Indian Painting, 1940–1960* (Durham, NC: Duke University Press, 2006), in particular pages xiii–xxi; and Elizabeth Hutchins, *The Indian Craze: Primitivism, Modernism, and Transculturation in American Art, 1890–1915* (Durham, NC: Duke University Press, 2009). The latter quote, of course, is from the title of the most significant and influential discussion of this topic, Phillip J. Deloria, *Indians in Unexpected Places* (Lawrence: University Press of Kansas, 2004).

13. The concept of cultural hybridity in colonial/post-colonial studies was developed famously in Homi K. Bhabha, *The Location of Culture* (London: Routledge, 1995). For an excellent overview of the utility of the concept in the wake of Bhabha's influential work, see Deborah H. Kapchan and Pauline Turner Strong, "Theorizing the Hybrid," Special issue, *Journal of American Folklore* 112, no. 445 (1999): 239–53. For a critique of hybridity that parallels my concern that the concept, deployed casually, resembles syncretism, see Robert J. C. Young, *Colonial Desire: Hybridity in Theory, Culture, and Race* (London: Routledge, 1995). For a broad application of the concept in an art history/criticism context, see Cynthia Fowler, "Hybridity as a Strategy for Self-Determination in Contemporary American Indian Art," *Social Justice* 34, no. 1 (2007): 69. The concept and term also appears in Deloria, *Indians in Unexpected Places*, 35.

14. "The proliferation of hybrids" is the title of the opening chapter of Latour, *We*

Have Never Been Modern, 1–12, wherein Latour introduces the concept of human-made "hybrids of nature and culture," such as the hole in the ozone layer, chlorofluorocarbons, refrigerators and aerosols, factories, meteorology, international treaties, elections, corporate boards, and their connections by networks that cannot be circumscribed by categories like science, politics, or economics. The separation of the "social" from "science," or culture and nature, is one of the symptoms, he argues, of the illusion we call "modernity."

15. Muriel H. Wright, "The American Indian Exposition in Oklahoma," *Chronicles of Oklahoma*. 24 (Summer 1946): 164.

Blackhawk

1. Phillip H. Round, *Removable Type: Histories of the Book in Indian Country, 1663–1880* (Chapel Hill: University of North Carolina Press, 2010), 21.

2. Michael Gaudio, *Engraving the Savage: The New World and Techniques of Civilization* (Minneapolis: University of Minnesota Press, 2008), xiii.

3. For the rise of American expositions, see Robert W. Rydell, *All the World's a Fair: Visions of Empire at American International Expositions, 1876–1916* (Chicago: University of Chicago Press, 1987). For changing print culture, see Alan Trachtenberg, *The Incorporation of America: Culture and Society in the Gilded Age* (New York: Hill and Wang, 1982). For more about amusement parks, see John Kason, *Amusing the Millions: Coney Island at the Turn of the Century* (New York: Hill and Wang, 1978).

4. Theda Perdue, *Race and the Atlanta Cotton States*

Exposition of 1895 (Athens: University of Georgia Press, 2010), 1–2.

5. Frederick Jackson Turner, "The Significance of the Frontier in American History," *Annual Reports of the American Historical Association for the Year 1893* (Washington, DC: Government Printing Office, 1894), 199–227. See also, Turner, *The Frontier in American History* (New York: Henry Holt and Company, 1920).

6. James Belich, *Replenishing the Earth: The Settler Revolution and the Rise of the Anglo-World, 1783–1939* (New York: Oxford University Press, 2009), 6.

7. Turner, "The Significance of the Frontier in American History," 208.

8. Philip J. Deloria, *Playing Indian* (New Haven, CT: Yale University Press, 1998).

9. Mark David Spence, *Dispossessing the Wilderness: Indian Removal and the Making of the National Parks* (New York: Oxford University Press, 1999).

10. T. C. McLuhan, *Dream Tracks: The Railroad and the American Indian, 1890–1930* (New York: Abrams, 1985), 33.

11. Paige Raibmon, *Authentic Indians: Episodes of Encounter from the Late-Nineteenth-Century Northwest Coast* (Durham, NC: Duke University Press, 2005).

12. Denise K. Cummings, *Visualities: Perspectives on Contemporary American Indian Film and Art* (East Lansing: Michigan State University Press, 2011), xiii.

13. Maurice O. Wallace and Shawn Michelle Smith, eds., *Pictures and Progress: Early Photography and the Making of African American Identity* (Durham: Duke University Press, 2012), 5–6.

14. Ibid., 6.

15. Laura Wexler, "'A More Perfect Likeness': Frederick Douglass and the Image of the Nation," in Wallace and Smith, *Pictures and Progress*, 18.

16. Leigh Raiford, *Imprisoned in a Luminous Glare: Photography and the African American Freedom Struggle* (Chapel Hill: University of North Carolina Press, 2011), 9.

17. As Philip J. Deloria suggests, "things get weird . . . when the symbolic systems built on cars and Indians intersect." See Deloria, *Indians in Unexpected Places* (Lawrence: University of Kansas Press, 2004), 138.

18. As Beth H. Piatote has suggested, American Indian performances and self-representations from the early twentieth century are laden with oppositional styles and intentions that "trouble the order of the domestic space of both the house and nation." See Piatote, *Domestic Subjects: Gender, Citizenship, and Law in Native American Literature* (New Haven: Yale University Press, 2013), 105.

19. See, for example Lowery Stokes Sims, Truman T. Lowe, and Paul Chaat Smith, eds., *Fritz Scholder: Indian/Not Indian* (New York: Prestel, 2008).

Smith, Beaded . . .

1. Jacki Thompson Rand, *Kiowa Humanity and the Invasion of the State* (Lincoln: University of Nebraska Press, 2008), 150.

2. John A. Buntin, Kiowa Agency Superintendent to the Commissioner of Indian Affairs, letter, October 2, 1926. Record Group 75, Kiowa CCF 1907–1939, Associations and Clubs, US National Archives Records Administration, Washington, DC.

My work on the subject of modernity, modernism, and Horace Poolaw's photographs is further developed in my 2008 dissertation "Obscuring the Distinctions, Revealing the Divergent Visions: Modernity and Indians in the Early Works of Kiowa Photographer Horace Poolaw, 1925–1945." A revised version of this research to be published by the University of Nebraska Press is forthcoming.

3. Linda Poolaw, telephone interview with the author, September 2012.

4. I am inspired here by Native scholar Jolene Rickard's reading of one of Poolaw's images of his sister Trecil. The direct gaze between the indigenous subject and photographer is key to her interpretation of their reclamation of Indian land within the space of the photograph. See Rickard, "The Occupation of Indigenous Space as Photograph," in *Native Nations: Journeys in American Photography* (London: Barbican Art Gallery, 1998), 57–71. Native American photographer Hulleah Tsinhnahjinnie also employs the direct gaze of her indigenous male and female subjects in her *Portraits Against Amnesia* series (2003) to express as sense of "authority and power." Veronica Passalacqua, "Hulleah Tsinhnahjinnie," in *Pathbreakers: The Eiteljorg Fellowship for Native American Fine Art* (Indianapolis: Eiteljorg Museum in association with University of Washington Press, 2003), 87. Nancy Mithlo has presented insightful alternative observations in this volume on how indigenous female authority in some Native communities is expressed by averting the photographer's gaze. Linda Poolaw was not aware of any rules for Kiowa women about avoiding eye

contact. Vanessa Jennings acknowledged such expectations for women in the past. "It was considered lewd, bold, and low-class behavior to make direct eye contact." However, she indicated that very few Kiowas honor this today or remember it. Jennings, interview with the author, September 2012. Jennings' comment provokes questions about the application of the eye-contact rule in the 1920s or 1930s. Based on the family's stories of Xó:mà, it seems unlikely that she would demonstrate "low-class" behavior. Rather, in line with Rickard and the other physical signs of status in the picture, I find Xó:mà's visual engagement with the photographer to be an act of poise and self-determination.

5. Linda Poolaw, "Spirit Capture: Observations of an Encounter," in *Spirit Capture: Photographs from the National Museum of the American Indian*, ed. Tim Johnson (Washington, DC: Smithsonian Institution Press in association with the National Museum of the American Indian, 1998), 173. Kiowa George died in 1939.

6. Women built and owned their tipi homes. Bernard Mishkin's study of class among Kiowa women in 1940 affirmed that their creative industries were key to their stature in the community. Mishkin, *Rank and Warfare Among the Plains Indians* (Lincoln: University of Nebraska Press, 1992), 55.

7. Vanessa Jennings, interview with the author, October 8, 2005. Linda Poolaw, "Bringing Back Hope," in *All Roads Are Good: Native Voices on Life and Culture* (Washington, DC: Smithsonian Institution and the National Museum of the American Indian, 1994), 216. Ethnologist Elsie Clews Parsons recorded similar rules

for Kiowa female behavior and self-presentation during her 1927 fieldwork, in *Kiowa Tales* (New York: American Folklore Society, 1929), x.

8. Xó:mà only spoke Kiowa, which limited what information her English-speaking grandchildren obtained from her about her life. They have no memories of her beadworking. A Poolaw descendent now owns this dress. Linda Poolaw, interview with the author, September 2012.

9. John C. Ewers, "Climate, Acculturation, and Costume: A History of Women's Clothing Among the Indians of the Southern Plains," *Plains Anthropologist* 25, no. 87 (February 1980): 78.

10. After 1885, some Kiowa and Comanche leased reservation pasture lands to Texas cattlemen. Rand, 131. Barbara Hail's work on Kiowa and Comanche cradleboards has illuminated the relationship of this source of income to a dramatic period of beadwork production. Hail, *Gifts of Pride and Love: Kiowa and Comanche Cradles* (Bristol, RI: Haffenreffer Museum of Anthropology, Brown University, 2000), 22.

11. Rand, 150. Marsha Clift Bol has made similar conclusions about Lakota women's beadwork in "Lakota Women's Artistic Strategies in Support of the Social System," *American Indian Culture and Research Journal* 9, no. 1 (1985): 33–51.

12. Vanessa Jennings, interview with the author, October 8, 2005.

13. Horace's nephew Newton Poolaw (b. 1918) remembered Kiowas going occasionally to movie theaters in Mountain View in this period. Newton Poolaw, interview with the author, October 17, 2005.

14. The Keahbones appear in a series of photos that Poolaw took of a group of Kiowas dressed in full regalia near the farmer's public market in Oklahoma City. Based on documentation in the 1979 brochure to Poolaw's exhibition at the Southern Plains Indian Museum in Anadarko, some Kiowas may have participated in the opening ceremonies for this market in 1928. Newspaper accounts of the opening do not make note of any Indian activities that would help clarify their involvement. Vanessa Jennings indicates that Sindy Keahbone was an excellent beadworker, but her prized dress was made by Old Lady Smoky. The dress that Hannah is wearing was made by Mrs. Kicking Bird, a revered beadworker. Vanessa Jennings, interview with the author, September 2012.

15. Ibid.

16. Sara Ross, "'Good Little Bad Girls': Controversy and the Flapper Comedienne," *Film History* 13, no. 4 (2001): 409.

17. Parsons, viii–xi.

18. Alice Marriott, *The Ten Grandmothers* (Norman: University of Oklahoma Press, 1945), 272.

Bibliography

Bol, Marcia. "Lakota Women's Artistic Strategies in Support of the Social System," *American Indian Culture and Research Journal* 9, no. 1 (1985): 33–51.

Ewers, John C. "Climate, Acculturation, and Costume: A History of Women's Clothing Among the Indians of the Southern Plains," *Plains Anthropologist* 25, no. 87 (February 1980): 63–82.

Hail, Barbara. *Gifts of Pride and Love: Kiowa and Comanche Cradles*. Bristol,

RI: Haffenreffer Museum of Anthropology, Brown University, 2000.

Marriott, Alice. *The Ten Grandmothers*. Norman: University of Oklahoma Press, 1945.

Mishkin, Bernard. *Rank and Warfare Among the Plains Indians*. Lincoln: University of Nebraska Press, 1992.

Parson, Elsie Clews. *Kiowa Tales*. New York: American Folklore Society, 1929.

Passalacqua, Veronica. "Hulleah Tsinhnahjinnie." In *Pathbreakers: The Eiteljorg Fellowship for Native American Fine Art*, 81–98. Indianapolis: Eiteljorg Museum in association with University of Washington Press, 2003.

Poolaw, Linda. "Spirit Capture: Observations of an Encounter." In *Spirit Capture: Photographs from the National Museum of the American Indian*, ed. Tim Johnson, 167–78. Washington, DC: Smithsonian Institution Press in association with the National Museum of the American Indian, 1998.

———. "Bringing Back Hope." In *All Roads Are Good: Native Voices on Life and Culture*, 208–19. Washington, DC: Smithsonian Institution and the National Museum of the American Indian, 1994.

Rand, Jacki Thompson. *Kiowa Humanity and the Invasion of the State*. Lincoln: University of Nebraska Press, 2008.

Rickard, Jolene. "The Occupation of Indigenous Space as 'Photograph.'" In *Native Nations: Journeys in American Photography*, 57–71. London: Barbican Art Gallery, 1998.

Ross, Sara. "'Good Little Bad Girls': Controversy and the Flapper Comedienne," *Film History* 13, no. 4 (2001) 409–23.

Mithlo

1. Cheryl Finley, "The Practice of Everyday Life," in *Teenie Harris, Photographer: Image, Memory, History* by Cheryl Finley, Laurence Glasco, and Joe W. Trotter (Pittsburgh: University of Pittsburgh Press, 2011), 40.

2. See my forthcoming article on the contrast principle, "High Contrast: The Enduring Paradox of Native Photography" *Wicazo-Sa Review*, 2015.

3. My approach to viewing these images (what I term "American Indian curatorial practice") involves fieldwork, oral history, academic works, and personal narrative. I am a Chiricahua Apache. The Kiowas, Apaches, and Comanches share similar histories of government warfare, control, and, ultimately, survival, and they occupy adjacent lands today. When I view these photos I taste, feel, and smell the southern plains of Oklahoma where my family lives and my ancestors are buried. This experiential reading is essential to my academic efforts. Additionally, the mentorship of my family, especially my aunt Linda Poolaw, daughter of the photographer, has greatly enhanced my understanding of how Horace approached his craft. I accept, however, that any errors in analysis are my own. Multiple interpretations of Poolaw's images exist; as his legacy becomes more accessible, debates concerning his intent will certainly emerge, enlarging the dialogues available to us.

4. Catherine A. Lutz and Jane L. Collins, *Reading National Geographic* (Chicago: University of Chicago Press, 1993), 197.

5. See discussion of László Moholy-Nagy's approach to modernist photography in Sri-Kartini Leet, *Reading Photography: A Sourcebook of Critical Texts 1921–2000*, ed. Alison Hill (Burlington, VT: Lund Humphries, 2011), 21–22.

6. I credit former curator of the Georgia O'Keeffe Museum and the Emily Fisher Landau director of the museum's research center Barbara Buhler Lynes for her mentorship in exposing me to this distinction in the concept of modernism.

7. For a related critique, see Nancy Marie Mithlo, "Blood Memory and the Arts: Indigenous Genealogies and Imagined Truths," in *American Indian Culture and Research Journal* 35, no. 4 (2011): 103–18.

8. "Richard Ray Whitman," A Time of Visions: Interviews by Larry Abbott, accessed May 13, 2013, http://www.britesites.com/native_artist_interviews/rwhitman.htm.

9. Henri Cartier-Bresson, *The Decisive Moment: Photography by Henri Cartier-Bresson* (New York: Simon and Schuster, 1952), n.p.

10. Ibid.

11. From the research completed to date on Poolaw's legacy, we know that Horace was a keen observer of contemporary visual mores. He read encyclopedias, *Life* magazine, and numerous newspapers daily. Additionally, he was trained by local professional photographers and served as an aerial photographer in World War II.

12. Girls participating in the Apache coming-of-age ceremony are considered to be the giver of all life.

13. In addition to general mores of modesty, if we follow the Apache coming-of-age metaphor suggested earlier for Indian princesses, we know that during the transition from youth to womanhood,

a girl may be considered very powerful. So powerful, in fact, that she is told not to look up to the sky for she could make the weather turn to storm. She averts her eyes not from a position of weakness but from a perspective of unimaginable strength.

14. Eye-contact avoidance may also be attributed in Navajo contexts to values of privacy. See Sol Worth and John Adair, *Through Navajo Eyes: An Exploration in Film Communication and Anthropology* (Albuquerque: University of New Mexico Press, 1997), 156.

15. "Oklahoma Military Hall of Fame Announces 2008 Inductees," The Norman Transcript, November 8, 2008. http://normantranscript.com/local/x519031533/Oklahoma-Military-Hall-of-Fame-an-nounces-2008-inductees.

16. The photographer's daughter, Linda Poolaw, reported during a discussion with the author that it was her father who organized and raised money so that a bust of Pascal Cletus Poolaw, Sr., could be placed at the American Indian Hall of Fame in Anadarko, Oklahoma.

17. As conceptualized by Fatimah Tobing Rony in *The Third Eye: Race, Cinema, and Ethnographic Spectacle* (Durham, NC: Duke University Press, 1996), the third-eye perspective draws from the writings of African American sociologist W. E. B. Du Bois. Working in the early part of the twentieth century, he identified the "double consciousness" of seeing oneself through the eyes of others and the resulting sense of self-alienation. W. E. Burghardt Du Bois, *The Souls of Black Folk: Essays and Sketches* (New York: Bantam Classic text reprinted from the 1953 Blue Heron edition, 1989,

originally published in 1903), 3. An important distinction in Poolaw's work is the mobilization of this third-eye perspective to be inclusive, not exclusive, in character.

18. I give credit to photographer David Grant Noble of Santa Fe, New Mexico, for pointing out this important visual strategy.

19. Rony, 3–4, 41.

Jones, Insider Knowledge

1. Linda Poolaw, "Spirit Capture: Observations of an Encounter," in *Spirit Capture: Photographs from the National Museum of the American Indian*, ed. Tim Johnson (Washington, DC: Smithsonian Institution Press, 1998), 168.

2. Gail Tremblay, "Constructing Images, Constructing Reality: American Indian Photography and Representation," *Views: The Journal of Photography in New England* 13–4/14–1 (Winter 1993): 9.

3. Candace S. Greene, *One Hundred Summers: A Kiowa Calendar Record* (Lincoln: University of Nebraska Press, 2009), 1; orthography, 197.

4. Jim Cooley, "A Vision of the Southern Plains, the Photography of Horace Poolaw." *Four Winds, The International Forum for Native American Art, Literature, and History* 3, no. 9 (Summer 1982): 67.

5. Rennard Strickland, "Native American Art: The Great Circle and the Power of Dreams; an Address to the Heard Museum Board of Trustees," (1987), 7.

6. Larry Abbott, A Time of Visions: Interviews by Larry Abbott, accessed December 12, 2012, http://www.britesites.com/native_artist_interviews/.

7. John Szarkowski, *Mirrors and Windows: American*

Photography since 1960 (New York: Museum of Modern Art, 1978), 11–25.

Jones, Truth and Humor

1. Philippe D. Mather, *Stanley Kubrick at* Look *Magazine: Authorship and Genre in Photojournalism and Film* (Bristol, UK: Intellect, 2013), 35. See also "Oral history interview with Roy Emerson Stryker, 1963–1965," Archives of American Art, Smithsonian Institution, accessed November 14, 2013, http://www.aaa.si.edu/collections/interviews/oral-history-interview-roy-emerson-stryker-12480.

2. Linda Poolaw, in discussion with University of Wisconsin–Madison Poolaw Summer Research Program, July 2008.

3. Linda Poolaw, "Spirit Capture: Observations of an Encounter," in *Spirit Capture: Photographs from the National Museum of the American Indian*, ed. Tim Johnson (Washington, DC: Smithsonian Institution Press, 1998), 168.

4. See the Sendeh tales told in Elsie Worthington Clews Parsons, *Kiowa Tales* (New York: The American Folklore Society, G. E. Stechert and Co., agents, 1929), 21–46.

John Poolaw

1. In Native culture, your grandparents' siblings are not called "great-uncle" or "great-aunt" as is common in the dominant culture; they are called "grandpa" and "grandma," and they are just as special and important as the biological ones.

Whitman

1. Thanks to Dr. Gus Palmer, Jr., associate professor of linguistics and anthropology at the University of Oklahoma,

for his assistance with the Kiowa language.

2. See, for instance: M. D. Velarde, G. Fry, and M. Tveit, "Health effects of viewing landscapes—Landscape types in environmental psychology," *Urban Forestry & Urban Greening*, 6 (2007): 199–212.

Jennings

1. All Kiowas had to know and remember their allotment number for services at the Anadarko Indian Agency. This number is necessary for the person to request monies from their Indian monies (IIM) account or to request services from one of the offices at the agency. It is a number that is drilled into our memories by our elders. It was a way of identifying an Indian photographed by Horace Poolaw.

Dane Poolaw

1. I used linguist Parker McKenzie's (Kiowa, 1897–1999) style of writing Kiowa (there are more than ten different methods) because his diacritical marks make it a more precise way to write the language.

CONTRIBUTORS

Ned Blackhawk (Western Shoshone) is a professor of history and American studies at Yale University and was on the faculty at the University of Wisconsin–Madison from 1999 to 2009. A graduate of McGill University, he holds graduate degrees in history from UCLA and the University of Washington. He is the author of *Violence over the Land: Indians and Empires in the early American West* (2006), which received several professional prizes and was recognized as one of the most significant books of the decade by the Native American and Indigenous Studies Association. He has led the establishment of two fellowships—one for American Indian Students to attend the Western History Association's annual conference, the other for doctoral students working on American Indian Studies dissertations at Yale.

Cheryl Finley is associate professor and director of visual studies in the department of the history of art at Cornell University. She is co-author of *Harlem: A Century in Images* and author of the forthcoming *Committed to Memory: The Slave Ship Icon in the Black Atlantic Imagination*. She is also a noted curator; her book *Diaspora, Memory, Place: David Hammons, Maria Magdalena Campos-Pons, Pamela Z* documented her 2004 Dak'Art Biennial exhibition in Dakar, Senegal. The recipient of numerous awards and grants, Finley has received research support from the Ford Foundation, the Center for Advanced Study in the Visual Arts, the Alphonse Fletcher Sr. Fellowship, and the American Academy of Arts and Sciences. She frequently writes and lectures about African diaspora art, photography, the art market, heritage tourism, and the aesthetics of memory.

John Haworth (Cherokee) has been the director of the Smithsonian's National Museum of the American Indian in New York City since 1995. Under his leadership, the museum developed the Diker Pavilion for Native Arts and Cultures (2006) and the ambitious collections-based exhibition *Infinity of Nations: Art and History in the Collections of the National Museum of the American Indian* (2010). He has been a featured speaker at regional and national arts conferences, and has written extensively on cultural and museum issues. Prior to his work at the National Museum of the American Indian, Haworth served as assistant commissioner for cultural institutions at the NYC Department of Cultural Affairs and taught arts management and cultural policy courses at New York University. Haworth received an MBA from Columbia University, where he was also designated as a Revson Fellow on the Future of New York City.

Vanessa Paukeigope Jennings (Kiowa Apache/Gila River Pima) is the granddaughter of Stephen Mopope, a member of the Kiowa Six group of artists. "I am a traditional artist," Jennings said. "I do the old-style work of my grandmother and great-grandmother's work. I make beaded dresses, shirts, lances, shields, bowcases, and other material culture items." In 1989, Jennings was made a National Heritage Fellow. This award from the National Endowment for the Arts designates each recipient as a "living national American treasure." In 2004, she was named the Honored One by the Red Earth Festival. She lives in Red Stone, east of Fort Cobb, Oklahoma.

Tom Jones (Ho-Chunk) is an associate professor of photography at the University of Wisconsin–Madison. He received his MFA in photography and an MA in museum studies from Columbia College in Chicago. Jones's work may be found in numerous collections, including the National Museum of the American Indian, the Polaroid Corporation, the Sprint Corporation, the Chazen Museum of Art, the Nerman Museum of Contemporary Art, and the Microsoft Corporation.

Nancy Marie Mithlo (Chiricahua Apache) is the chair of American Indian studies at the Autry National Center Institute and associate professor of art history and visual arts at Occidental College. She earned her PhD in 1993 from Stanford University. Mithlo's extensive relationship with the Institute of American Indian Arts includes directing the Museum of Contemporary Native Arts and editing the 2011 publication *Manifestations: New Native Art Criticism*. She was awarded fellowships from the Woodrow Wilson Foundation, the School for Advanced Research, and the Georgia O'Keeffe Museum's Research Center. Mithlo's curatorial work has resulted in seven exhibits at the Venice Biennale.

David Grant Noble started photographing in 1962 and has work in the collections of the New York Public Library, Yale University's Beinecke Library, and the Museum of Fine Arts, Houston. Notably, in the early 1970s, he photographed Mohawk steelworkers and Ojibwe wild-rice harvesters. From 1972 to 1989, he was a program director at the School for Advanced Research in Santa Fe. His books include *In the Places of the Spirits* (2010) and *The Mesa Verde World* (2006). He is presently preparing the fourth edition of *Ancient Ruins of the Southwest: An Archaeological Guide*. He is a recipient of the Victor Stoner Award from the Arizona Archaeological and Historical Society and the Emil Haury Award from the Western National Parks Association. Both awards recognized his contributions to advancing public understanding and appreciation of the Southwest's cultural and natural resources. Noble's photographs can be viewed at www.davidgrantnoble.com.

David W. Penney is the associate director of museum scholarship at the Smithsonian's National Museum of the American Indian and an internationally recognized scholar of American Indian art. Formerly the vice president of exhibitions and collections strategies at the Detroit Institute of Arts and the longtime curator of that museum's Native American art collections, he is the co-author of *North American Indian Art* (2004) and the author of *The American Indian: Art & Culture between Myth & Reality* (2012), which accompanied an exhibition that he curated at De

Nieuwe Kerk in Amsterdam. Recently, Penney was the co-curator of the NMAI–New York exhibition *Before and After the Horizon: Anishinaabe Artists of the Great Lakes* and the co-editor of its accompanying catalogue. He has written many other books, exhibition catalogues, and essays.

Dane Robert Monroe Poolaw is the son of Robert William Poolaw, Jr., and Sandra Carole (Willis) Poolaw. His paternal grandparents are Robert William Poolaw, Sr., and Martha Nell (Kauley) Poolaw. His maternal grandparents are Henry Willis and Carole (Botone) Willis. He is the great-grandson of Horace Monroe Poolaw and the great-great-grandson of Kiowa George. He is of Kiowa, Choctaw, and Delaware descent and grew up in Anadarko, Oklahoma. He received a degree in Native American studies at the University of Oklahoma and is now pursuing a MEd in instructional leadership and academic curriculum at the same institution. He has also been an instructor of Kiowa language at the university since fall 2007.

John Poolaw is of the Kiowa, Comanche, Chiricahua Apache, Delaware, Creek, and Seminole Nations. He currently resides in Lawton, Oklahoma, where has served as the assistant professor of science at the Comanche Nation College for the past ten years; recently, he has taken on the responsibilities of interim dean of student services. John received his BS in zoology from the University of Oklahoma, a MEd in teaching from Cameron University, and is currently in his third year of the Adult and Higher Education doctoral program at the University of Oklahoma. John is the son of Dr. Bryce Poolaw, the grandson of Horace Poolaw, and the great-grandson of Kiowa George.

Linda Poolaw (Kiowa/Delaware) is a former member of the Delaware Tribe Executive Committee, a health researcher, playwright, curator, and educator. She was born in 1942 in Lawton, Oklahoma, to Horace (Kiowa) and Winnie Chisholm Poolaw (Delaware/Creek/Seminole), and was raised on her parents' allotted land near Anadarko. She holds a BA in sociology from Oklahoma College of Liberal Arts, and worked towards a master's degree in speech communication from University of Oklahoma. In 1989, Poolaw taught a photo-documentation class at Stanford University and curated the exhibition of her father's photographs: *War Bonnets, Tin Lizzies, and Patent Leather Pumps: Kiowa Culture in Transition, 1925–1955*. For more than twenty years, Poolaw worked for the University of Oklahoma Health Sciences Center investigating the causes of heart disease among Indian people. She is now living comfortably on her family's allotment just west of Anadarko, reflecting on her life and occasionally speaking publicly about her father's photos. She appreciates how much her father's photographs have taught her about her Kiowa people.

Martha A. Sandweiss is a professor of history at Princeton University. She received her PhD in history from Yale University and began her career as a photography curator at the Amon Carter Museum in Fort Worth, Texas. She then taught American studies and history at Amherst College for twenty years. She is the author or editor of numerous books on American history and photography, including *Passing Strange: A Gilded Age Tale of Love and Deception Across the Color Line* (2009), a

finalist for the National Book Critics Circle Award, and *Print the Legend: Photography and the American West* (2002), winner of the Organization of American Historians' Ray Allen Billington Award.

Laura E. Smith is an assistant professor of art history and visual culture at Michigan State University, where she specializes in North American art, Native North American art, and photography. Upon receiving her BFA in painting from Moore College of Art and Design in Philadelphia in 1996, she worked at the University of Pennsylvania Museum of Archaeology and Anthropology as a Native American Graves Protection and Repatriation Act (NAGPRA) project assistant. She holds a MA in art history from the University of New Mexico (2002) and received a PhD in art history from Indiana University in 2008. Her dissertation entitled "Obscuring the Distinctions, Revealing the Divergent Visions: Modernity and Indians in the Early Works of Kiowa Photographer Horace Poolaw, 1925–1945," is currently being revised into a book to be published by the University of Nebraska Press.

Richard Ray Whitman (Yuchi/Muscogee Creek) is an internationally acclaimed artist and photographer. His work has been exhibited at museums and galleries nationally and internationally, with highlights including the exhibition *Continuum 12* at the Smithsonian's National Museum of the American Indian in New York; La Biennale di Venzia in Venice, Italy; and Honor the Earth's nationwide touring exhibit, *Impacted Nations*. His work has been published in magazines and featured in books such as Aperture's *Strong Hearts*, and the Oxford University Press college textbook *Native North American Art*. An actor, Whitman's appearances include *Winter in the Blood* based on the novel by James Welch, *Red Reflections*, *Lakota Woman*, the Sundance Institute production *Drunk Town's Finest*, and the award-winning feature films *Barking Water* and *Four Sheets to the Wind*.

ACKNOWLEDGMENTS

We are grateful for the energy, support, and spirit of the many people who helped make this catalogue, exhibition, and the entire Poolaw Photography Project possible. Our greatest thanks go to the Poolaw family, who have entrusted us to care for and interpret their father's legacy. Horace Poolaw's story is the story of American Indian people—their humor, creativity, resilience, and strength.

Our gratitude goes to our catalogue authors, and the talented staff at the Smithsonian's National Museum of the American Indian, including Kevin Gover, Tim Johnson, John Haworth, Alexandra Harris, Steve Bell, Ann Kawasaki, Lindsay Shapiro, Tanya Thrasher, and our beloved colleague, the late Fred Nahwooksy.

The 1989 Stanford University exhibition *War Bonnets, Tin Lizzies, and Patent Leather Pumps: Kiowa Culture in Transition, 1925–1955*, traveled by The American Federation of Arts and directed by the photographer's daughter, Linda Poolaw, informed the current project in multiple ways. We would like to acknowledge the efforts of this early project and related exhibitions, including *Photography by Horace Poolaw* (May 27–June 27, 1979), by the US Department of the Interior, Indian Arts and Crafts Board, Southern Plains Indian Museum and Crafts Center, the only exhibition known to have been displayed during the artist's lifetime. In 1983 and '84, Jaune Quick-To-See Smith curated the exhibit *Photographing Ourselves: Contemporary Native American Photography*, at the Southern Plains Indian Museum, Anadarko, Oklahoma, with the assistance of Rosemary Ellison. Organized by ATLATL, the Phoenix, Arizona, arts service organization, this exhibition featured Poolaw's photographs and traveled nationally. The University of Science and Arts of Oklahoma (USAO) art gallery in Chickasha, Oklahoma, curated the exhibition *The Photographs of Horace Poolaw* (January 24–March 31, 1998). USAO's Nash Library currently holds the Horace Poolaw photography collection on long-term loan by the Poolaw family. We would additionally like to acknowledge the research led by Laura Smith, editor for the *Great Plains Quarterly* special issue 31 (Spring 2011) with essays by Morgan F. Bell, Hadley Jerman, and Thomas Poolaw.

Important research and preservation was accomplished in the 2004, 2008, and 2010 Poolaw Photography Projects, sponsored by Smith College, the University of Science and Arts of Oklahoma, and the University of Wisconsin–Madison. We thank the many people who participated in the project during those years, including Jordan Anderson, Julie Bohannon, Andrea Brdek, Kelly Broadway, Kelly Brown, Tania Bruno, Jennifer Chen, Christine DiThomas, Natalie Duty, Delana Joy Farley, Dr. John Feaver, Lisa Frank, Nancy Goldenberg, Sarah LeVaun Graulty, Lorene "Ella

Faye" Horse, Rita Irigan, Derek R. Jennings, Hadley Jerman, Julianna LaBruto, Eve Little Shell LaFountain, Stephanie Marinone, Sarah Masai, Molly McCadden, Kelly McCray, Katie McGowan, Kendall McMinimy, Shaun Miller, Sascha Navarro, Judy Natal, Jenaille Northey, Stephanie Nutt, Nicole O'Connor, Doris J. Poolaw, Paul Baker Prindle, Mackenzie Reynolds, Sarah Ripp, Flannery Rogers, Tossie Ryan, Laura Smith, Leslie Stager, Sarah Stolte, Morgan Swett, Lane Thrift, Melva J. Keahbone-Wermy, Dorothy Whitehorse DeLaune, Nic Wynia, and Kristen Zeiser.

The Poolaw Photography Project at Smith College and the University of Wisconsin–Madison received support over the years from the following organizations: Americans for Indian Opportunity, Future of Minority Studies, Georgia O'Keeffe Museum Research Center, Institute of American Indian Arts, Savannah College of Art and Design, School for Advanced Research, Smith College, Society for Visual Anthropology (American Anthropological Association), Society for Visual Anthropology Visual Research Conference, and Stanford University Research Institute of Comparative Studies in Race and Ethnicity. At the University of Wisconsin–Madison, additional support came from the Freshman Interest Group class of 2010, the Graduate School Research Award 2008 and 2010, the Vilas Associated Grant, the University of Wisconsin Institute on Race and Ethnicity, the Center for the History of Print Culture, the Tribal Libraries Archives and Museums Student Group, the departments of art history and fine art, the American Indian studies program and the Woodrow Wilson National Fellowship Foundation.

We additionally extend our gratitude to professional colleagues Walter BigBee, Thomas D. Blakely, Chester R. Cowan, Malcolm Collier, Chuck Dailey, Jan McCoy Ebbets, Elisabetta Frasca, Alison Freese, Tara Gatewood, Dorothy Grandbois, Rayna Green, Karl Heider, Lucy Lippard, Amy Lonetree, N. Scott Momaday, Patricia Pate, Patsy Phillips, Willow Powers, Abby Remer, Eva Respini, Janice M. Rice, Joanna C. Scherer, and Tatiana Lomahaftewa-Singer. Please forgive any oversights; many people have generously assisted us over the fifteen years of the project research, and some may have been inadvertently overlooked.

——Tom Jones and Nancy Marie Mithlo

INDEX

Relationships to Horace Poolaw are given in parentheses where appropriate. Page numbers in *italics* indicate illustrations.

Abbott, Larry, 102
abstraction, 88, 94
African Americans, 66, 70–72, *71*
Ahpeatone, Lucy (Kiowa) *34*
Ahtone-ah (Mrs. Unap), daughter of Satanta (Kiowa), *160*
Ahtone, Juanita Daugomah (Kiowa), *61*
airplanes, *2, 28, 116, 117, 122,* 123
allotment numbers, 153, 174n1
American Indian Exposition (Expo or Indian Fair), *35,* 35–37, *36, 38, 39, 48,* 49, 58–61, *60–63, 82, 86, 90,* 91, *96, 106, 107,* 113–15, *118, 119, 121,* 128, *129*
Anadarko, Oklahoma, 9–11, 85, 117
Archilta, Rose Sharon (Kiowa Apache), 99
art versus documentary photography, 111–12
Asah, Spencer (Kiowa), *A Dancer* (1929), 57, *58*
Ashley, George (Wichita), 49
assimilation, 10, 23, 62, 68, 75, 77, 102, 103, 140, 169n2
Attocknie, Albert (Comanche), 50
Auchiah, James (Kiowa), 57
automobiles, *22,* 32, *34,* 60–62, *61, 63,* 72–75, *74,* 85, 86, *87,* 88, *114, 118, 119, 138, 139, 141,* 172n17

Barsh, Augustine Campbell (Kiowa), *61*
beading and beadwork, 66, 77–78, 150–54, *152, 155,* 172n8, 172n10–11, 173n14
Beaver, Donna (Kiowa), *152,* 153, *167*
Beaver, Lucy Whitehorse (Kiowa), *152,* 153, *167*

Berry, Myrtle (Kiowa) *34, 83*
Big Bow, Abel (Kiowa), *110*
Big Bow, Agnes (Mrs. Abel) (Kiowa), *26, 110*
Big Bow, Old Man (Kiowa), *11*
Big Bow, Vivian (Kiowa/Caddo), *118,* 119
Black Legging Ceremonies, *55*
Blackhawk, Ned (Western Shoshone), 65, 175
Bosin, Caroline (Kiowa), *34, 83*
Bosin, Frank (Kiowa), *83, 159*
Bosin, Mrs. Frank (Kiowa), *83*
Botone, George (Kiowa), *63*
Botone, Robert and Ruby (Kiowa), *161*
Bow, Clara, *80*
boxer, U.S. Army Air Forces, *52*
Bread, Marilyn Kodaseet (Kiowa), *55*
Bryant, Anita (as Miss Oklahoma), *38*
buffalo and buffalo meat, 32, *33,* 144
Buntin, John A., 77, 78, 79
Bureau of Indian Affairs, takeover of (1972), 23
burials and funeral services, 26, 92, 94, 94–95, *108, 109, 118, 126, 127*

Caddo, Judith (Delaware/Caddo), *39*
Carnegie, Oklahoma, *24, 25,* 31, 72, 92, *118,* 150
Carter, Patsy Ann (Caddo/Kiowa), *39*
Carter, Phil Keith (Caddo), 15
Carter, Wayne (Caddo), *14*
Cartier-Bresson, Henri, 90–91
Catlin, George, 57–58, 62
Cáu:ánàun (Goose That Honks) (grandmother), 30, *167*
Cí:dèémqí:gyài (A Person Coming Toward You) (aunt), 30, 35
citapa:dau (food drying rack), 144, *145*
Citizenship Act (1924), 20
Civilian Conservation Corps–Indian Division (CCC-ID), 20

Clayton, Charlotte (Caddo), *84*
Cobb, Jennie Ross (Cherokee), 9
Coyle, John, 30–31
Cozad, Belo (Kiowa), *83*
cradleboards, *36,* 60, 78, 154, *155*
Craterville Park Indian Fair, *33,* 35–37, 49, 58, *59,* 88–89, *89,* 112
Cûifò:làu (Old/Mature Wolf; Kiowa George Poolaw) (father), 29–30, 31, 35, 41, 49, 76, 77–78, *100,* 102, *120, 156, 167,* 177
Curtis, Edward, 58, 62
cyclone of 1928, 31

Daguerre, Louis-Jacques-Mandé, 15
dancing: Apache fire dancers, *48, 104;* fancy dancers, *59,* 59–60, *60, 62, 105;* Gallup Inter-Tribal Indian Ceremonial, New Mexico, *104, 105, 137;* honor dances, *25, 99, 110;* Kiowa Ohomah child dancers, *97;* Osage dancers, *107;* parade at Expo, *113;* photographers of children dancing at Expo, *129;* stomp dancing, *106;* Sun Dance, 29, 78; unidentified dancer from Mountain View, *131*
Dawes Act (General Allotment Act; 1887), 19, 169n2
De Bry, Theodor, *America* (1590), *64,* 65
Deer, Alvin Burke and Melvin (Kiowa Ohomah), *97*
Deloria, Philip J. (Standing Rock Sioux), 68, 172n17
documentary versus art photography, 111–12
Doonkeen, Eula Mae Narcomey (Seminole), *90,* 91–92
Doty, Maria (Navajo), *114*
Douglass, Frederick, 70–72, *71*
Drywater, Peter (Cherokee), *13*

Edwards, Howard (Delaware) (brother-in-law), *132,* 133
Eliot, John, *Algonquian Bible* (1663), 65
Ellis, Rosie, *83*
Ellison, Rosemary, 40
entertainment industry, 32, 68, 70, 79–80, 134
Evans, Dale, *38, 114*
Evans, Walker, 23, *124*
eye contact and gaze, 77, 87–88, 91–92, 130, 172n4–5, 173n12–13, 174n14

Farm Security Administration (FSA) photographers, *22,* 23, *124*
Farmers Public Market, Oklahoma City, *34,* 79, *83,* 172–73n14
female identity, 77–81, 154, 173n12–13
Finley, Cheryl, 87, 117, 175
fish caught after flood of Washita River (ca. 1930), 31
flags, *24,* 92, 94, 94–95, *110, 111,* 117–19, *118, 119*
football team, Fort Sill Indian School, *52*
For a Love of His People: The Photography of Horace Poolaw (exhibit, NMAI, 2014), 10
Fort Sill Indian School, *52*
Funmaker, Jim (Ho-Chunk), 102, *103*

Gallup Inter-Tribal Ceremonial, New Mexico, *104, 105,* 111, *112, 137*
games: hand game, *54;* stick ball, *106*
Gast, John, *American Progress* (1872), 66, *67*
Geiogamah, Claudette (Kiowa), *60*
Geronimo, Soule's portrait of, 50
giveaways, *120*
Given, Frank (Kiowa), *55*
Goombi, Adolphus (Kiowa), *13*